I0235531

IMAGES
of America

LANESBORO
MINNESOTA
HISTORIC DESTINATION

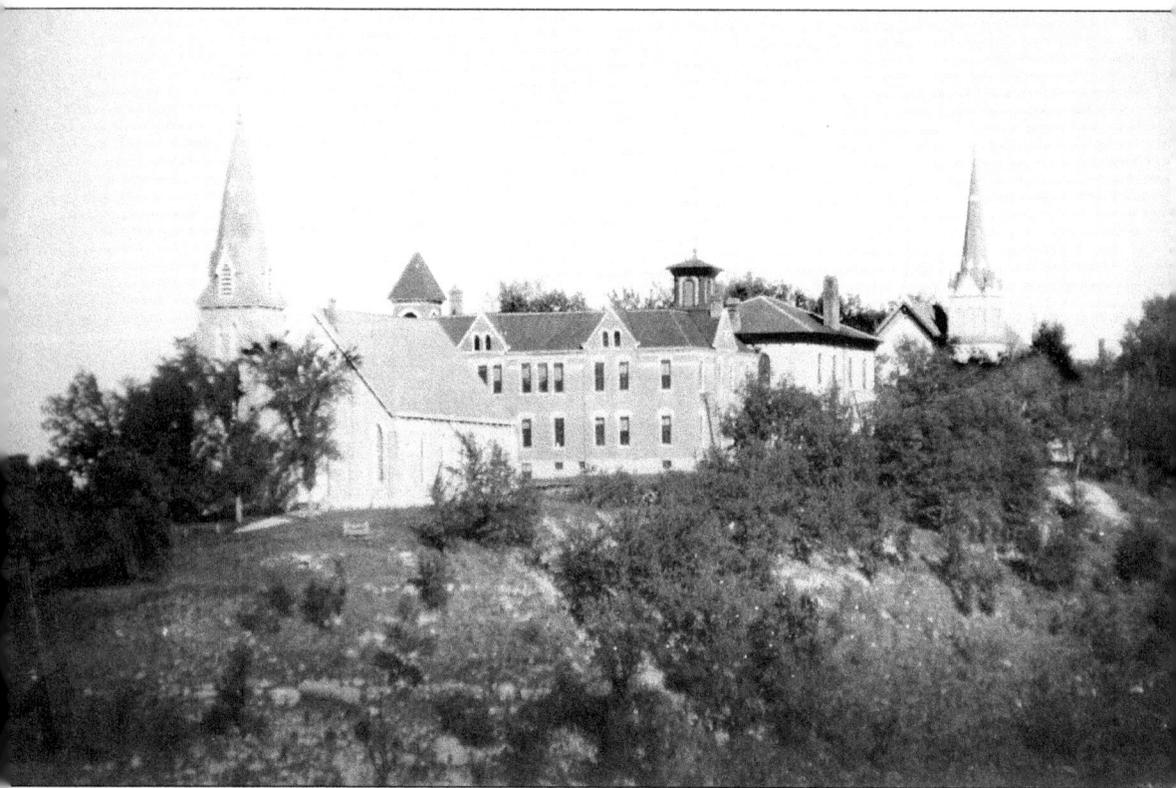

IMAGES
of America

LANESBORO
MINNESOTA
HISTORIC DESTINATION

Don Ward and Ted St. Mane

ARCADIA
PUBLISHING

Copyright © 2002 by Don Ward and Ted St. Mane
ISBN 978-1-5316-1383-9

Published by Arcadia Publishing
Charleston, South Carolina

Library of Congress Catalog Card Number: 2002111594

For all general information contact Arcadia Publishing at:
Telephone 843-853-2070
Fax 843-853-0044
E-mail sales@arcadiapublishing.com
For customer service and orders:
Toll-Free 1-888-313-2665

Visit us on the Internet at www.arcadiapublishing.com

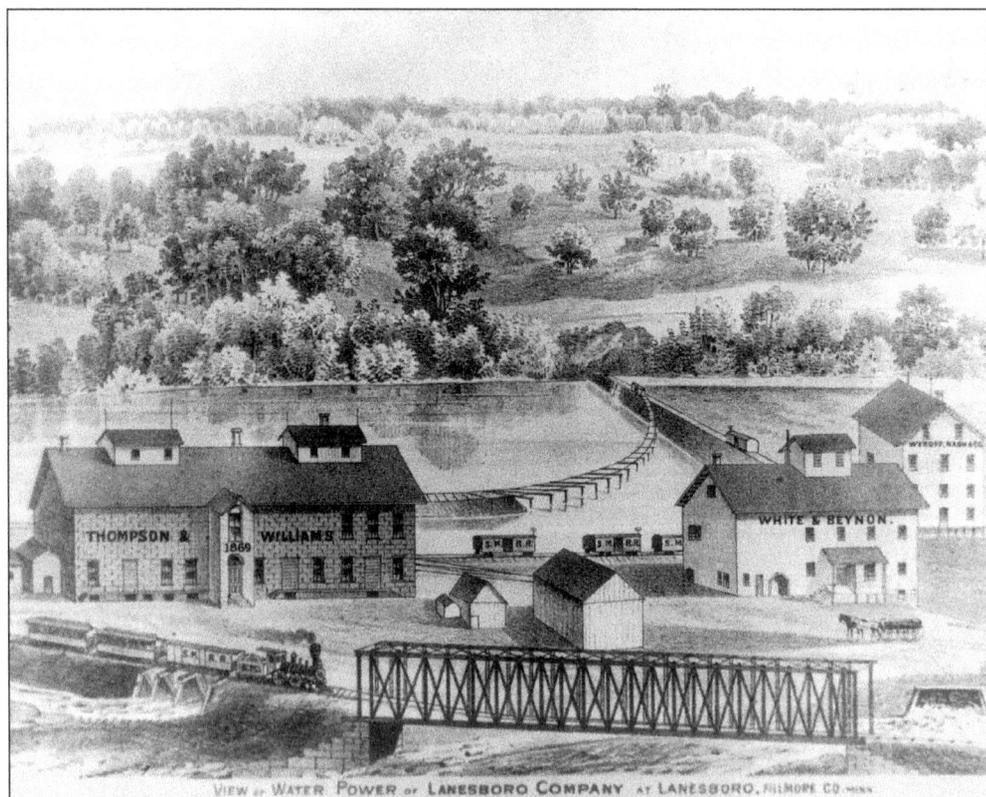

VIEW of WATER POWER of LANESBORO COMPANY at LANESBORO, FILLMORE CO. MINN.

CONTENTS

ACKNOWLEDGMENTS

While the majority of the photographs used in this volume came from the private collection of Donald Ward, the authors would like to thank all of the people who contributed photographs for this book: Helen Thoen and the Harold Thoen Collection, Mike Pruett and MLT Group of Rochester, Charles Conan St. Mane, the family of Chuck and Cathy St. Mane, Sergei Zhiganov, and the Minnesota Historical Society.

The photo of Lanesboro's restored downtown on page 123 is provided courtesy of A. Renée Bergstrom. The photo on page 46 is provided courtesy of the Wisconsin Historical Society. The photos on pages 47, 49, and 50 are courtesy of Murphy Library, University of Wisconsin, La Crosse. We are especially appreciative of the ready assistance provided by Dee Anna Grimsrud and Lisa Hinzman of the Wisconsin Historical Society, and by Paul Beck, Special Collections Librarian at Murphy Library.

We would also like to express our sincere appreciation to the many citizens of Lanesboro, past and present, who contributed the benefit of their memories. Particular gratitude is owed to the late Matt Bue, T.F. Bersagel, C.G. Edwards, and other early photographers whose efforts in recording Lanesboro on film have made this history possible.

INTRODUCTION

An 1870s newspaper advertisement boasted, "No place in Minnesota presents more natural attractions than the romantic town of Lanesboro, surrounded as it is by beautiful coves, shady retreats, splendid boating, fine drives, and breathtaking cliffs that tower above the charming valley. Switzerland, acknowledged to be the richest country in the world in natural scenery, cannot produce more magnificent views." More than a century later, publications across America are again remarking on these same splendid qualities. But it was not always so. For a period of several decades, Lanesboro, the scenic retreat and tourist destination, had itself retreated into a contained existence largely unnoticed by the outside world.

Credit for the creation of the town of Lanesboro rests with the enterprising members of the Lanesboro Townsite Company. A group of investors, most from New York, Massachusetts, and Connecticut, who in 1868 acted on the advice of Clark W. Thompson, C.G. Wykoff, H.W. Holley, and others to purchase land on the present-day site of Lanesboro for the purpose of developing there a thriving new community in the midst of the "howling wilderness." The site was chosen largely due to the Southern Minnesota Railroad's 1866 decision to route its line through the Root River Valley, and the railroad's 1867 discovery of a natural treasure between sections 13 and 24 of Carrolton Township. This discovery—a river channel excavated by nature through walls of limestone rock forming an ideal location for a dam—prompted the railroad to make plans to locate a station in its vicinity. The combination of potential rail line and waterpower made the site amid the rugged bluffs ideal for the town site development.

The Lanesboro Townsite Company was composed of 11 investors owning a total of 25 shares at $3,000 per share. The stockholders were C.W. Thompson, 5 shares; A.P. Man, 4 shares; Professor Henry C. Kingsley, 4 shares; F.A. Lane, 3 shares; Townsend Brothers, 3 shares; Eliza Thompson, 1 share; Wm. Windum, 1 share; H.W. Holley, 1 share; C.G. Wyckoff, 1 share; Thomas Bard, 1 share; and L. Meyers, 1 share. With this capital of $75,000, the investors commenced the ambitious project in the summer of 1868 by purchasing land at the then costly rate of $30 per acre from Michael Scanlan, Con Scanlan, E.P. Enright, Thomas Barrett, Charles Johnson and Ed Johnson, all of whom were early settlers living on the land at the time. A total of 500 acres was purchased, surveyed, and plotted with visions of a thriving city growing up within the scrub-covered and river-washed valley hemmed by largely barren rock bluffs.

In July of 1868, with the railroad reaching only as far as Rushford, 17 miles to the Northeast, Tom Densmore brought the first load of lumber from Rushford to the site by ox team. He continued hauling lumber until a sufficient amount was on hand for the construction of a boarding shanty for the workmen who were employed to build up the town. This shanty was the first frame structure in Lanesboro and was located in the vicinity of the current Lanesboro Light Plant. Other dwellings and houses of business sprang up, and by the fall of 1868, the new town was well underway.

Among the Townsite Company's first concerns was the construction of a grand hotel as the enterprising stockholders anticipated that Lanesboro was destined to become a popular summer resort for families from the East. Indeed there was considerable interest, and over the next three decades, numerous visitors delighted in Lanesboro's natural beauty. The four-story Phoenix Hotel, completed by the Townsite Company in 1870, was widely acknowledged as the finest hotel in Southern Minnesota.

By the national centennial in 1876, Lanesboro had enjoyed several years of rapid growth and the population was near its peak of about 1,600 persons. The town's boom was curtailed in 1879 after a general failure of wheat crops in the area reduced milling activities and slowed growth. Lanesboro's business leaders persevered, refusing to allow economic downturn to spoil their faith in the town's future. An article from February 22, 1889, stated, "Our citizens all feel that Lanesboro is about to take long strides to the front in material growth and prosperity. Next summer promises to be an active building season here and we certainly hope a good substantial 'boom' is soon to be realized by Lanesboro."

In fact Lanesboro did continue forward but neither as a thriving resort area nor as an industrial hub as first envisioned. From 1900 to the last quarter of the 20th century, the people and businesses of Lanesboro forged a path of quiet productivity and community pride. Agriculture remained core to the town's economy; however, by America's bicentennial, a marked downturn in the number and means of family farms and a general economic reduction had placed Lanesboro on a track that seemed destined to make it a modern-day ghost town.

In the early 1980s, the beginning of an exciting new phase in Lanesboro's community life began with the formation of a city arts council and renewed city promotion. A plan was suggested for converting the old rail line, abandoned in 1979, into a state trail. Through persistent local efforts, the Root River State Trail became a reality and attracted new businesses to Lanesboro along with a new generation of summer visitors. The scenic valley was rediscovered, and soon people were flocking to Lanesboro by the tens of thousands. This return of tourism has brought Lanesboro full circle, from a summer resort town through a century-long community life cycle of agriculture and other pursuits, to its current place as one of the finest and most beautiful arts and recreation destinations in America.

One

THE LANESBORO
TOWNSITE COMPANY

Having secured the land for the new village of Lanesboro, Clark W. Thompson, C.G. Wykoff, H.W. Holley, and the first official agent of the Lanesboro Townsite Company, George Ellis, arrived at the location on the Fourth of July 1868, ready to commence work.

If the remote valley, devoid of even a real road, was to attract Easterners interested in the perceived joys of Minnesota summer living, then significant improvements on the investment property were needed. Three items were considered paramount: a first-class accommodation for travelers, a road up the west bluff to allow settlers to continue west out of the valley, and a dam on the Root River to form a lake for resort living.

Responsibility for these tasks was entrusted to four men, each with his own sphere of influence. Col. W. H. Walrath of Rushford was appointed 'boss' over the crew of workers hired to build the dam, while Col. Van Fleat was in charge of the men engaged in excavating and grading the road up the west bluff. William Listman of La Crosse, Wisconsin, was employed to construct a grand hotel near the center of the newly plotted town. Overall responsibility was entrusted to Mr. Thos. W. Brayton, agent and general overseer for the Lanesboro Townsite Company, who was called to the job from New York. Mr. Brayton was described in the Lanesboro Leader as, "a Christian gentleman of sound judgment and winning ways" who "entertained high ideas of the future of Lanesboro."

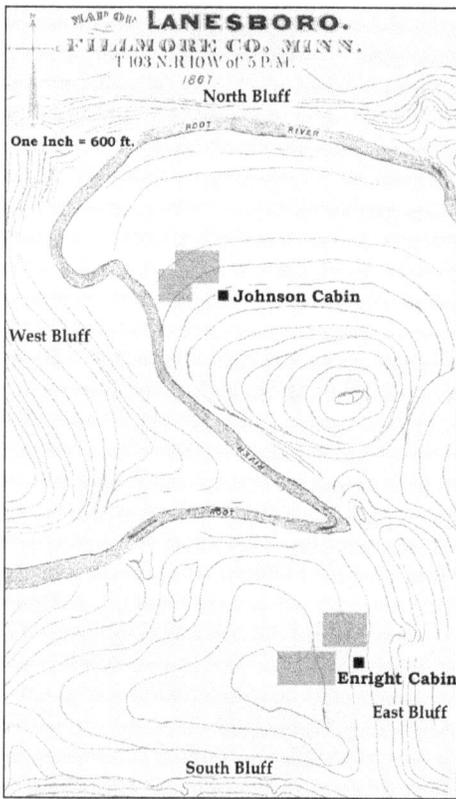

Map of **LANESBORO.**
FILLMORE CO., MINN.
T 103 N. R 10 W of 5 P.M.
1867

North Bluff

One Inch = 600 ft.

ROOT RIVER

■ Johnson Cabin

West Bluff

■ Enright Cabin

East Bluff

South Bluff

LANESBORO IN 1867. In 1856 Con Scanlan of County Kerry, Ireland, built the first cabin on the future town site. Thomas Barrett and John McLaughlin both built in the valley the following year. McLaughlin later sold to Charles Johnson, who, with his brother Ed, planted crops in the area now comprising Lanesboro's downtown. Ed Enright owned land in what is now Brooklyn, while Lars Christenson settled above the current dam site.

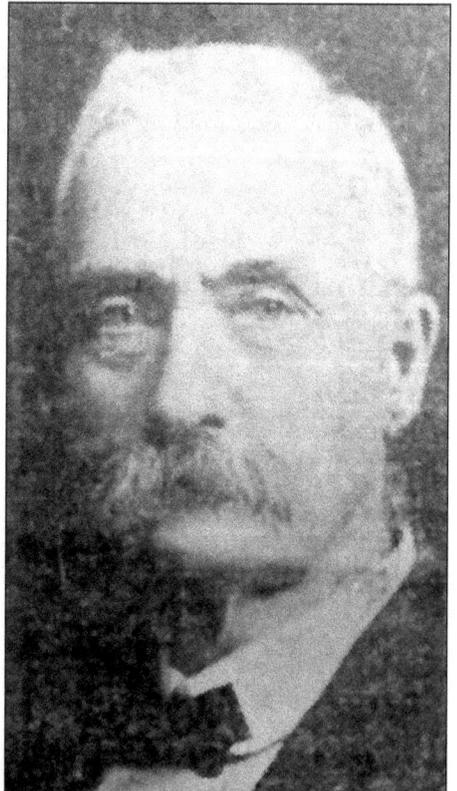

TOWNSITE INVESTOR. Born in New York in 1840, B.A. Man served as a First Lieutenant in the Union Army during the Civil War and came to Lanesboro in 1869 as a stockholder. In 1872 he succeeded G. Ellis as agent of the Lanesboro Townsite Company, a position he held for six years. An involved businessman and practicing attorney, he filled various city posts including a term as mayor.

10

MAP OF LANESBORO.
FILLMORE CO. MINN.
T 103 N. R 10 W of 5 P.M.
1874.

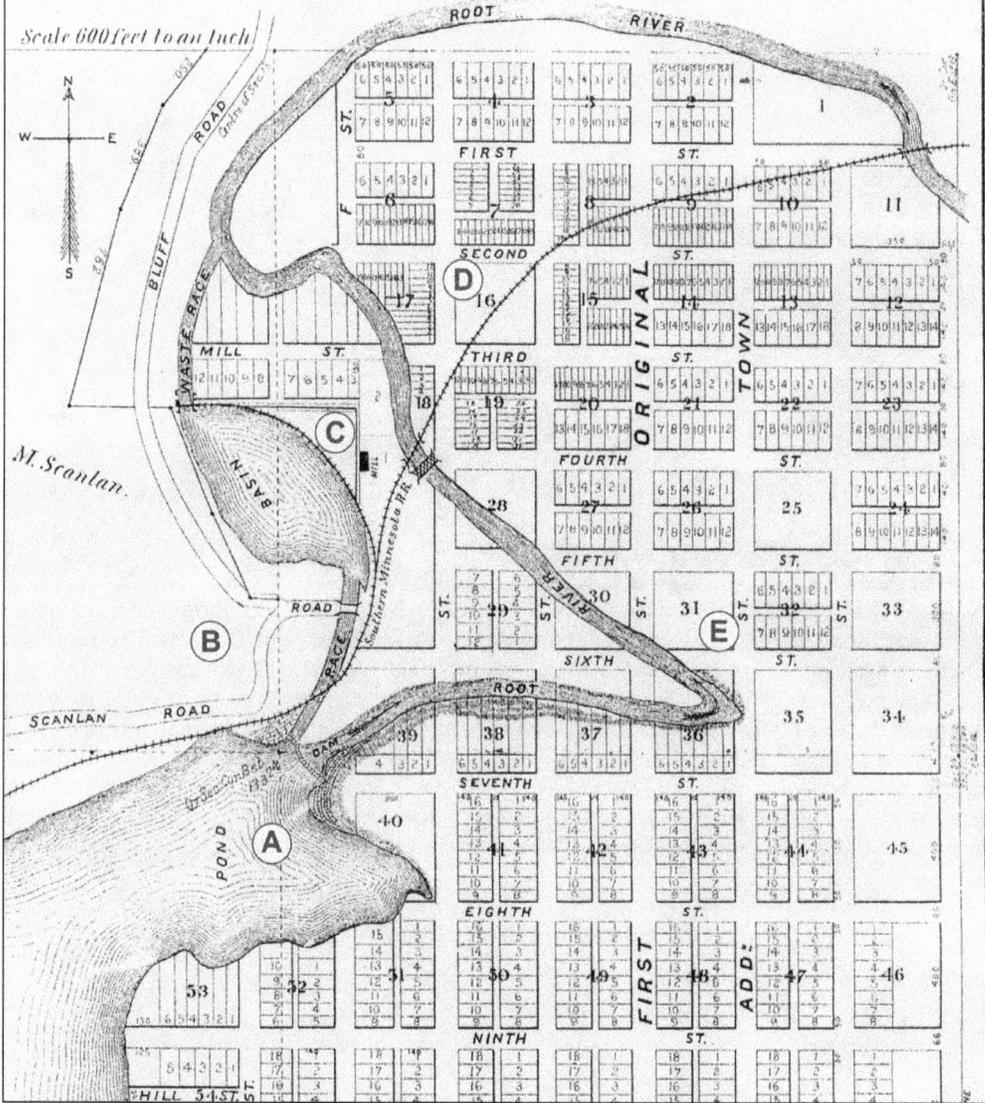

Scale 600 feet to an Inch

1874 Plot Map. There are numerous features of note in this Lanesboro plot map from 1874. (A) Mill Pond Lake spreads over land once owned by John Scanlan Sr. and Lars Christenson due to the newly constructed dam on the Root River. (B) A wagon bridge crosses the man-made raceway leading to both Scanlan Road, later called the Ox Trail, and the Bluff Road. (C) The Mill Pond, labeled here Basin, is fed by the raceway and bordered by a spur of the Southern Minnesota railway running through town. (D) Lanesboro's original 'town square' layout can be seen. (E) Note the original course of the Root River through what is now Sylvan Park. Before 1874, Parkway Avenue, labeled here 'E' Street, had no bridges to connect Lanesboro's downtown with the residential area of Brooklyn to the south.

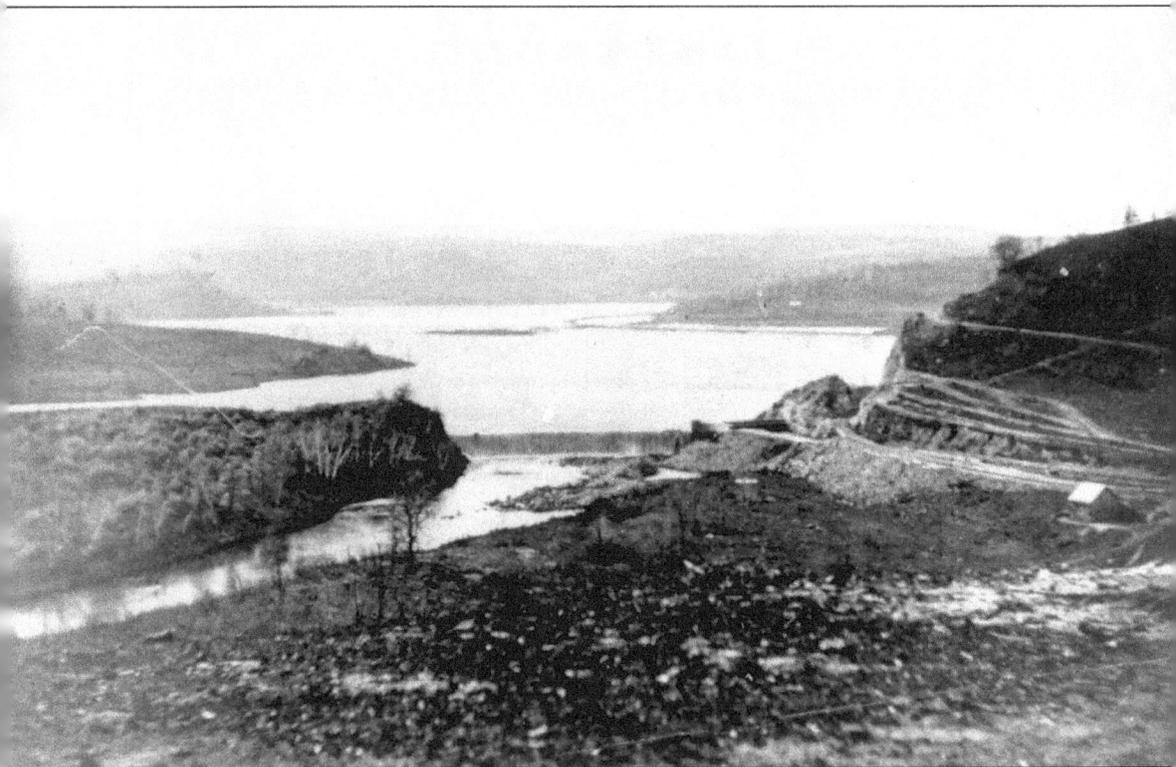

NEWLY CONSTRUCTED DAM. The waters of the young Mill Pond Lake can be seen spreading southwest along the Root River Valley from the newly-constructed Lanesboro power dam. Engineer Mr. Porter laid out plans for the dam, and W.H. Walrath oversaw the work. The first dam was swept away by flood waters before completion, releasing a torrent of water that also destroyed the sole bridge over the river. As reported by R.R. Greer, a city founder and eye witness to the event, "a wall of water twenty feet [high] struck the bridge, the timbers flying in the air in the most terrifying manner possible." After the dam's loss, an intoxicated Col. Van Fleat, boss in charge of the highly-successful grading of the west bluff road, reportedly accosted Walrath with, "Well, Walrath, your dam went out but my road is there!"

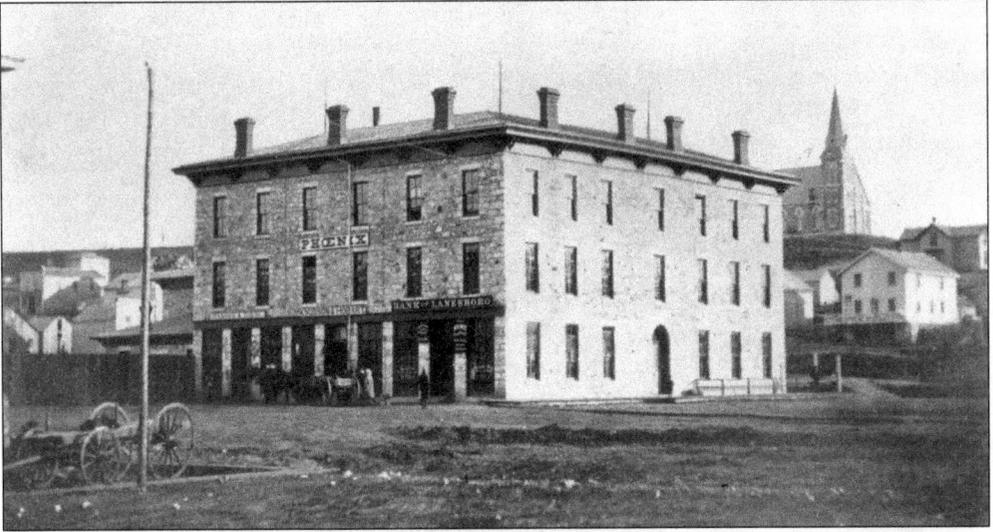

PHOENIX HOTEL, 1870. Hailed throughout the region as the most capacious and splendidly-furnished hostelry in Southern Minnesota, the Phoenix Hotel was constructed and furnished by the Lanesboro Townsite Company at a cost of about $50,000 at a time when a haircut was 25¢. At street level were housed the hotel's offices as well as the Bank of Lanesboro and the businesses of Hanson & Davis and Knudson & Hobart.

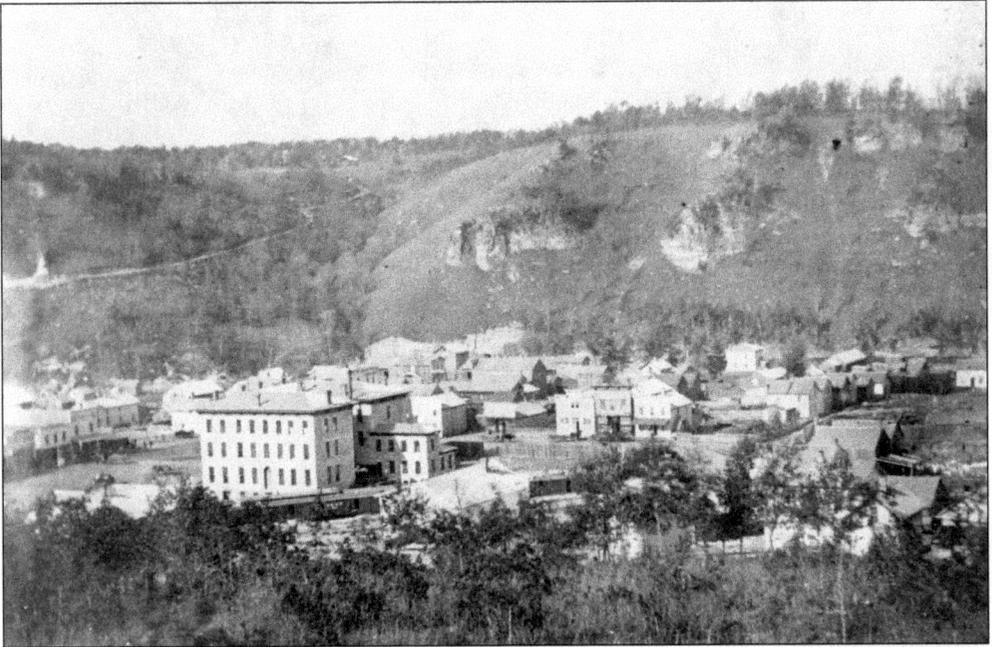

LANESBORO'S CENTERPIECE. Stone for the Phoenix Hotel was quarried from local bluffs and conveyed to the site on a temporary track. The hotel had four stories including a walkout basement that housed a saloon, baggage room, and RR ticket office. The upstairs parlors and suites of rooms "were of great amplitude in size and furnished in the most elegant manner with full-length mirrors, marble-top tables and costly and fashionable furniture" throughout.

WEST BLUFF ROAD. Popular with the workers under his charge, Col. Van Fleat organized the men into "gangs," each at a different place along the route and each given an equal allotment of time to grade their section. The men put in full hours for each day's liberal wages. Completed on time, the resulting roadway was later described by M.G. Fellows, longtime editor of the *Lanesboro Leader*: "Coming in sight of Lanesboro we beheld the village located along the river at the base of the bluff 300 feet below, the only way to get there being by a road excavated alongside of the bluff, too narrow for the passing of teams except in two or three places. I had crossed the Green Mountains of Vermont, the White Mountains of New Hampshire, but I had never traveled over so perilous and unprotected a piece of highway." This photo was taken *c.* 1935.

14

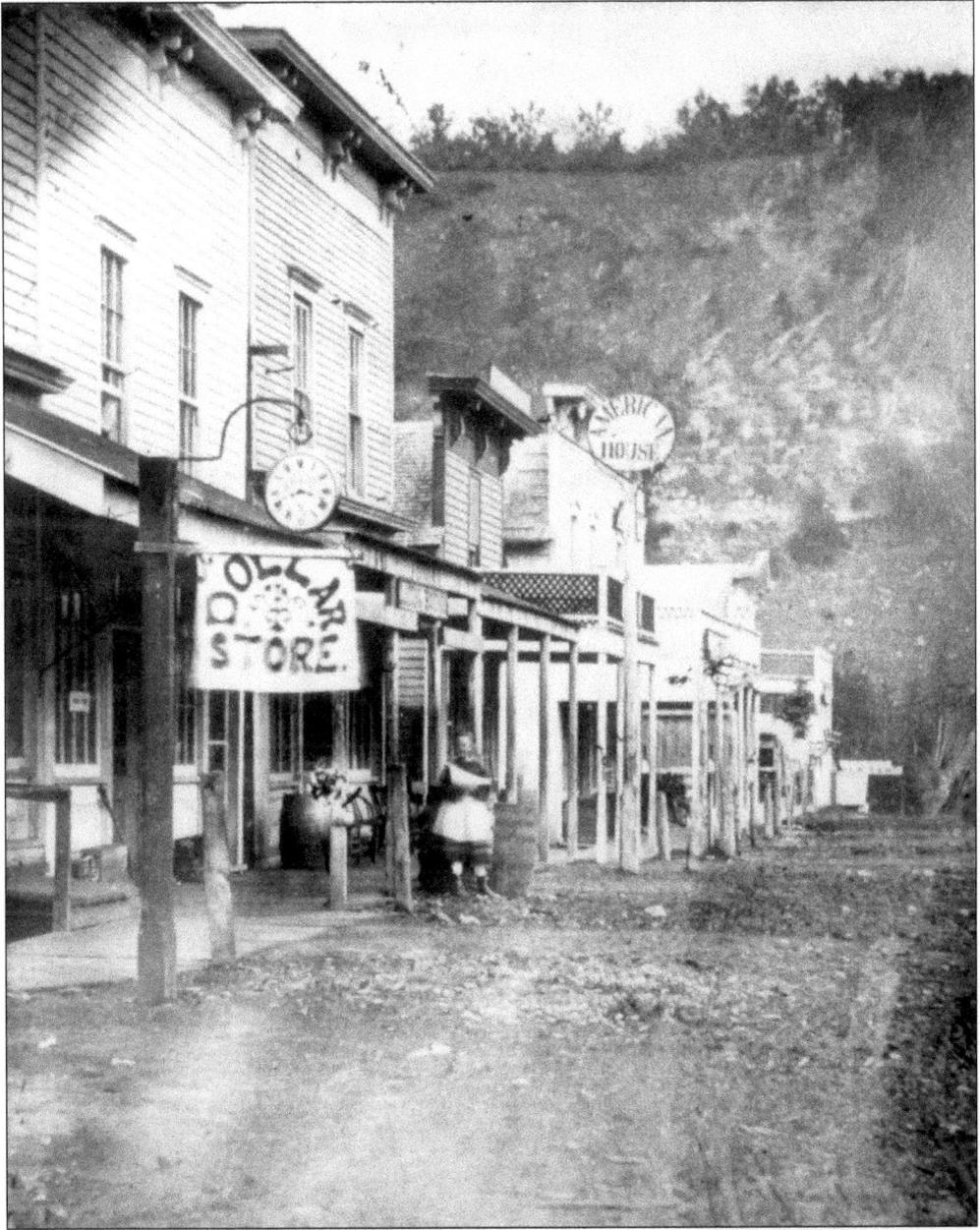

OLD MAIN STREET LOOKING NORTH. Taken in about 1870, this is one of the oldest surviving photographs of Lanesboro. Just two years earlier, a visitor to this valley would have found no traces of a village. However, beginning in the summer of 1868, adventurers poured in and buildings were rapidly erected. W.H. Roberts raised the first business building on the northwest corner of what are now Parkway Avenue and Coffee Street in 1868, clearing small trees and brush to put in a foundation. Roberts stocked $20,000 worth of general merchandise and dubbed the business "The New York Store." R.R. Greer and his partner J.C. Greer soon followed with a store building to the south. Two hardware stores were established nearby, owned by Dan O'Brien and Scanlan & Abbott, respectively. The first hotel was the Grant, opened in 1868. The American House Hotel is fourth from the left.

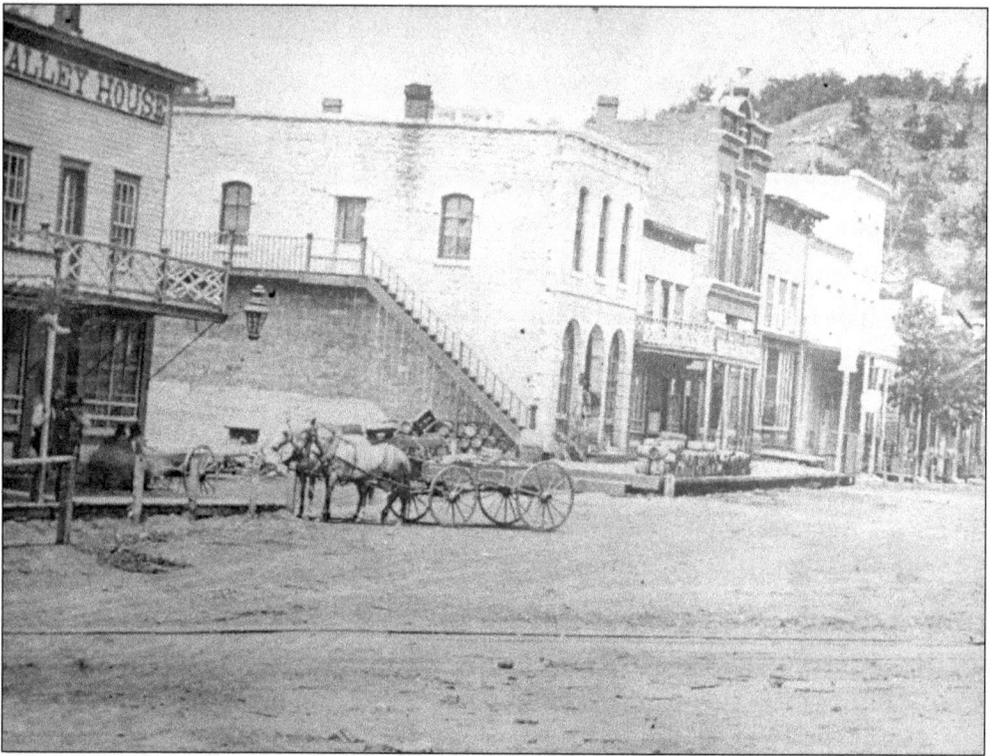

MAIN STREET IN 1875. This photograph shows the west side of Lanesboro's 'E' Street, later called Main Street and now known as Parkway Avenue. Patrick Mallany built the Valley House Hotel at left in 1869. The establishment advertised "good accommodations, moderate rates" for commercial travelers and "good stabling." The building was 24 by 40 feet with two stories and a basement. A brick addition was made in 1876.

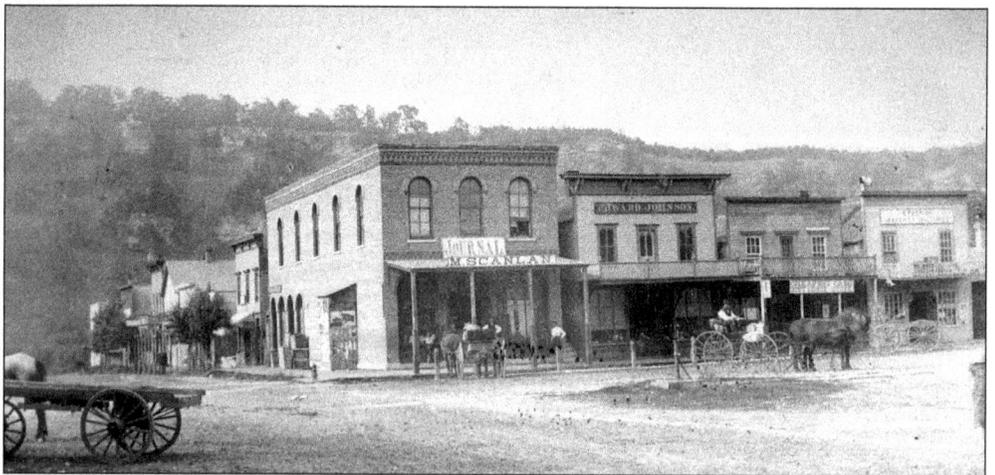

THE LANESBORO JOURNAL. This photo (c. 1880) shows the Journal printing office in the M. Scanlan building on the northeast corner of Parkway Avenue and Coffee Street. First published on June 17, 1874, the Journal was Lanesboro's second weekly. The Lanesboro Herald preceded it in September of 1868. Editor J. Lute Christie printed the first Lanesboro Herald from beneath a temporary shelter while awaiting construction of a building.

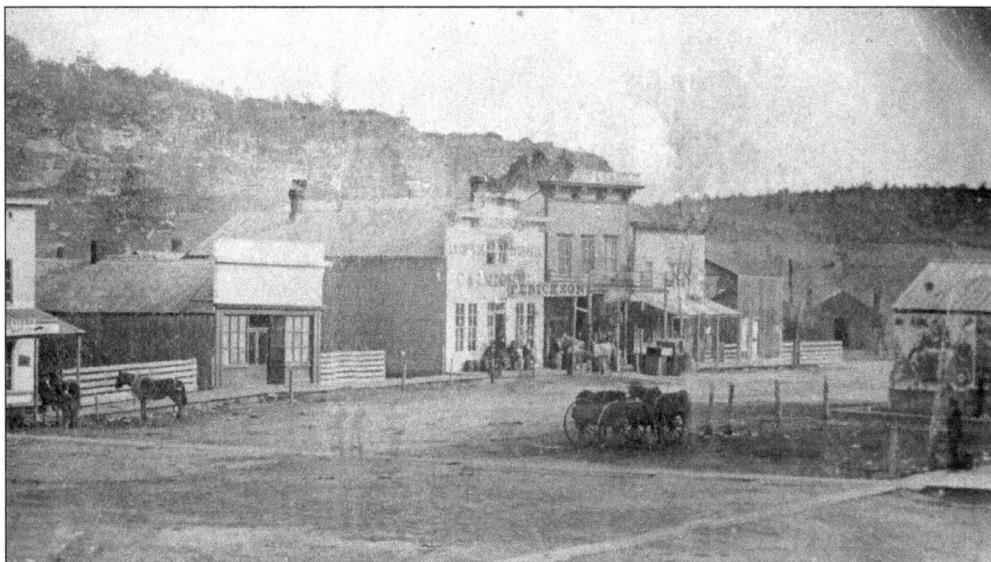

BILLIARDS AND BEER. Pictured is East Coffee Street as it appeared in 1871. The light-colored building at center is the La Crosse Beer Hall, a saloon advertising "billiards" as well as liquid refreshment. Proprietor signs of C & J Midhill and F. Erickson are also seen on the building. The Nelson & Langlie store is the next building to the right. These buildings and those to the east all burned sometime before 1885.

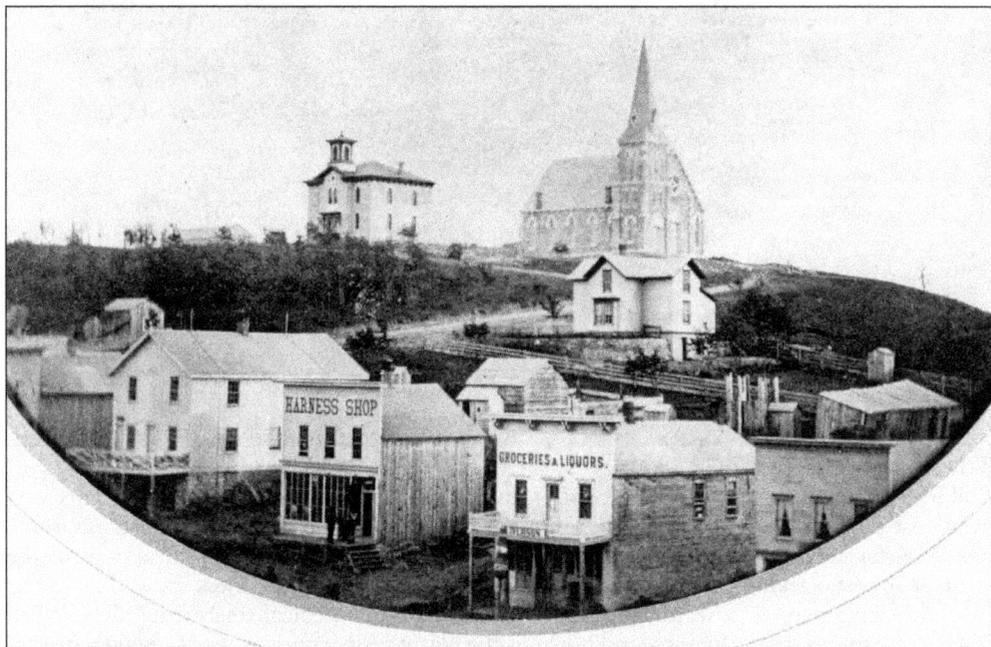

CHURCH HILL. Taken in 1870, this photo shows the newly-completed Presbyterian Church and Stone School House atop a largely treeless Church Hill and the Slant Avenue business district. O. Iverson's Groceries & Liquors is well marked, as is the M.V. Bean Harness Shop, which was built in 1868 by Mr. Drake but sold in 1869 to Mr. Bean, who later remodeled the building into a fine home.

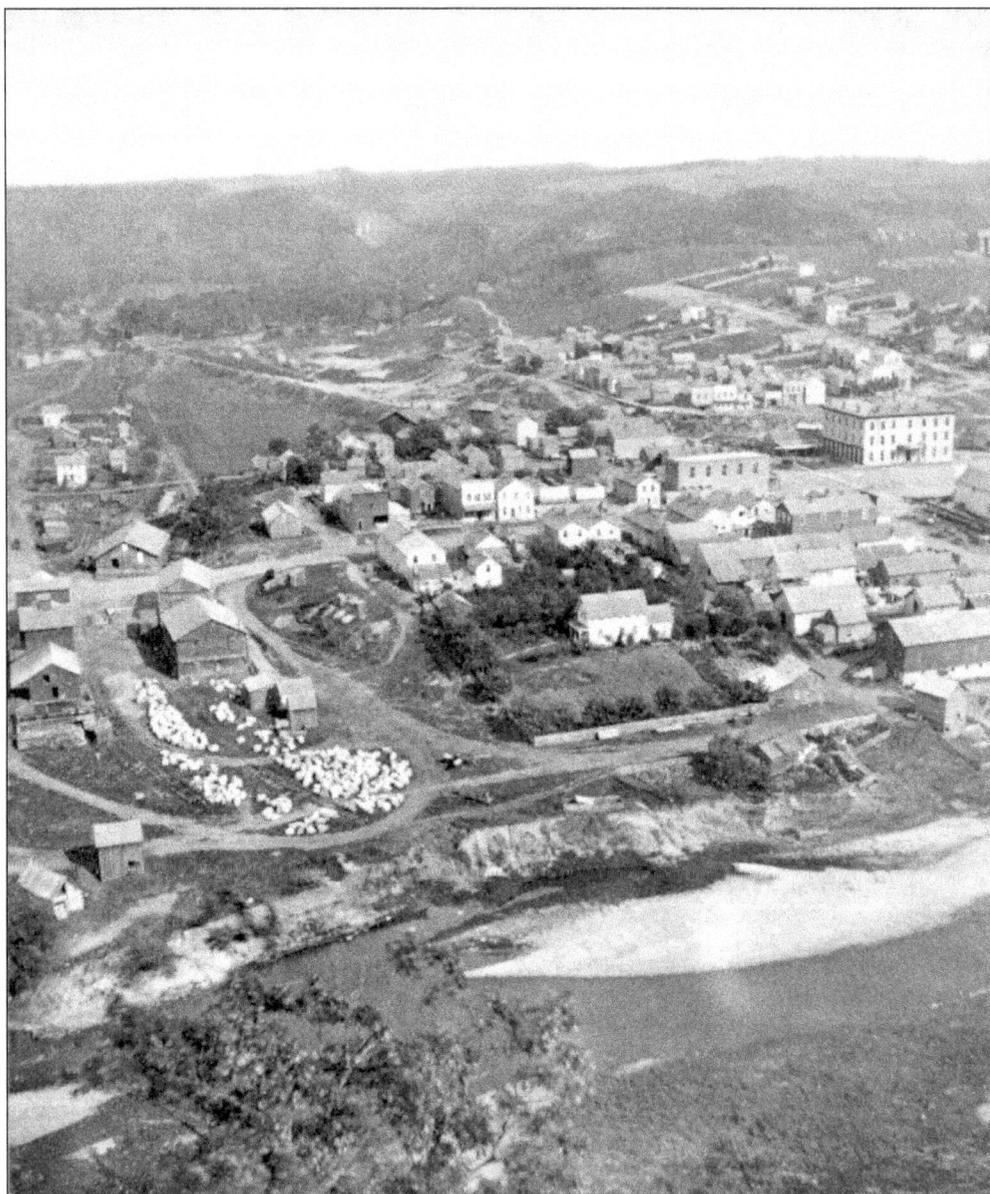

TOWN ON THE BOOM. From 1868 to 1878, Lanesboro was nothing less than a "boom town." Buildings sprang up and people poured in—adventurers, speculators, settlers, immigrants, and even east coasters seeking a "cure" at Lanesboro's luxurious Phoenix Hotel and Sanitarium. The five-star facility, shown at the upper right, advertised "unrivalled [sic] attractions to the summer tourist, seeking pleasure and relaxation from the cares of business, as well as to the invalid seeking pure air, cheerful surroundings and scientific medical treatment." D.F. Powell M.D., a capable and colorful surgeon known to the Native Americans as White Beaver, headed the facility's medical department. The numerous white spots at the lower left of the photo are limestone building blocks transported via wagon from quarries at the base of the nearby North Bluff and shipped by rail to neighboring towns for construction.

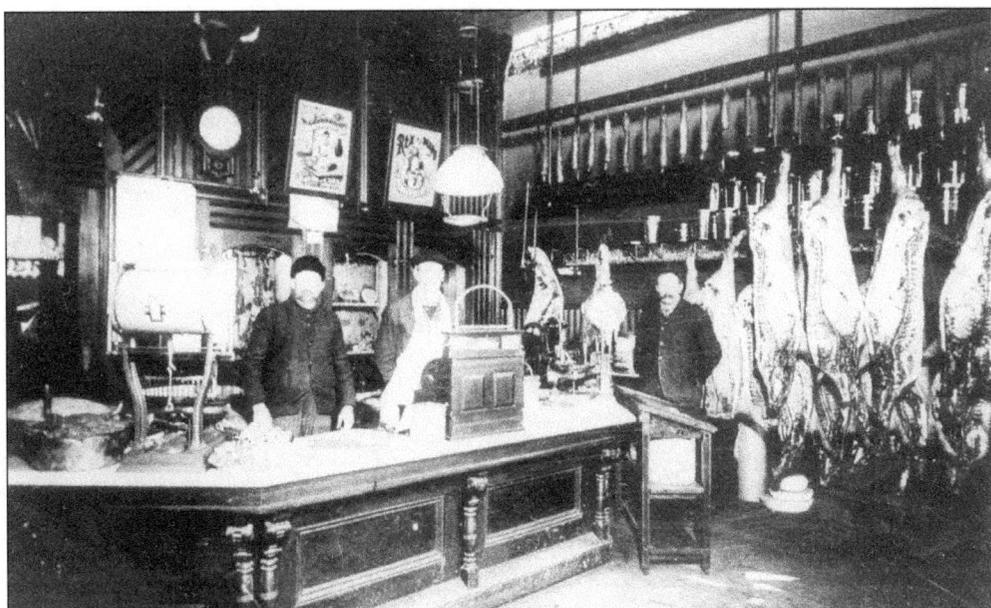

BEST LIVERS IN THE COUNTRY. Schansberg, Soberg & Co.'s 'Pioneer Meat Market' is shown here during Lanesboro's boom. The proprietors boasted, "We feed the Best Livers in the country. We know we do this because we sell the kind of goods that people appreciate who are good livers. Our juicy steaks and roasts are famous for their tenderness and quality." Pictured from left to right are, unidentified, unidentified, and John Solberg.

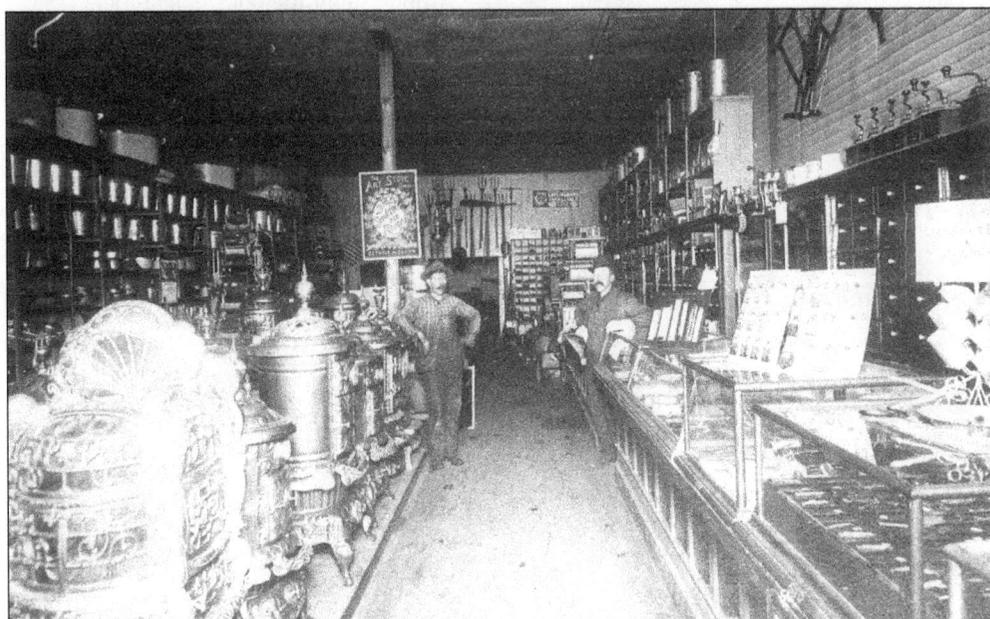

M.W. WILLIAMS HARDWARE. M.W. Williams operated a well-stocked hardware store in Lanesboro's early days. Hardware stores of the time advertised a wide range of products including steel, nails, ropes, glass, black-smith's coal, pumps, coffee grinders, stoves, and barbed wire. Other early hardware businesses in Lanesboro included Dan O'Brien's, Scanlan & Abbott, C. Johnson & Co., and Thompson & Habberstad. Pictured are Hans Paulson (left) and M.W. Williams (right).

19

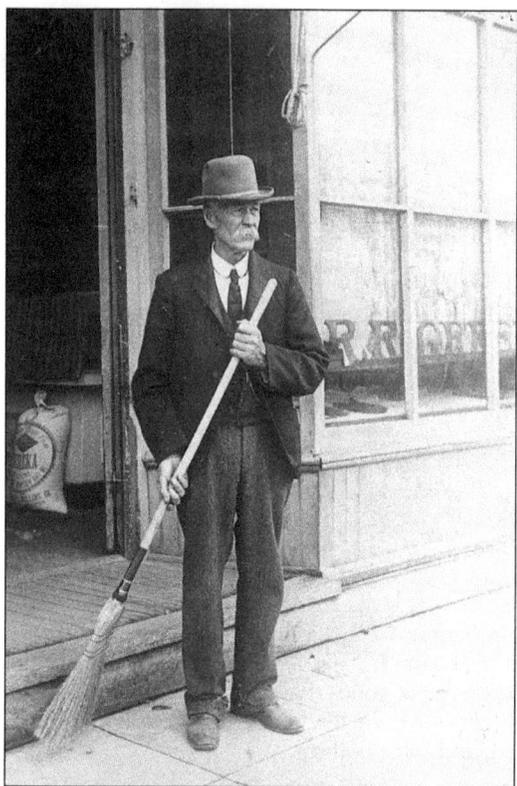

PROMINENT PIONEER. Robert R. Greer, pictured in front of his Lanesboro business in 1905, was one of the town's first and foremost businessmen and leaders. In 1916 the local newspaper summed up his 37 years of business in Lanesboro with, "He was honest to the core." Mr. Greer was Lanesboro's first mayor; he served on the city council and school board and was twice elected to the Minnesota Legislature.

INTERIOR OF THE GREER DRY GOODS STORE. R.R. Greer and his cousin J.C. Greer of Quebec, Canada, came to Lanesboro in 1868 and erected the town's second store. An active business for nearly four decades, the Greer Store is shown here in about 1880. The customer and salesman are unidentified. Note the stools at left provided for the use of ladies while examining bolts of material.

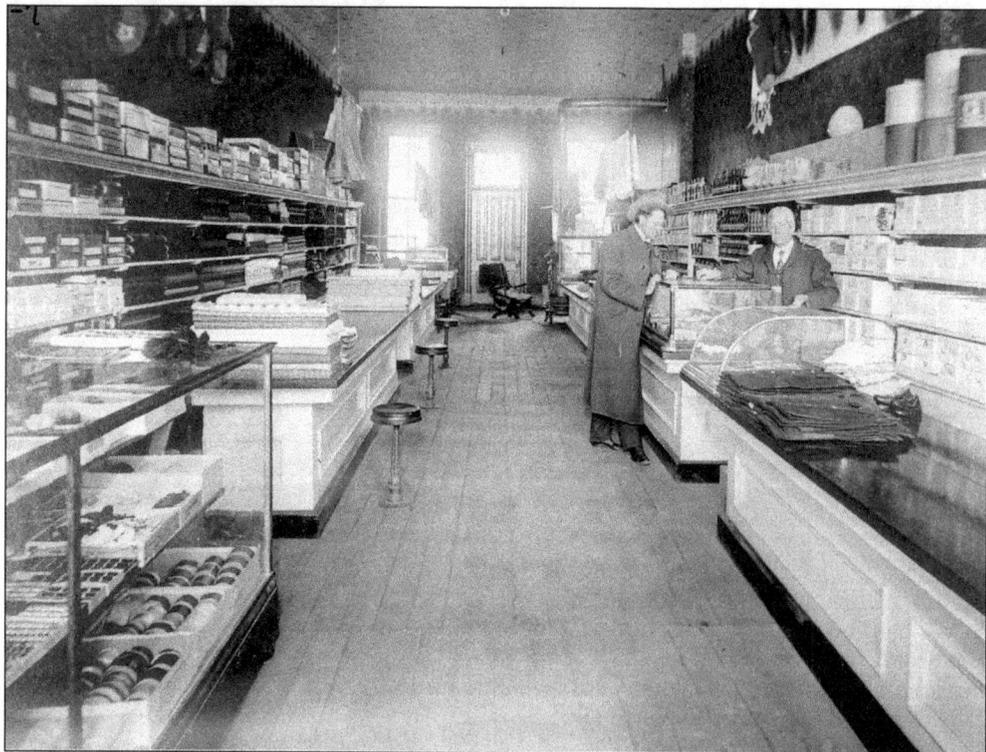

THE TRAVELING SALESMAN. A lost breed today, the traveling salesman was essential to small-town business in the late 19th century. This unidentified salesman sits comfortably with his trunks of merchandise in the interior of the G.B. Ellestad Jewelry store on Lanesboro's main street. Mr. Ellestad had himself been a traveling salesman for several years before entering the jewelry business and reportedly fostered a kindness for salesmen.

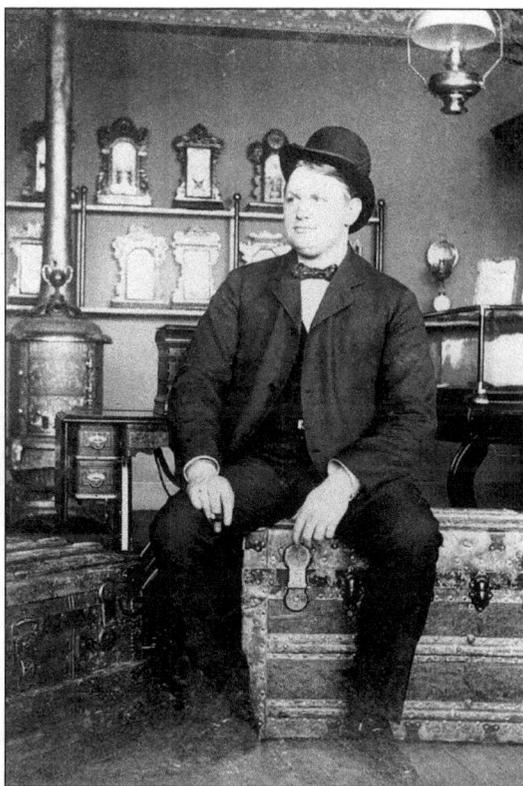

HOTEL AND SAMPLE ROOM. O. Iverson left the Grocery & Liquor business (picture on page 17) to open the Winona Hotel near the wagon bridge on Coffee Street in 1877. During the days of rail, the hotel changed owners, became the Merchants Hotel, and doubled in size. The structure at right is the sample room where merchants came to view salesmen's samples and place orders.

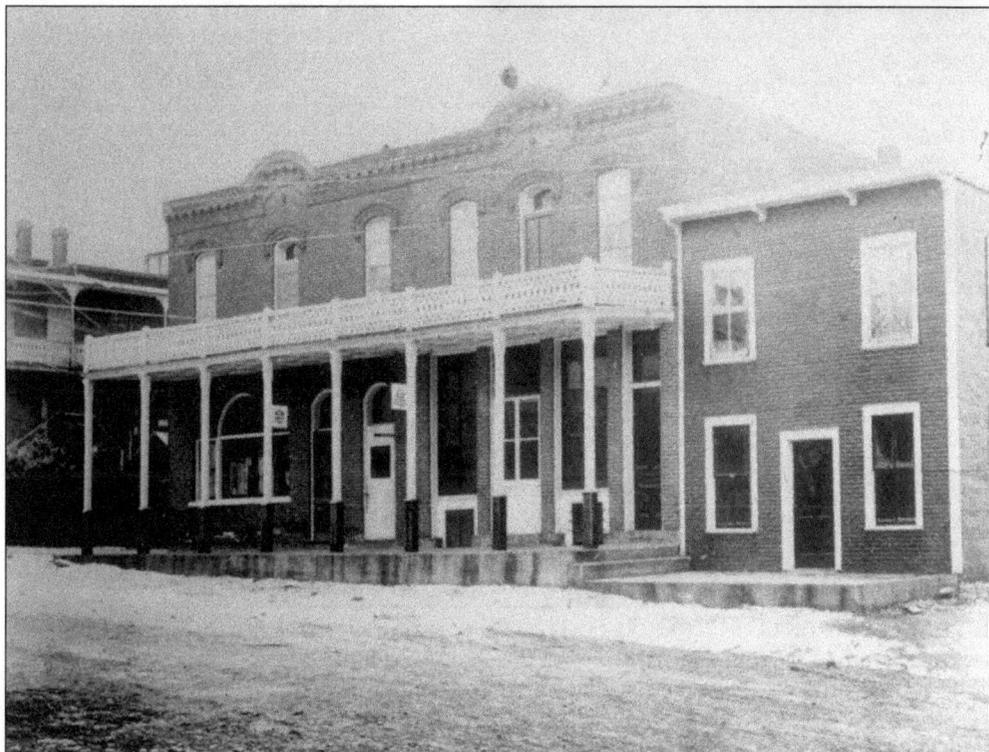

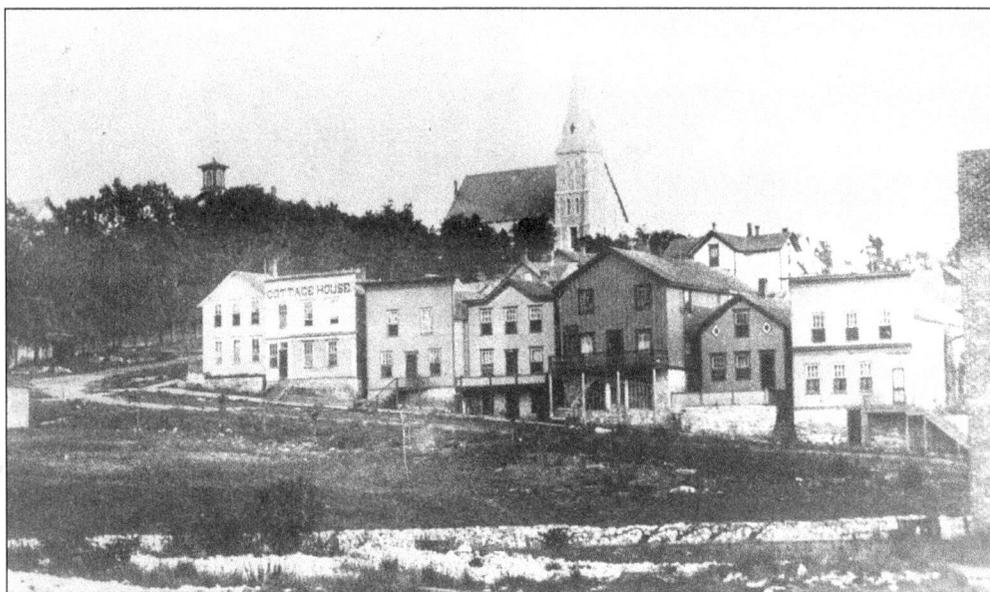

BUSINESSES ON SLANT AVENUE. Slant Avenue leading up Church Hill comprised, in the period of Lanesboro's initial "boom," the southern line of businesses surrounding the open square where the Phoenix Hotel stood. Businesses along the avenue included Drake's Harness Shop (later M.V. Bean's) and the Cottage House Hotel. In Lanesboro's first year, Mr. Drake, R. Finley, R. Hudson, E. J. Tull, and George Truax all erected buildings along Slant Avenue.

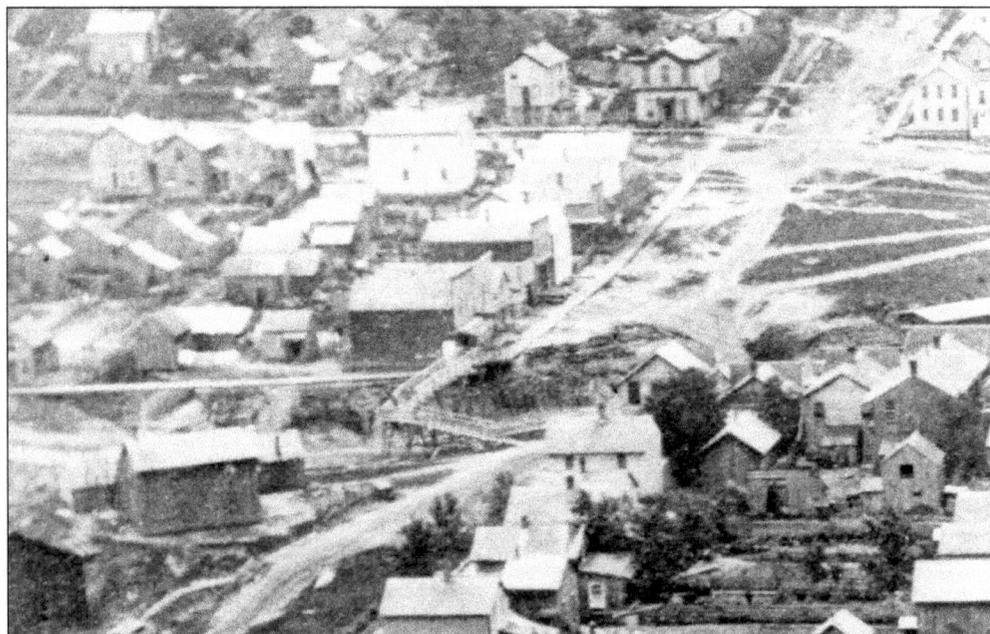

BOOM TOWN FRONTS ON CHURCH HILL. The east side of Lanesboro's expansive town square was made up of rapidly-constructed business houses complete with "boom town" fronts. When the Southern Minnesota rail line was laid through town, an angled walking bridge was constructed over the tracks so shoppers could reach the line of business houses when stopped trains blocked access from the north side of the downtown.

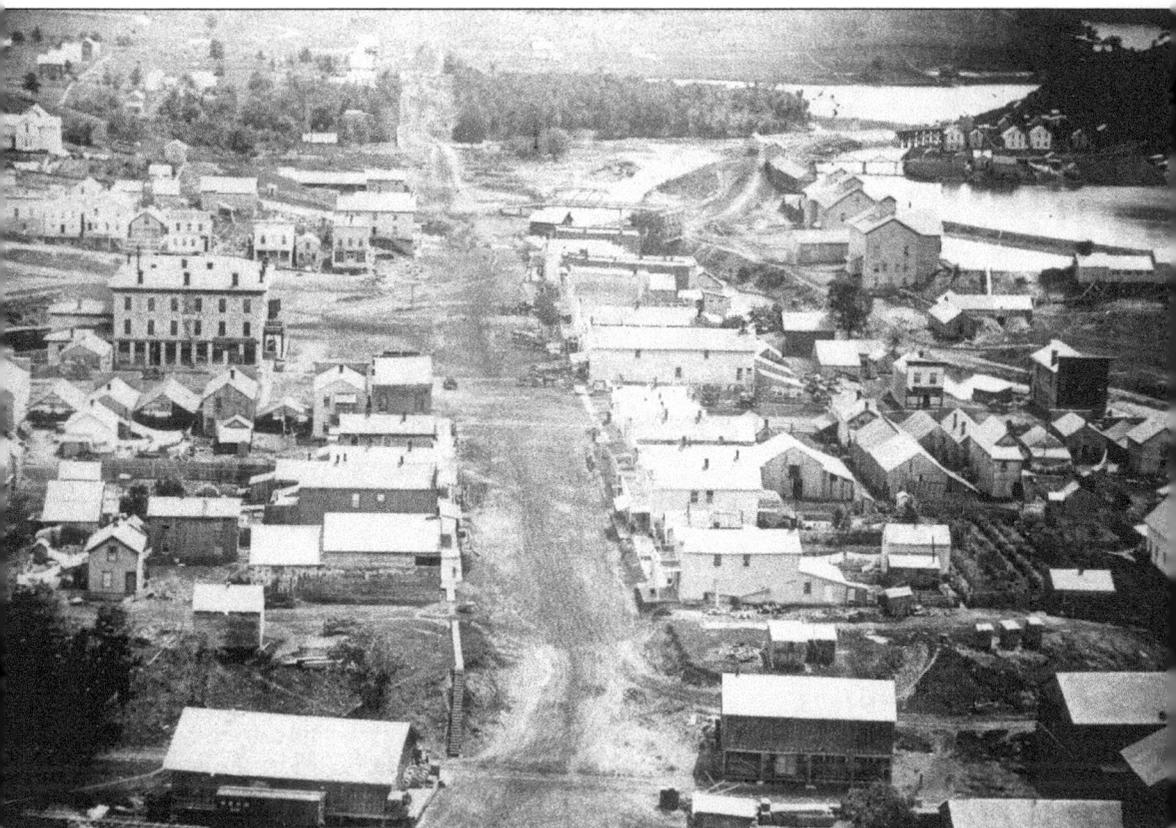

CHANGE OF COURSE FOR ROOT RIVER. Prior to 1874, the well-plotted area south of Lanesboro's downtown, known then and now as Brooklyn, had produced little construction. The difficulty lay in the natural course of the Root River, which wound through the area that later became Sylvan Park, creating a double river crossing between downtown and Brooklyn. No bridges connected the two halves of the little village. Likewise the road over the top of Church Hill, known for many years as Lover's Lane, had not yet been constructed. A shopkeeper wishing to house himself in Brooklyn would have been faced with a lengthy buggy drive or walk. In 1874 this impediment to expansion was erased as Mr. Greer supervised the construction of a causeway altering the Root River's course and creating the dirt road shown here along what is now Parkway Avenue.

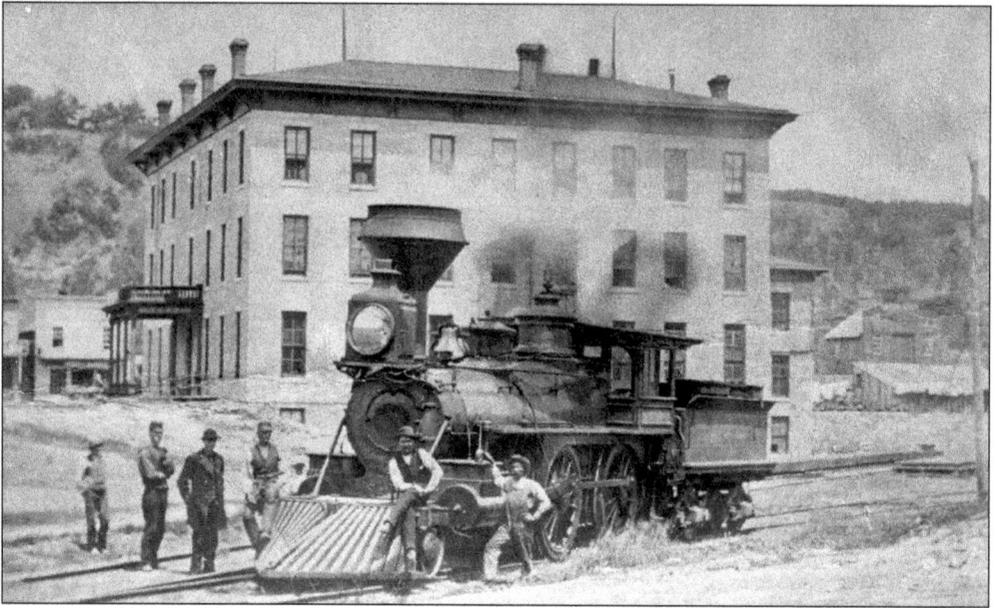

PHOENIX HOTEL 1875. Engineers and firemen of the Southern Minnesota Railroad pose by their locomotive as it rests opposite Lanesboro's grand Phoenix Hotel in 1875. Five years earlier, in July of 1870, the hotel was opened with a celebratory dinner hosted by the hotel's popular landlords, Messrs. Chase and White, at a cost of $2,000. A truly lavish event equal to the success the Lanesboro Townsite Company was celebrating. The opening of the majestic hotel marked the summation of two years of rapid growth, and Lanesboro was well on its way to being a city of some scope and importance. The destruction (shown below) of the hotel by fire on May 5, 1885, was considered a great loss to Lanesboro and the traveling public.

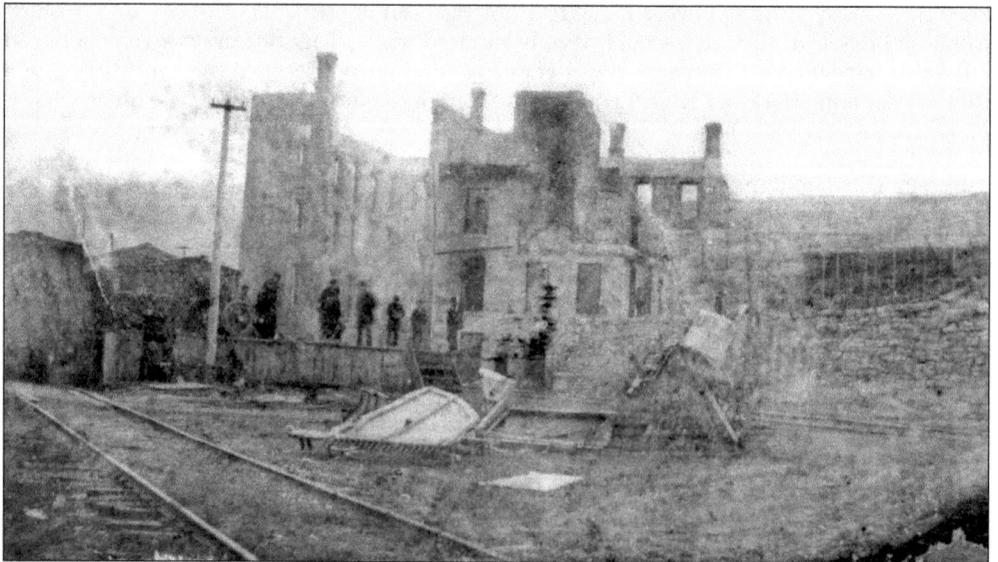

Two

LANESBORO'S WATERPOWER

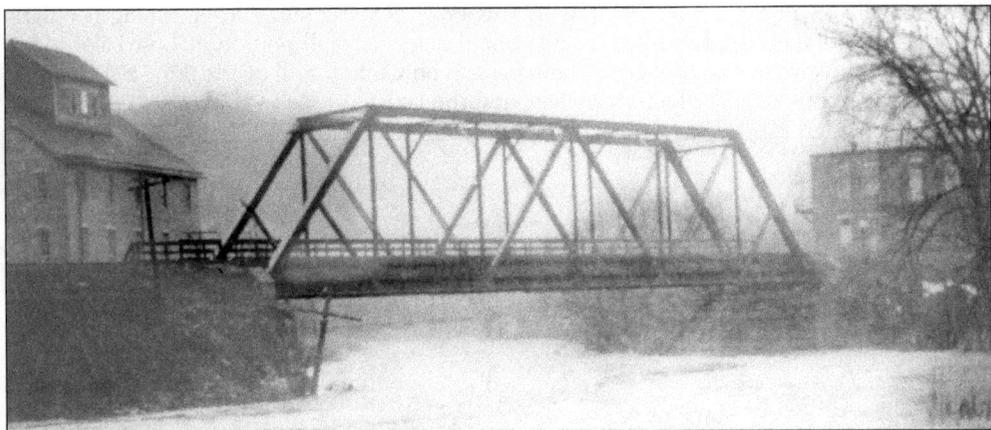

An article published in the *Hartford Journal & Courier* (Connecticut) in 1889 boasted of Lanesboro, Minnesota, with the words, "There is not a better town of its size in the Northwest than Lanesboro. . . . We have the finest water power on the Root River, building stone in unlimited quantities, good water, picturesque scenery, in fact everything to make this one of the most thriving cities in the state."

That Lanesboro was proud of its resources was only natural. Acknowledged near and far as the finest source of waterpower in Southern Minnesota, the Lanesboro dam provided motive force for a number of enterprises, among them three flour mills. The first, Thompson & Williams, was built in 1869 at a cost of $30,000. The Wykoff, Nash & Co. Mill and White and Benyon's Mill followed soon after. All three stood along the perimeter of the Mill Pond, known today as the Bass Pond. (See illustration, page 4.) Other mills and a canning factory operated in the same area over the years, as well as other mills on the Root River near Lanesboro. By the mid-1890s Lanesboro's first electric light plant was established—utilizing the same waterpower system—to supply electric light to the community. Still in operation today, Lanesboro's dam and hydroelectric plant are ranked among the most historic in the entire United States.

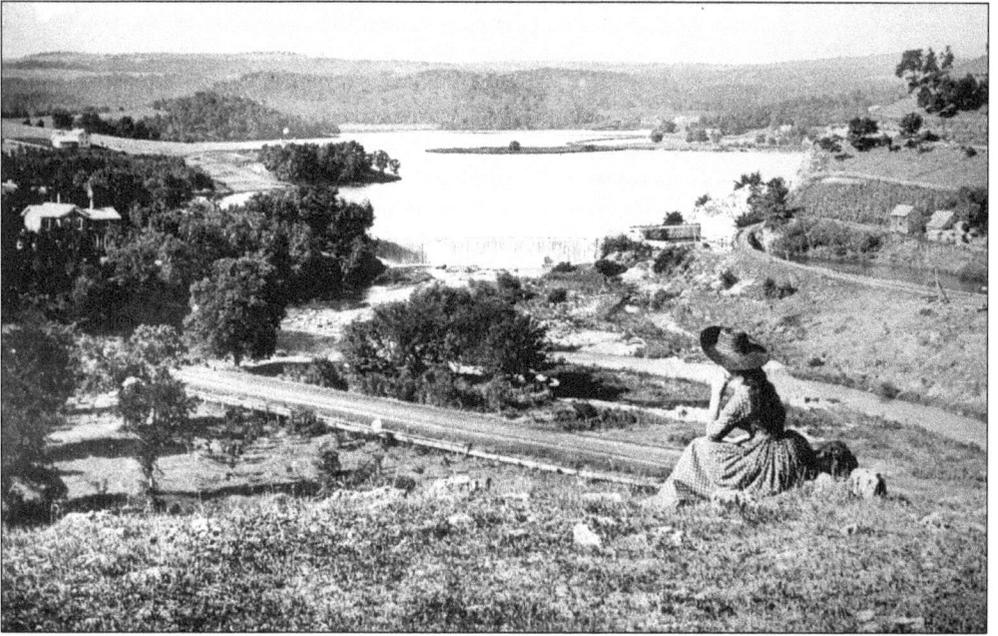

MILL POND LAKE. Construction of the dam on the Root River created a sprawling lake above the dam called Mill Pond Lake. Eventually this body of water silted in becoming popularly known as Lost Lake. The Lanesboro football field marks a small portion of Lost Lake today. The unidentified woman in this 1885 photograph is on Church Hill overlooking Sylvan Park, the rerouted Root River, the Lanesboro dam, and the lake.

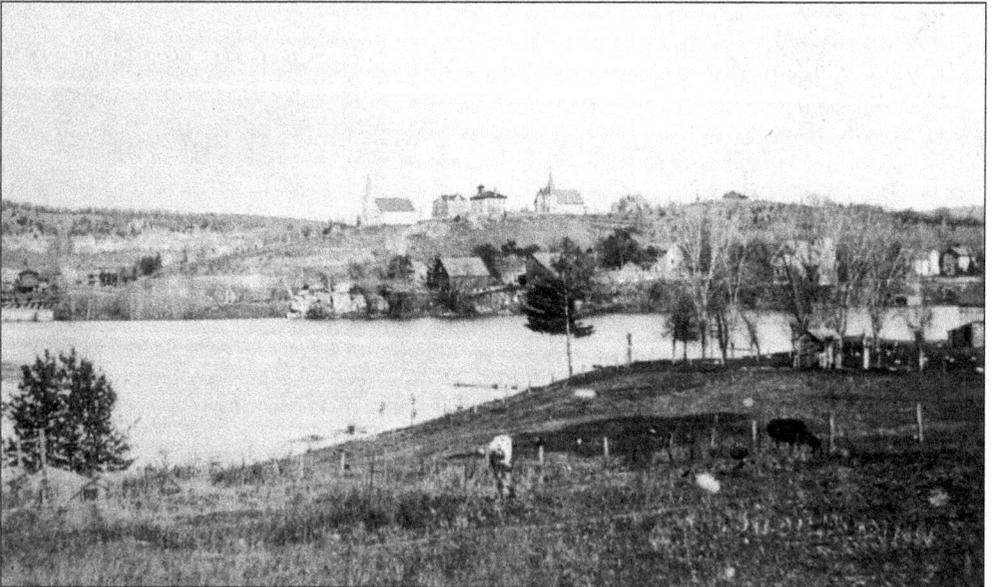

NORTH ACROSS THE LAKE. A byproduct of commercial progress, Mill Pond Lake was a source of beauty and recreation. The people of the area took advantage of boating, swimming and ice-skating on the lake. The Lutheran and Catholic churches, as well as Lanesboro's two schoolhouses, can be seen atop Church Hill in the background of this photograph looking north across the lake, *c.* 1895.

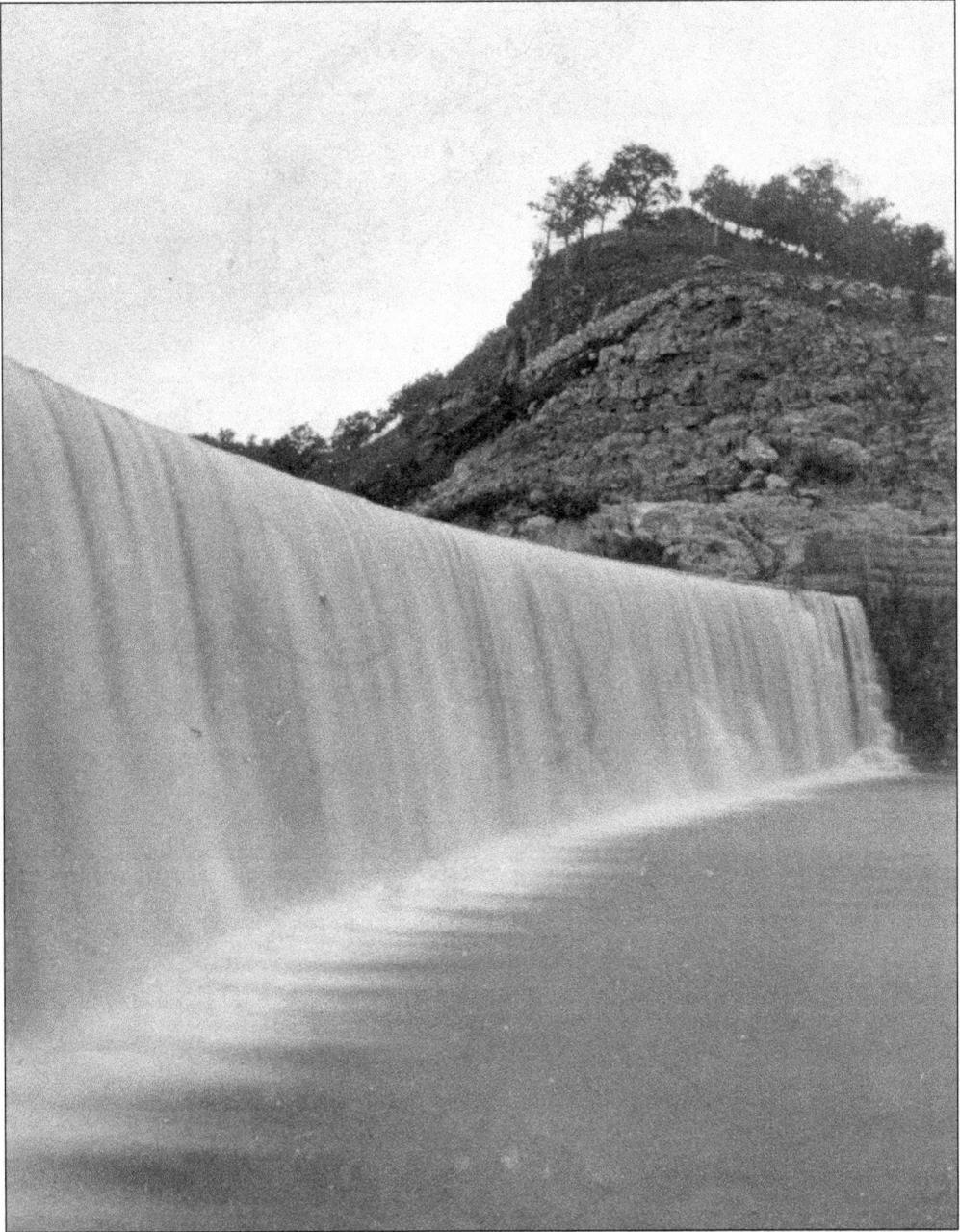

Magnificent Waterpower. This photograph of the Lanesboro dam on the Root River was taken before 1885 and gives some sense of the power and majesty of the dynamic structure. Built in 1868 at a cost of $15,000, the dam has proved an engineering success, having survived in working order for well over a century. This is much to the credit of its engineer, Mr. Porter, and to the principle stonemasons on the project, Frank Erickson, Nels Benson, Engebret Enger, and Olaf Olson. Constructed of solid square stones approximately two-and-one-half-feet thick, the dam was built on a foundation of solid stone and anchored at each side by rock bluffs. Stone for the structure was quarried from the North Bluff and RR cut near the dam. The dam measures 150 feet long and 26 feet high.

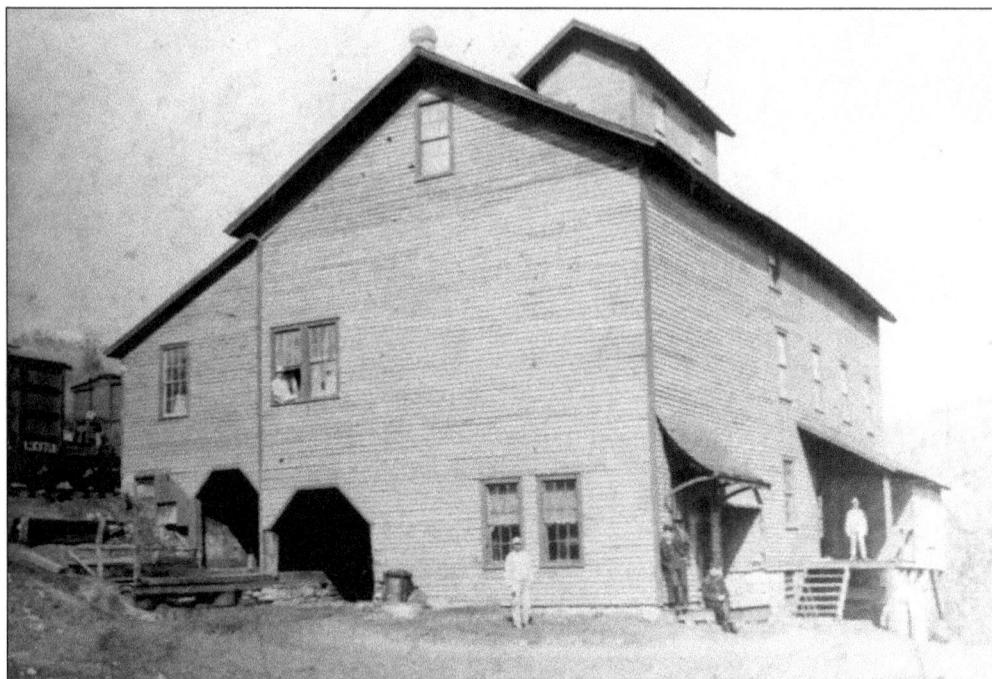

ONE OF LANESBORO'S ORIGINAL MILLS. Pictured is the White & Benyon Mill, c. 1898. The mill was built in 1870, when the farms surrounding Lanesboro garnered a golden harvest of wheat—20 to 30 bushels to the acre. In 1879–1880 the wheat crops failed due to depletion of the soil and local farmers turned to mixed crops and the raising of livestock. The mills sold flour, mill feed, bran, and shorts.

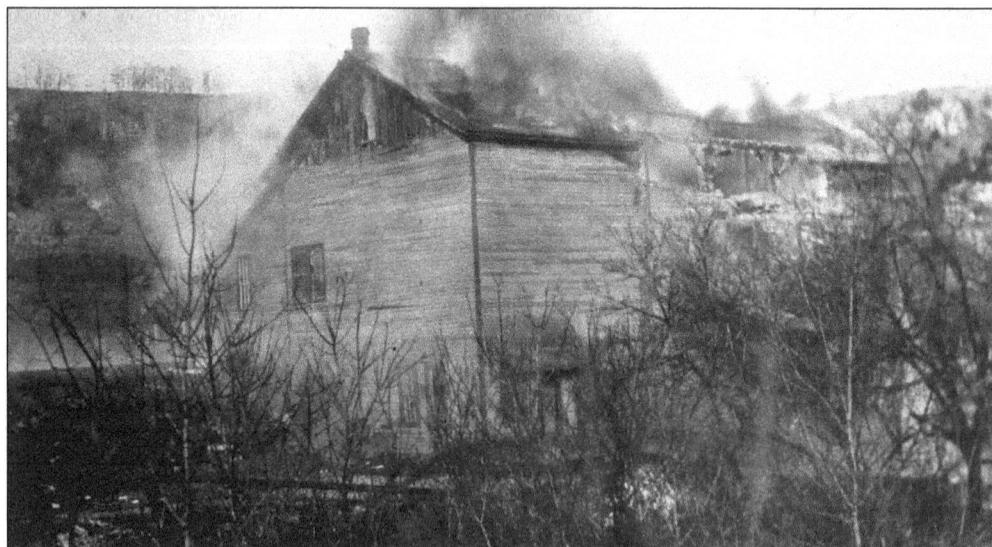

MILL FIRE. The last of the three original mills on Mill Pond to be destroyed, the White & Benyon Mill burned in 1902. It was rebuilt but again burned in 1934. The Thompson & Williams Mill burned on September 29, 1876, but was rebuilt with improved machinery and a brick addition only to burn a second and final time on November 30, 1892, while owned by partners Remmington and Leahy. The Nash & Gilbert Mill burned in about 1887.

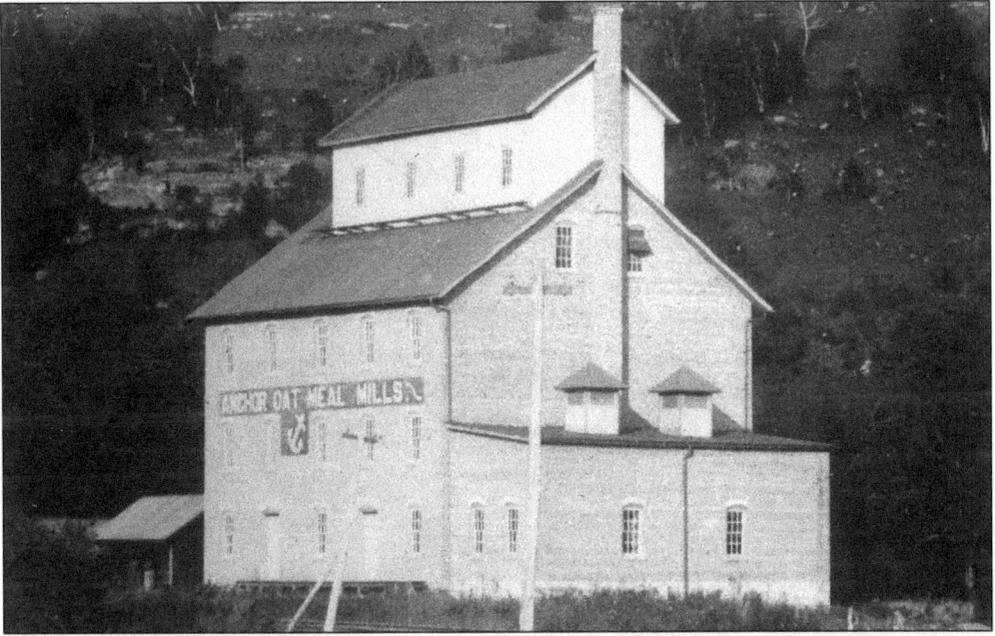

ANCHOR OAT MEAL MILL. Not all of Lanesboro's mills were established along Mill Pond. The Anchor Oat Meal Mill, shown here c. 1890, was located a mile downstream of the railroad bridge on Lanesboro's Eastern edge. Another flour mill was located on Duschee Creek south of Lanesboro. During Lanesboro's wheat years, production was immense. In 1874 Lanesboro's mills ground and shipped 77,299 barrels of flour, paying $440,000 for wheat.

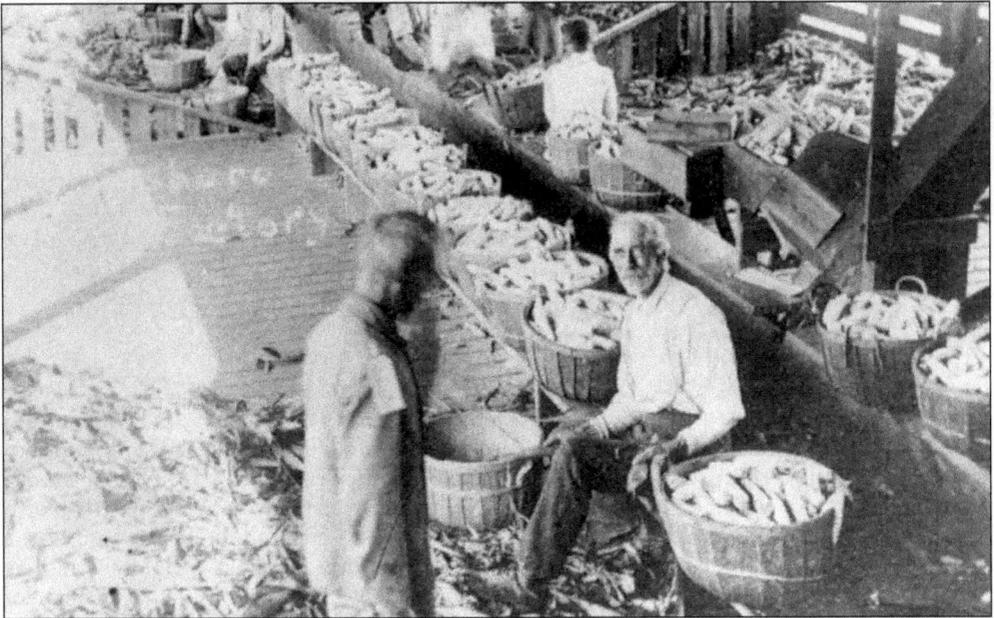

HUSKING SWEET CORN. This photo, c. 1925, shows workers husking sweet corn in the Lanesboro Canning Co.'s plant, which was built around 1903 along Mill Pond where one of the ill-fated flourmills had originally been established. The canning factory was closed in the early 1930s due to the Great Depression.

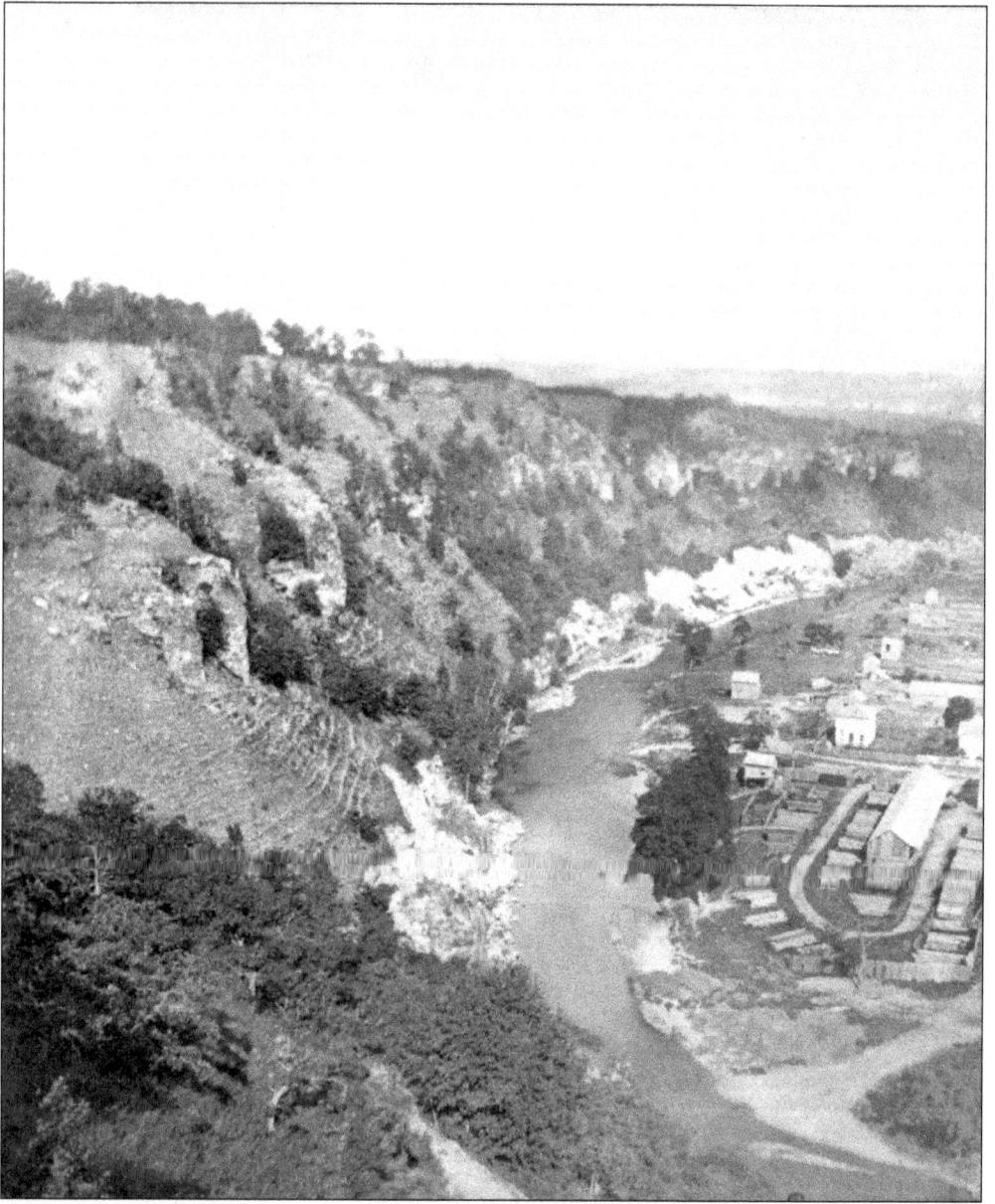

NORTH BLUFF RIVER BEND. The Root River moves languidly around the river bend beneath Lanesboro's north bluff in this early photo. Tracing a path along the Western and Northern bluffs of the valley, the Root River embraces much of the town and has always played a prominent role in Lanesboro's fortunes. Note how there are relatively few trees on the North Bluff compared to its thickly wooded state today. The white areas all along the base of the bluff are exposed rock where limestone was quarried for early buildings in Lanesboro. The lumberyard shown at the lower right remained in operation, under various managements, for about 100 years. The Farmers and Merchants Lumber Co. was one of the companies to run the facility. (Additional photograph, page 75.)

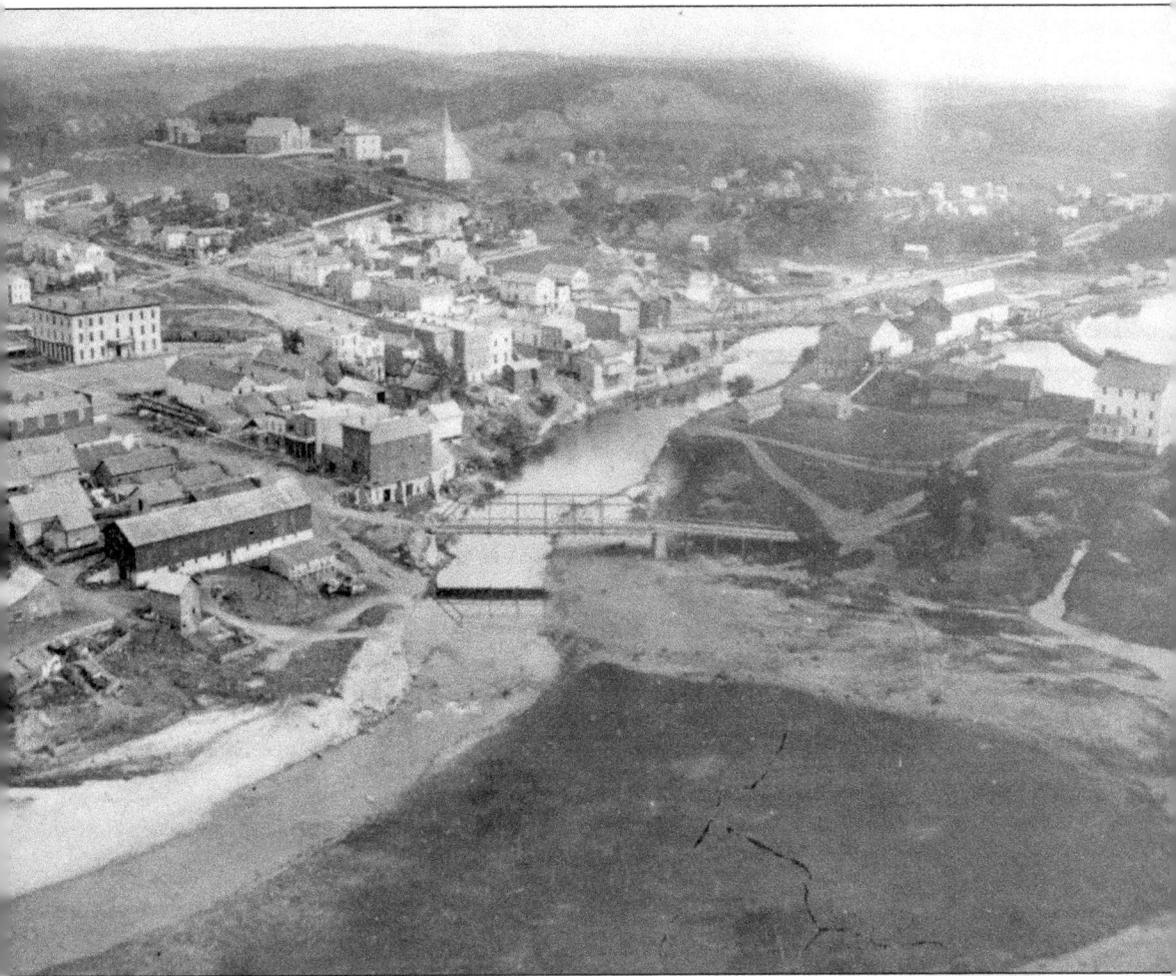

MUD FLATS BENEATH THE MILLS. This photograph from the mid-1880s shows all three of Lanesboro's original mills and their arrangement around Mill Pond. Note the rail lines along and across Mill Pond and the flume dispensing water west of the wagon bridge. The original wagon bridge shown here was replaced in 1893 with the Chicago Bridge Company structure that remains a Lanesboro fixture. Also of interest is the original course of the Root River north of the wagon bridge, seen here as a light colored band encircling the area that today accommodates Lanesboro's softball park. The natural course of the Root River has been much altered by the development of Lanesboro, first with the creation of Mill Pond Lake in 1868, then the rerouting of the Sylvan Park river bend in 1874, and finally by the abandonment of the river bend shown here.

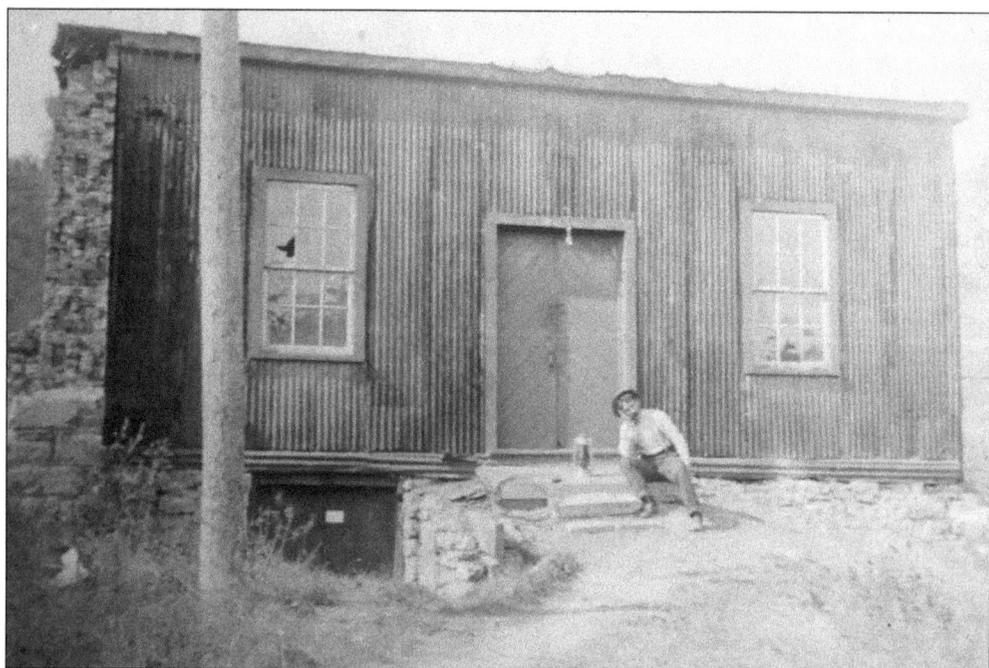

FIRST ELECTRIC LIGHT PLANT, 1895. Edward Lynch, pictured, was interested in the new phenomenon of electricity and became superintendent of Lanesboro's first hydro-electric plant, which was built in the mid-1890s on the site of the burned Remmington and Leahy Mill. Lynch did most of the early wiring of buildings in Lanesboro and designed the town's first electrical distribution system.

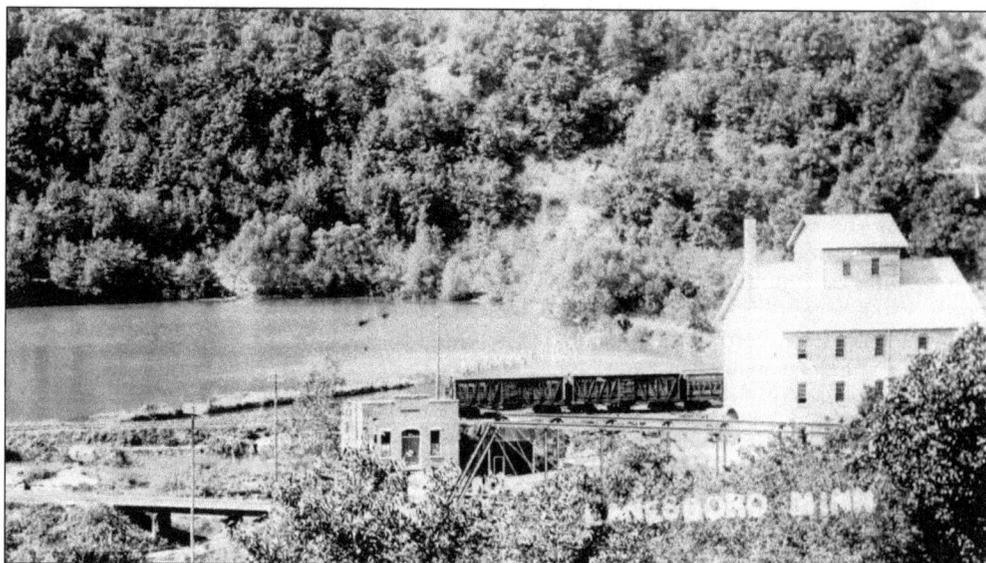

POWER PLANT AND ROLLER MILL. By the early 1900s, a small, brick power station had replaced the first simple structure. It is pictured here near the Lanesboro Roller Mill. John Dawson of Fillmore County invented the roller milling process in 1880, revolutionizing the milling industry. Note the deteriorated pilings on Mill Pond marking the route of the rail line established during Lanesboro's flour milling heyday.

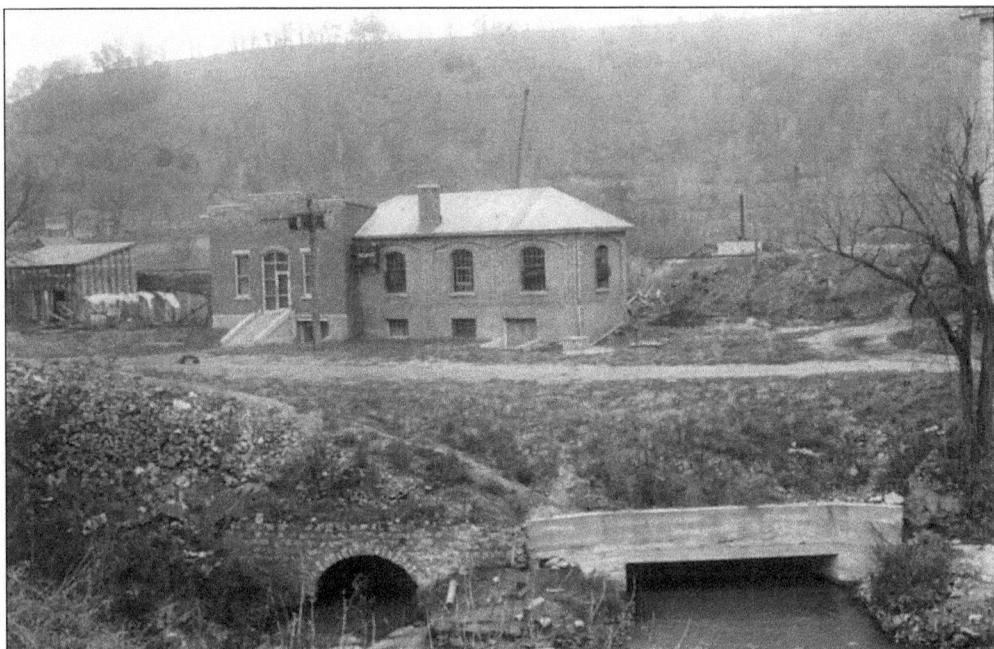

LANESBORO'S EXPANDING POWER STATION. By 1925 Lanesboro's hydroelectric plant had grown, as pictured here. Below the plant can be seen two large flumes dispersing water back into the Root River. The brick structure at left was home to the plant operator, whose Monday wash can be seen on the line at left.

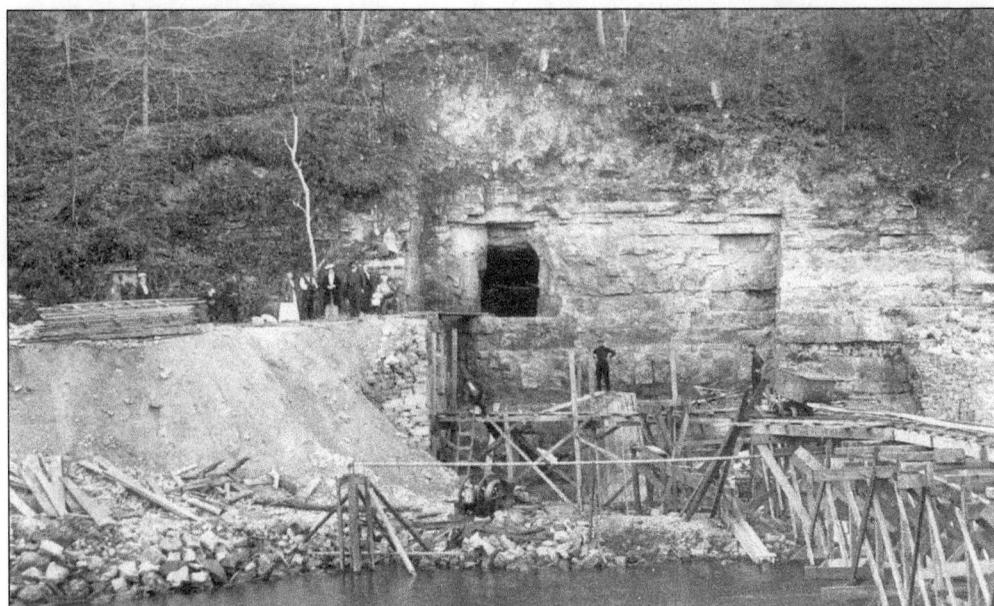

POWER STATION UNDER CONSTRUCTION. In 1915 the Root River Power and Light Company constructed a towering hydroelectric plant on a steep bluff embankment along the north branch of the Root River above Lanesboro. A tunnel, dynamited through a quarter mile of solid rock, connected the plant with the Brightsdale Dam two miles upriver. Water swept through the tunnel and was harnessed by a huge electric turbine.

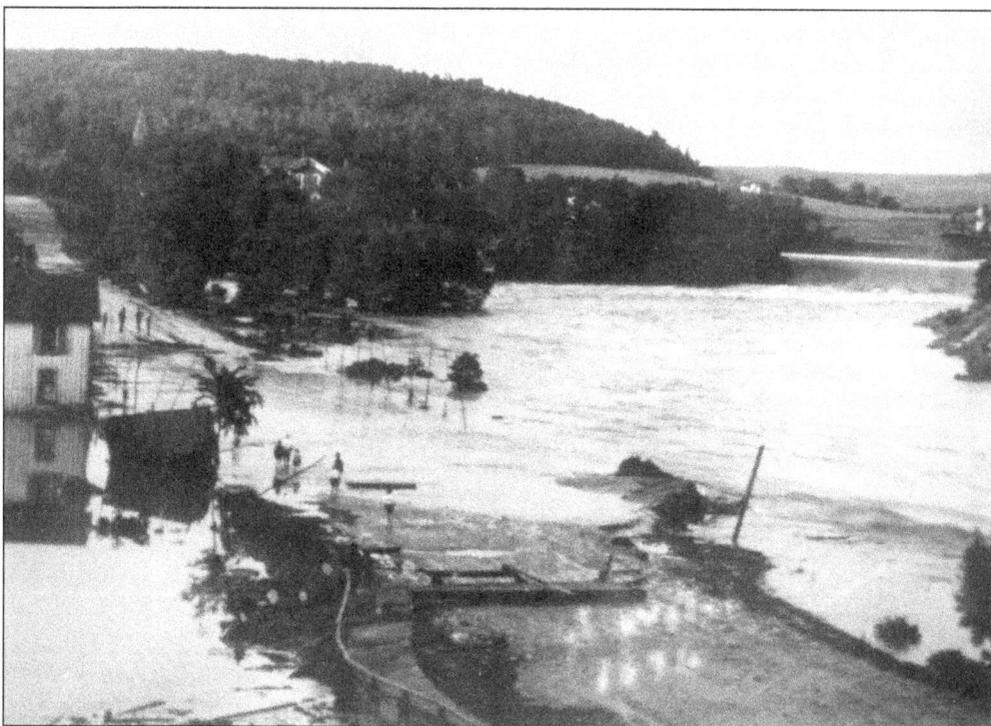

GREAT FLOOD OF 1876. Flood waters of the Root River overflowed the causeway on Lanesboro's main street in March of 1876. The scene was frequently repeated over the years prior to the installation of a dike along the roadway around 1935. The Park School House, which was established in 1882 along this same stretch, was repeatedly flooded until finally it was swept from its foundation by floodwaters in 1890.

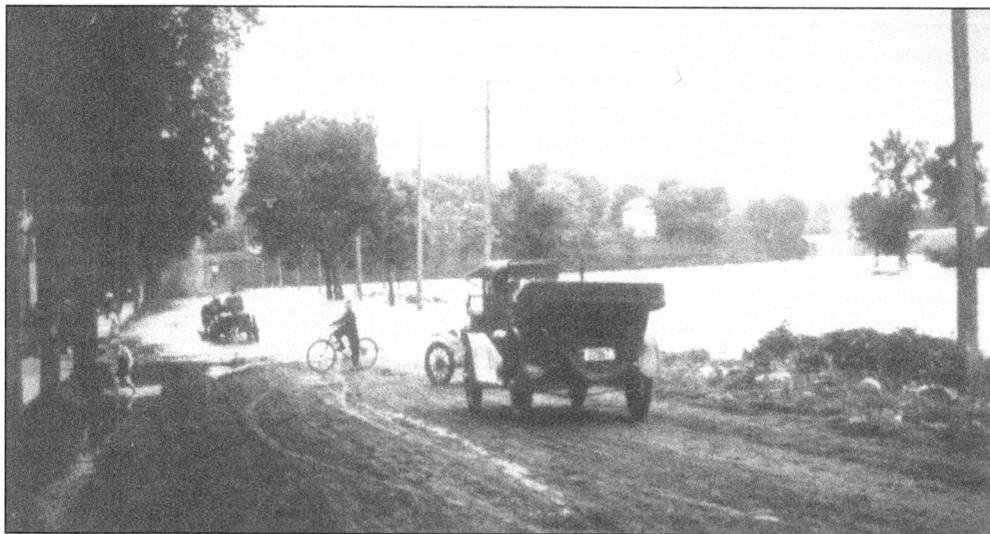

HIGH WATER AT LANESBORO. This Bue photograph from June 23, 1917, shows the Root River at flood stage with water covering the stretch of Parkway Avenue along Sylvan Park. Two automobiles are poised near the flood's edge as a wagon and team brave the waters on the way south toward Brooklyn.

Escape From Death—Excerpts from a letter by D.W. Hall of Lanesboro. Mr. D. W. Hall was a clerk in the White & Benyon flouring mill on March 10, 1876, when a great flood caused considerable damage in Lanesboro. He later wrote a description of the day's events to his family in Janesville, Wisconsin:

> The day opened with sharp flashes of lightning and heavy peals of thunder, until three o'clock in the afternoon. The ground was frozen solid and covered with about six inches of heavy snow and ice. The spectacle of such an incessant peal of thunder and blinding flashes of lightning when nature was wrapped in her winter robes was awfully sublime. The rain began to fall about seven o'clock and increased to a heavy shower melting the snow rapidly and filling every nook and corner with a flood of waters.
>
> Towards noon the river had reached several feet about any freshet ever know[n] in the valley and the citizens began to feel anxious in regard to what might soon happen. Roaring torrents now came down the hillsides. About this time White & Benyon's cooper shops moved off [their foundations], one of them going to pieces, the other swinging around to the west and was carried down the river. At the same time a building near Mosher's harness shop was swept off into the roaring river and came crashing against the railroad bridge. Fear now was for the bridge, but the shop was the weaker of the two – it was demolished, but the bridge remained intact.
>
> Great fear was excited lest the ice in the lake should break up and cause the dam to give away, but the ice held firm. The little highway bridge near the coal house went out with a rush of water, which soon tore away the west end of the embankment of the reservoir, when all danger to the mills disappeared.
>
> The bulkhead at the upper end of the canal began to show signs of weakness and an effort was made to strengthen it by braces and rods but the effort came too late. By five pm the water was running over the stone pier at the west end of the dam, which was all out of sight.
>
> Mr. Williams, Mr. Cummings and myself, and a little girl, Julia Peterson, were standing some twenty feet from the bulkhead and were about to leave when a crash of breaking timbers told us that all was gone and it was a run for life and no time to loose! The bank along side of the canal from the dam to the railroad is three for four feet lower than the bulkhead and the water began to pour over that space. This little girl, Julia Peterson, was standing nearer the dam than any of us; I was 10 to 12 feet nearer the dam than Williams or Cummings. Our first impulse was to run and all turned to do so but the thought came instantly that the girl would be lost and quick as thought I ran for her, calling to her, but she seemed riveted to the spot! Just as I reached the girl a huge wave, not over fifteen feet away, came on toward us with a mass of ice on its crest! I saw that a misstep or the loss of two or three seconds would cause our death; still, I felt calm, and seizing her arm, and bidding her run with all her might, we started for the railroad. We had 4 or 5 rods to make on this narrow strip of embankment and as the head of the great wave of water struck the trestle work in the canal, there was a dash of water over the embankment that came near carrying us over, but it subsided at once, and a moment later we were safe on the railroad; but the great wave behind us was there as soon as we were, and the flood was then running over the embankment we had just left two or three feet deep!
>
> Some have asked me if I thought of the danger at that time. Of course I did. My chief thought was to save the girl for without help little Julia Peterson was lost. I acted from impulse of the moment without stopping to weigh chances. I did just as I should hope to do again under like circumstances.

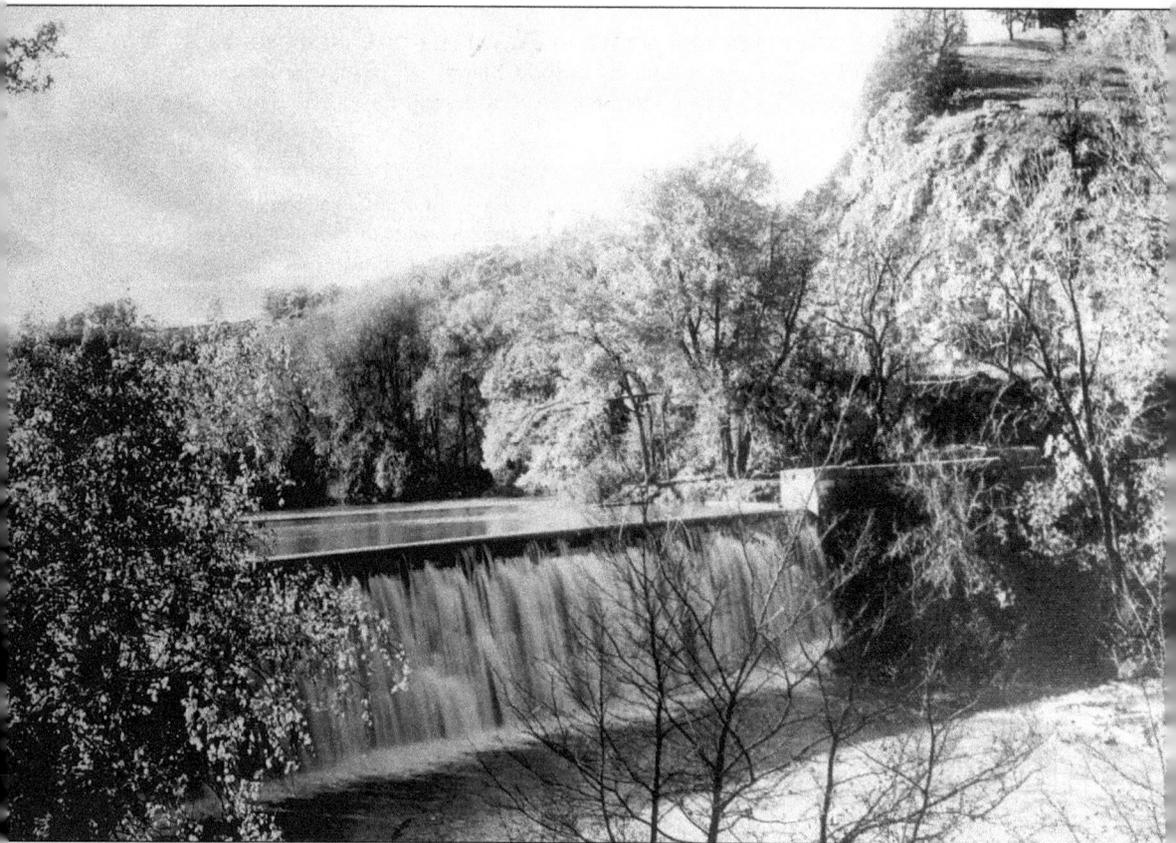

SCENIC MASTERPIECE. The enduring Lanesboro dam, shown here c. 1940, is a scenic masterpiece that has held visitors and locals alike in awe of its picturesque beauty for well over 100 years.

Three

MERGING CULTURES

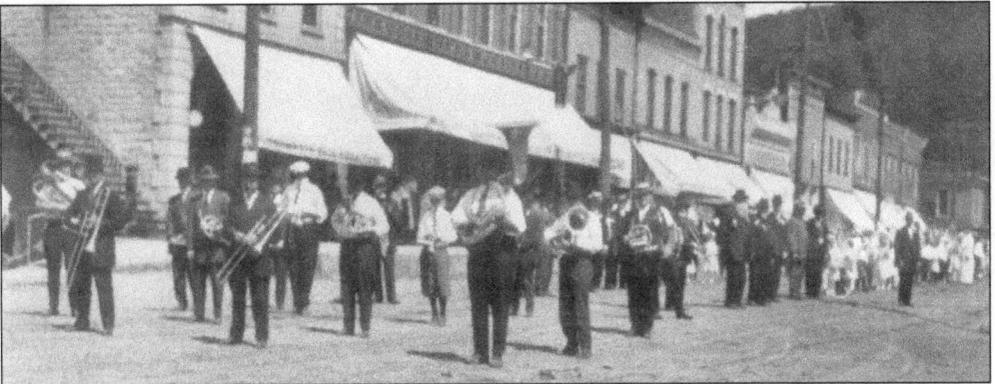

In 1849, with Minnesota a territory and tracks of land newly open for settlement, emigrants and adventurers flocked to the area by steamboat and "prairie schooner." The majority of these settlers were from New York and the New England states or immigrants fresh from the old world. The first white settlers on the future site of Lanesboro bore names such as Scanlan, Enright, Christenson, Dyerson, and Johnson.

The Lanesboro Townsite Company was made up of investors from the New York, New Haven, and Massachusetts areas; however, the new town attracted an eclectic group of enterprising pioneers. A great many of the people who originally settled in Lanesboro were Irish and Norwegian immigrants with ties to the Catholic and Norwegian Lutheran Churches, but natives of Canada, England, Denmark, Sweden, Germany, China, and other countries were also among the mix who came west undaunted by the hard work necessary to secure greater opportunity.

The Winnebago Nation of Native Americans living south of Lanesboro in Winneshiek County, Iowa, also kept a winter camp in the vicinity of Houston, Minnesota. After Lanesboro's founding, the Winnebago occasionally visited the town, sometimes camping and trapping along the Root River. It is well established that starting in the mid-1870s, Dr. Frank Powell of Lanesboro enjoyed a close relationship with the Winnebago here.

With common purpose, diverse peoples combined here to forge a community that has weathered the rise and fall of stormy fortune, emerging today as one of the fairest of Minnesota's small cities.

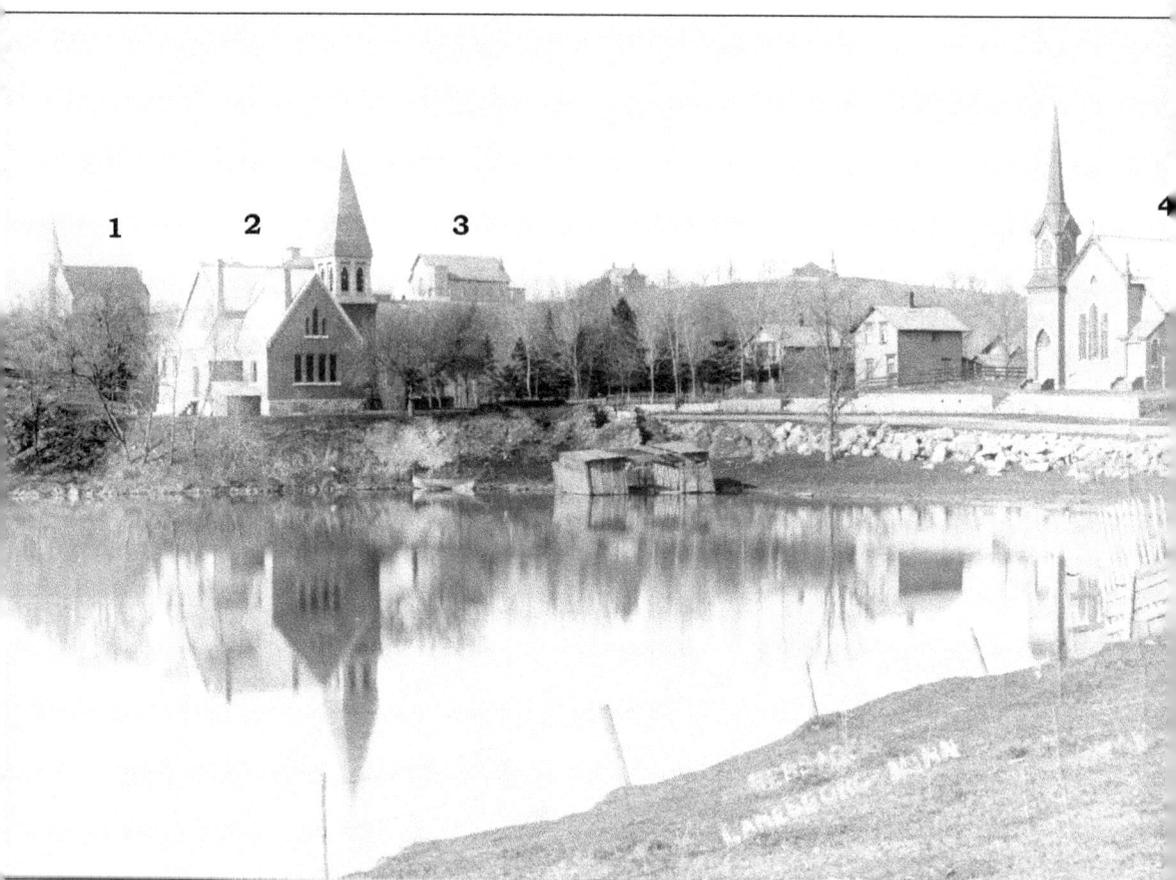

CHANGING CHURCHES. At least four Christian denominations have established worship services in Lanesboro, sometimes sharing facilities and twice taking them over entirely. Pictured here in the mid-1890s are the following: (1) the Norwegian Lutheran Church, (built as a Presbyterian Church in 1869 at a cost of $14,000 and sold to the Lutherans for about $4,500 in 1888); (2) the second Presbyterian Church (built c. 1889) on the shore of Mill Pond Lake; (3) St. Patrick's Catholic Church (built 1871–1873) also on Church Hill; and (4) the Methodist-Episcopal Church (built c. 1879). Around 1930, with their congregation shrinking, the Presbyterians discontinued services. In 1934 the Methodists bought, and moved into, the old Presbyterian Church. The original Methodist-Episcopal Church was later torn down. The Methodists retain their adopted house of worship today, while the Catholics and Lutherans remain atop Church Hill.

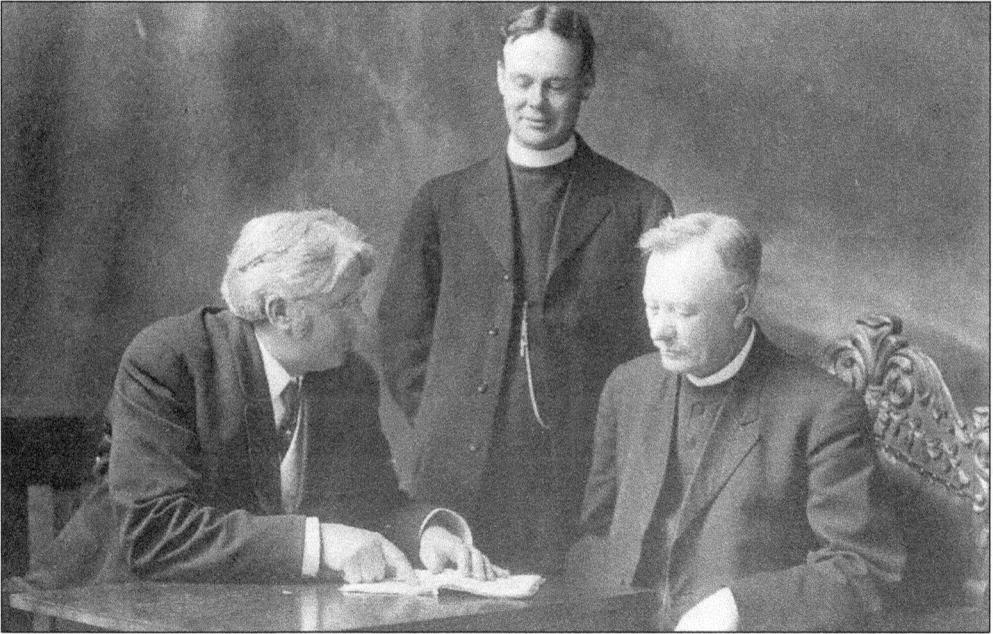

LANESBORO AREA PASTORS, 1925. The ability of the church to enrich community life and to provide peace and stability is directly related to the wisdom and ability of those who head each house of worship. Given Lanesboro's quietude, one might suppose this community has benefited from a good many wise clergy over the years. Pictured, from left to right, are Rev. Finn Magelssen, Rev. P.J. Nestande, and Rev. Nels Giere.

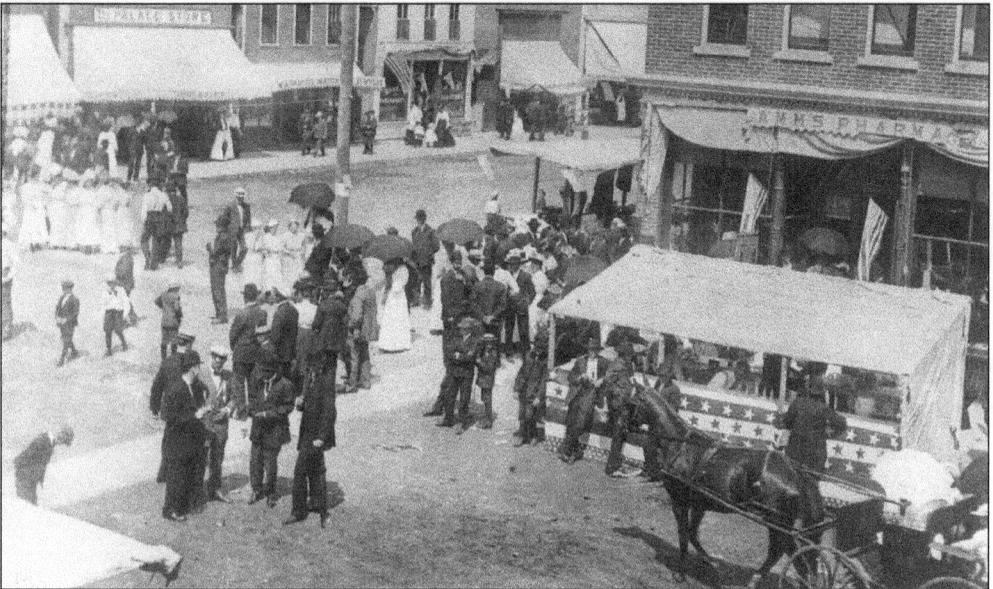

UMBRELLAS BUT NO RAIN. Citizens of Lanesboro gather at the corner of what are now Parkway Avenue and Coffee Street during a Fourth of July celebration. Numerous white and black umbrellas are in evidence to ward off the offending sun. A refreshment stand rests in front of Lamm's Pharmacy and awnings protrude from the Palace Store grocery and other buildings on Coffee Street.

A SOCIAL PEOPLE. In the early 1900s, the *Lanesboro Leader* professed, "Lanesboro people have been noted all along as proverbially social. A liberal kind of democracy prevailed. The well-to-do families did not shut the door against their less-favored neighbors nor did the poor laborer 'kick' unreasonably against his employer. 'Live and let live' was the motto." Lanesboro's own pictured socializing in Sylvan Park, *c.* 1915.

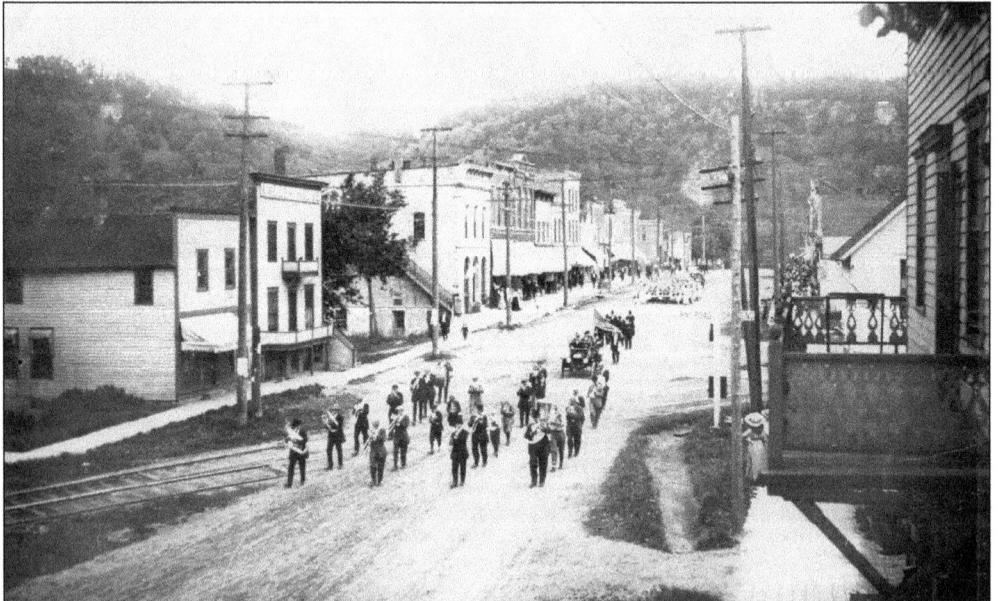

FOURTH OF JULY PARADE, 1911. Whether born in Norway, Ireland, America, or elsewhere, a common bond of patriotism united the varied peoples who made Lanesboro their home. Old Glory is evident in this photo from July 4, 1911, as the Lanesboro band parades past the Valley House Hotel on Main Street (now Parkway Avenue). Other early hotels in Lanesboro included the Winona (Merchants), American, Devey, Grant, Park, Phoenix, and Lanesboro.

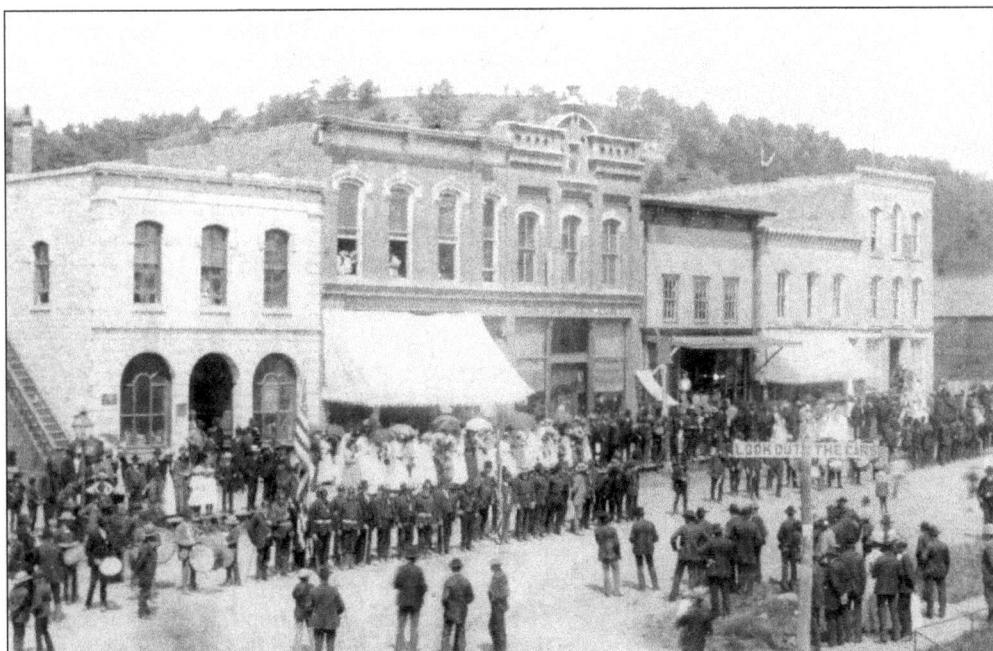

CIVIL WAR VETERANS, JULY 4, 1889. The *Lanesboro Leader* reported, "After the close of the rebellion many survivors of the 'late unpleasantness' went west to make their fortunes in the uprising cities and on the rich prairies beyond the mighty Mississippi. Some of them came to Lanesboro during the first years of its settlement and instituted a Grand Army Post under the name of Hardy Post, No. 118 on August 21, 1884."

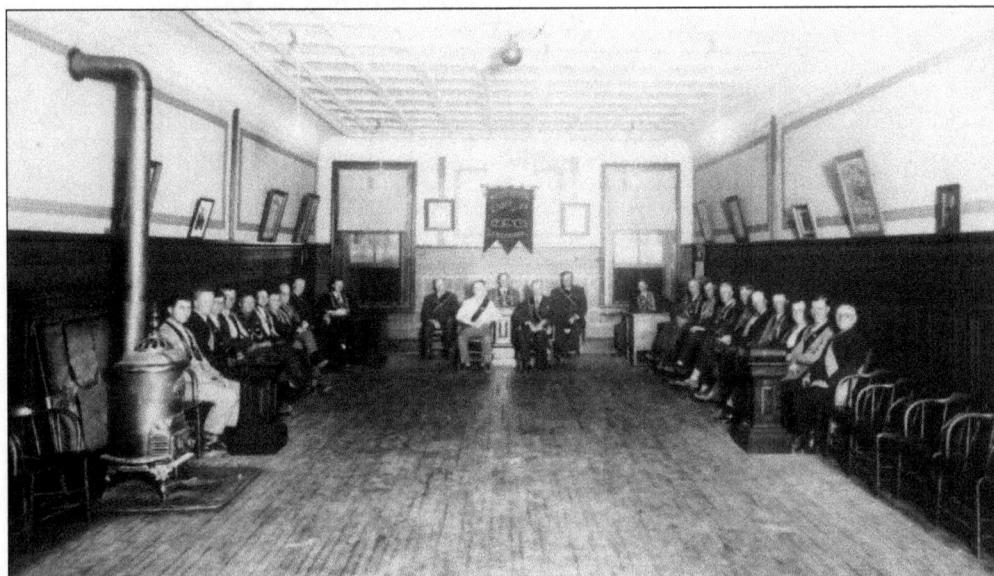

ODD FELLOWS. The Odd Fellows established the first lodge in Lanesboro on May 28, 1869. The Masons followed on November 27, 1872. Over the years, the lodge building pictured here was utilized for meetings of these and numerous other fraternal organizations including the Modern Woodmen of America, the Columbian Lodge—Knights of Pythias, Hardy Post No. 118, and the Kiwanis. Pictured is an Odd Fellows meeting, *c.* 1935.

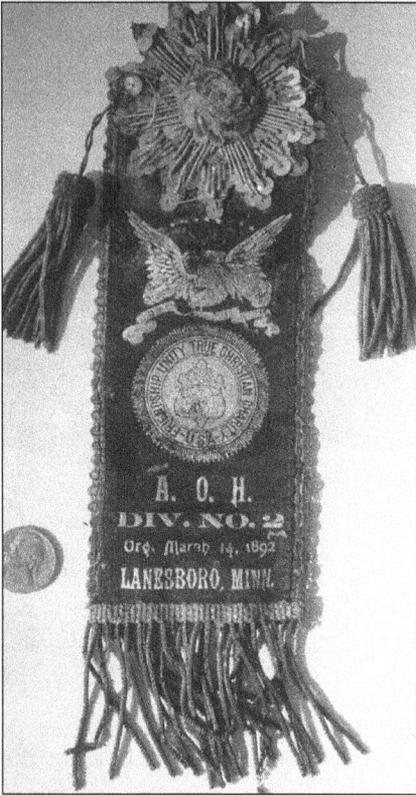

ANCIENT ORDER OF HIBERNIANS. Open only to Catholics, the Ancient Order of Hibernians met in the hall of the Lanesboro Bank building beginning in the early 1890s. The order was open to men and women and met on the Sabbath. In 1902 the *Lanesboro Leader* reported, "It is understood the principle of temperance is inculcated among its members." Pictured is an A.O.H. badge from the Lanesboro division established on March 14, 1892.

LANESBORO'S BAND. Lanesboro's community band was established in 1877 under the direction of Thomas Evans. The group is pictured here on the south side of Lansboro Bank building about 1890. The band was important to the community's sense of establishment and was a genuine source of entertainment, figuring prominently in most public celebrations. In the early 1900s, weekly concerts were given from a large raft floated on Mill Pond.

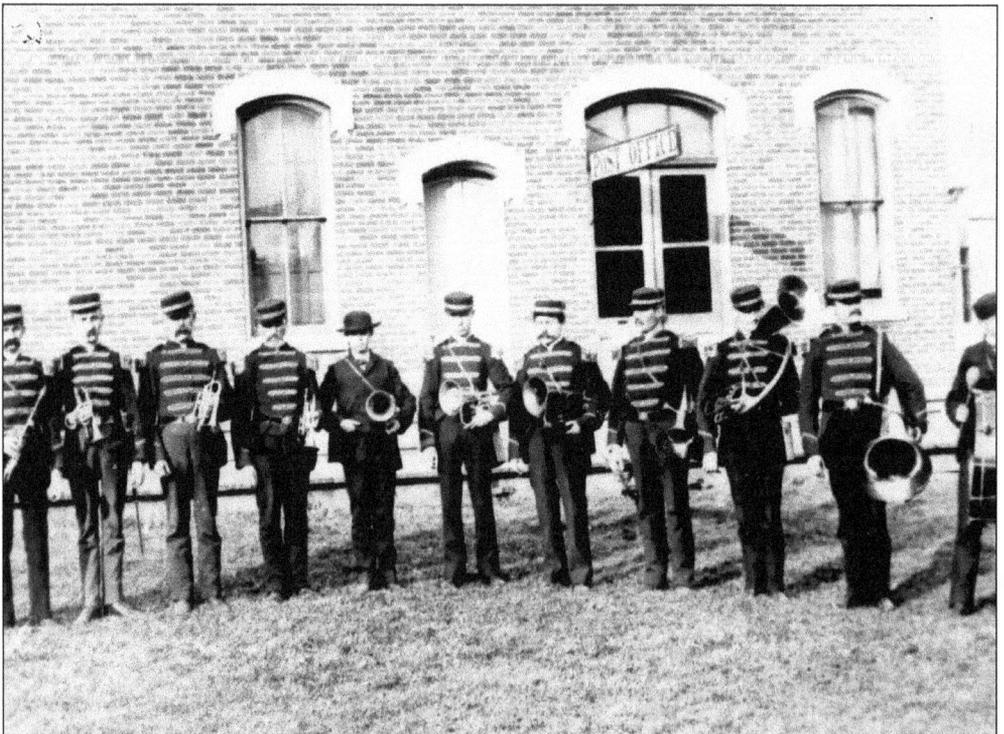

A NORWEGIAN CLASSIC. Olaf Thompson is pictured here, *c.* 1920, demonstrating the structural strength of a new baby carriage. A prominent Lanesboro supporter and businessman, Olaf was partner in the Thompson Brothers Furniture Store and was actively involved with The National Ski Association. He was a popular announcer at ski jump competitions from Lake Placid, New York, to Squaw Valley, California. The boys pictured are unidentified.

DEPARTING FOR NORWAY. This photo, *c.* 1910, shows a group of Norwegians from Lanesboro preparing to depart for the first leg of a journey back to Norway. From the town's founding until well into the 20th century, the Norwegian language was common on the streets of Lanesboro. The man with flat cap, beard, and suitcase at center is identified on the photo as "Mons Anderson, I think."

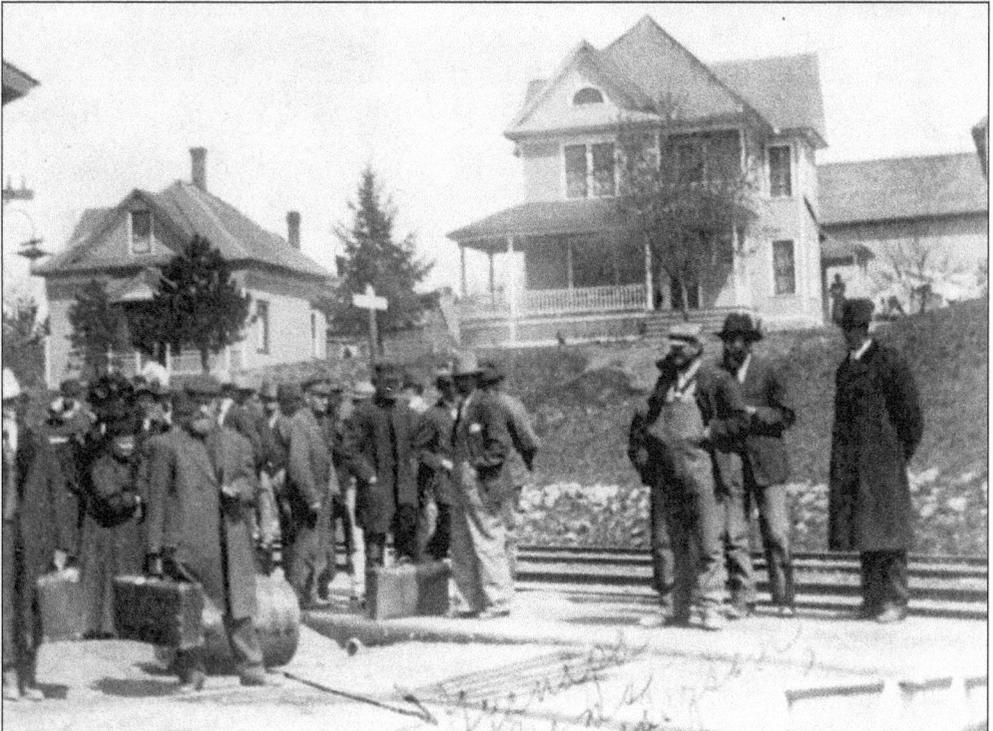

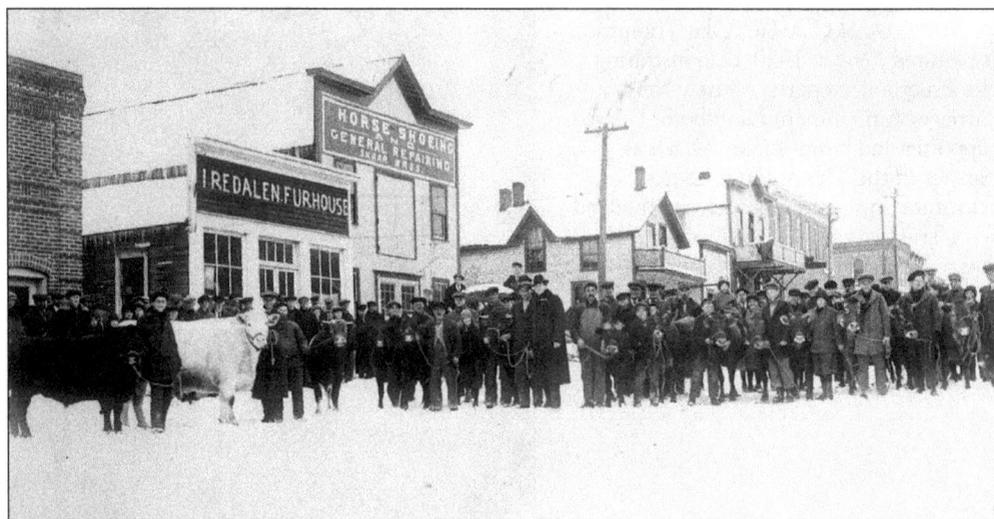

CATTLE ON COFFEE STREET. Area farmers assembled for a showing of calves on the west end of Coffee Street, *c.* 1915. The importance and social impact of Lanesboro's farming community cannot be overstated, as agriculture has been the one consistent element in the town's lifestyle throughout its history. None of the four woodframe buildings seen most prominently in this photo are still standing today.

SPITE FENCE ON CHURCH HILL. Even in the friendliest of small towns occasional differences arise. In his book, *Small-Town Stuff*, Lanesboro native Gerhard Ellestad detailed the property line dispute that led to the construction of this 6-foot-tall "spite fence" across the porch of an offending structure around 1900. Ellestad reported that the dispute was short lived, however, and the fence soon torn down.

Four

BUFFALO BILL
AND WHITE BEAVER

One of Lanesboro's most interesting historical sidelights is the story of Doctor David Franklin Powell, known as White Beaver, and his association with William F. Cody, the famous Buffalo Bill. Powell was a skilled physician educated at the University of Louisville in Kentucky. In 1871, already having extensive experience as an Army scout, he accepted a commission as post surgeon at Fort McPherson, Nebraska. During this time, Powell was reunited with friend and fellow Army scout William F. Cody, who would later gain national recognition as Buffalo Bill.

Powell moved to Lanesboro in 1875, establishing a medical practice as well as a relationship with the Winnebago Native American tribe of the area. A year later, Bill Cody arrived in Lanesboro to visit his old friend. It was in Lanesboro that the two developed the concept of a Wild West circus, eventually enlisting Powell's Winnebago friends for what was to be Buffalo Bill's first Wild West Show. Due to inclement weather, the first performance took place indoors at the Nelson Hall in Lanesboro. Outdoor exhibitions followed, and some time thereafter, Buffalo Bill, accompanied by Dr. Powell and a number of the Winnebago, took the show on a limited tour. Dr. Powell soon returned to his patients in Lanesboro, but Buffalo Bill continued to worldwide fame. Though Omaha, Nebraska, is often recorded as the birthplace of Buffalo Bill's Wild West Show in 1883, people here have long held that some years earlier Buffalo Bill and White Beaver started it all in Lanesboro.

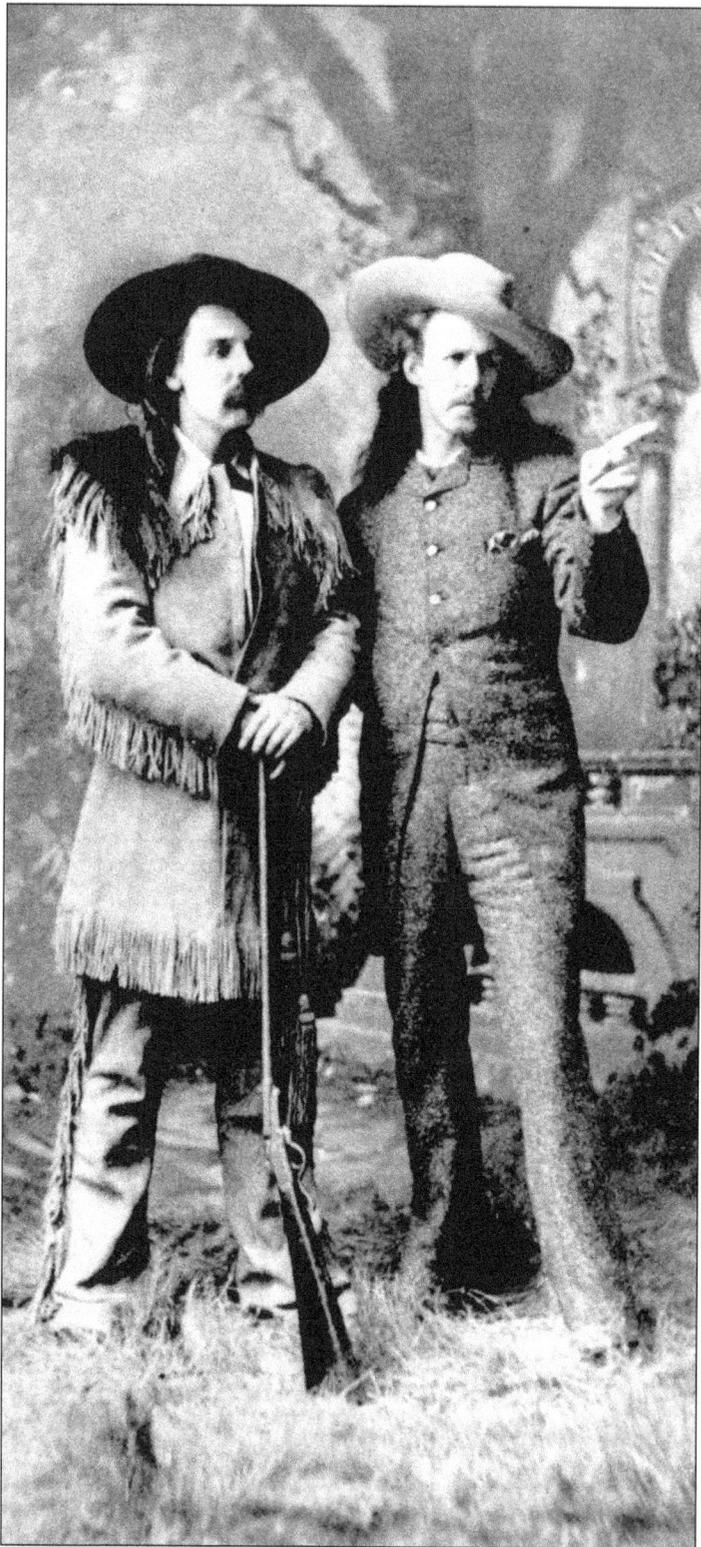

BUFFALO BILL AND WHITE BEAVER. Plainsman, Civil War veteran, buffalo hunter, and Army scout William F. "Buffalo Bill" Cody started in show business in December of 1872, playing in a series of traveling stage shows. Co-starring in these enthusiastically-received western dramas were fellow plainsmen and legends Texas Jack Omahundro and Wild Bill Hickok. One critic reported that the show had, "scarce the shadow of a plot and is like an animated dime novel with the Indian killing multiplied by ten, but it was enjoyable . . . and the bloodier the tragedy, the broader was the comedy." When the show broke up in 1876, Buffalo Bill came to Lanesboro, Minnesota, to visit his frontier friend, Dr. Franklin David Powell, widely known by the Indian name White Beaver. Taken in Racine, Wisconsin, the photo shows Buffalo Bill Cody (left) and White Beaver Powell (right).

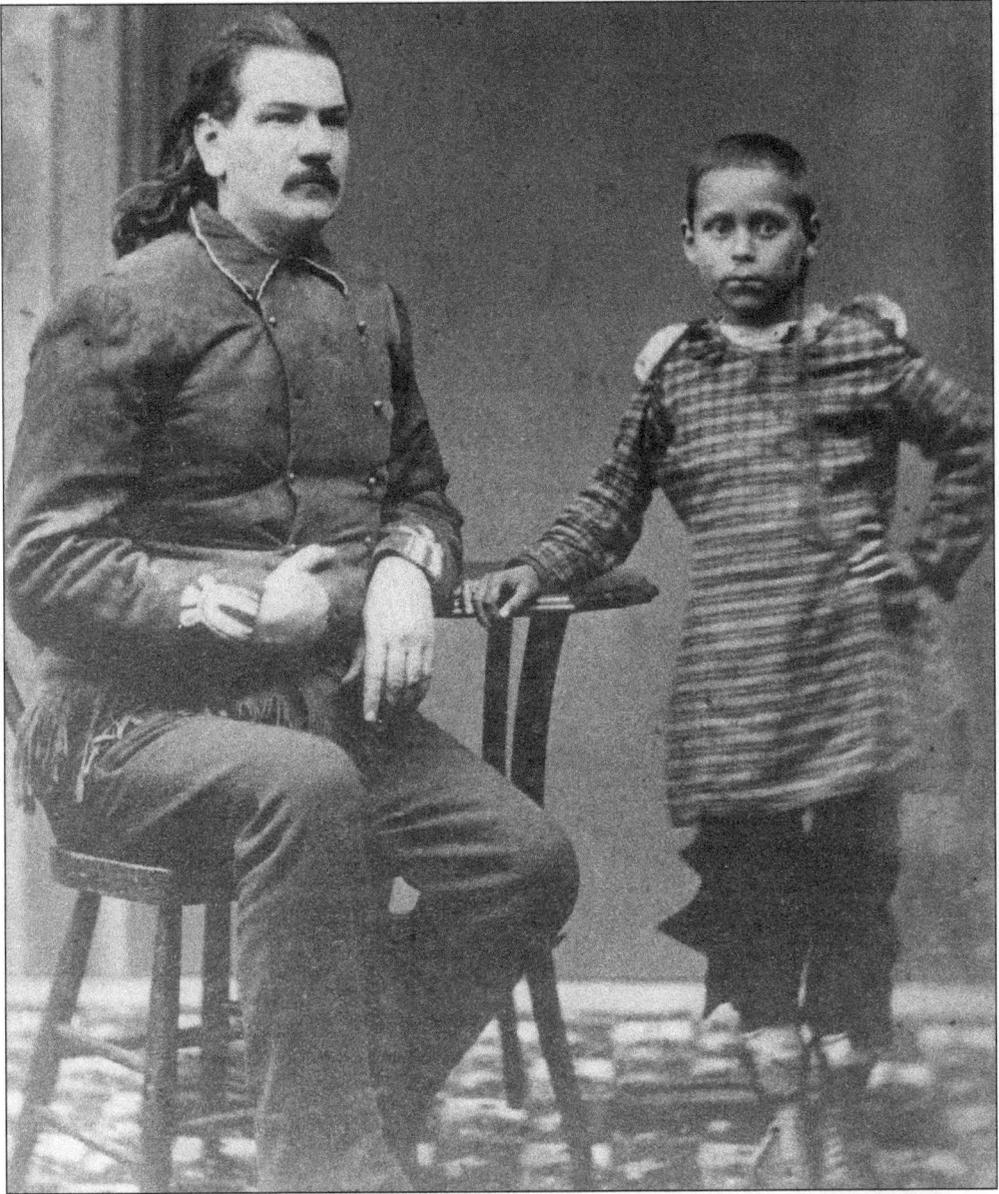

MEDICINE MAN. David Franklin Powell was born into a medical family in Kentucky on May 25, 1847. His father, Doctor C.H. Powell, had emigrated from Scotland some years before and married a quarter-blood Native-American woman from the Oneida Nation. Two younger Powell boys, George and William, also followed their father into the medical field. Later they followed their brother David to Lanesboro. Dr. George Powell became a veterinary surgeon and William Powell a pharmacist. Both were well known in Lanesboro where a local newspaper reporter later reminisced, "They were all three picturesque men, tall and large, wearing their hair to the shoulders in the manner of Buffalo Bill." Dr. C.H. Powell died in 1855, and Mrs. Powell moved the family to Nebraska where all three boys gained experience scouting for the U.S. Army. It was during this time that David Powell met a number of colorful frontier characters destined for the history books. Among them were William F. "Buffalo Bill" Cody, Wild Bill Hickok, John B. "Texas Jack" Omohundro, California Joe, Peon Pallerday, and others.

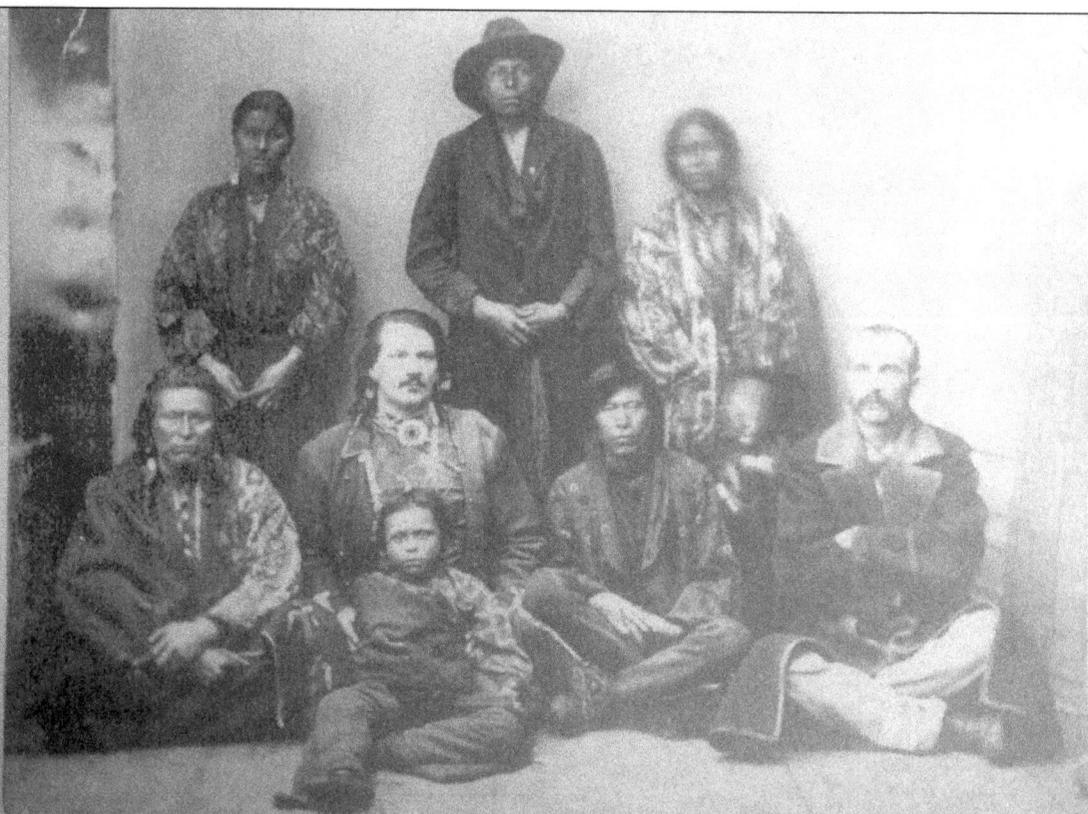

DEAR FELLOWS. This photo, dated 1879, is inscribed: "Fraternally and with sincere respect I am dear fellows, yours, Nop-ska." White Beaver is seated second from left. Nop-ska may also be pictured. The young man to the right of White Beaver may be Ne-pa-ma Ka-sa-cho-ga (translated Green Rainbow), a nephew to Chief Winneshiek, who visited Lanesboro in June of 1879. The *Lanesboro Journal* heralded Ne-pa-ma Ka-sa-cho-ga as a "Distinguished Arrival" giving a detailed description and noting approvingly, "His tout ensemble is aggravated by a red Mackinaw blanket gathered in folds of careless grace about his manly form. . . . Of good habits and high connection, he uses neither whisky nor tobacco, in which he is original but not aboriginal, and plays a rattling game of checkers, having beaten Nop-ska, the medicine man, five straight games." The paper further noted of the visitor, "He reads, writes and speaks better English than many of the Chicago reporters, and is quite as diffident."

REMARKABLE DEEDS. While attending college, David Powell fought a pistol duel with one of his professors over an insult to Powell's girlfriend. Fittingly, the duel took place in the anatomy dissecting room. During the first round of fire, Powell was wounded in the left forearm and the professor's cheek was grazed. Despite the pleas of friends, David insisted on a second round, during which the professor's shoulder was shattered by his bullet, ending the contest. Both survived and Powell was graduated in 1871. In the mid-1870s he acquired the name "White Beaver" after curing the daughter of a Sioux chief and being presented the pelt of a sacred white beaver in gratitude. Later he was honored as a medicine man of the Winnebago after saving the life of Chief Winneshiek near Black River Falls.

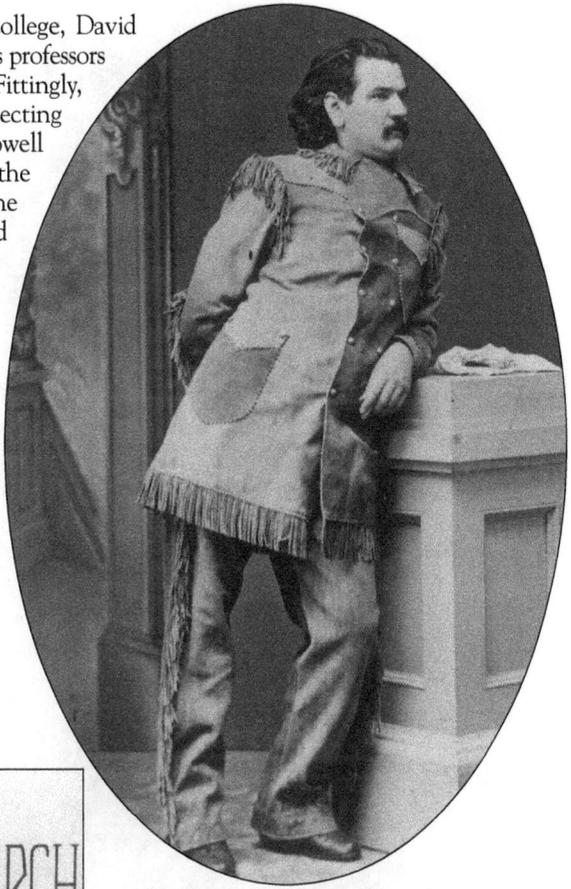

WHITE BEAVER'S MARCH
Respectfully dedicated to

Dr. D. FRANK POWELL (White Beaver)
Medicine Chief and Counsellor of the Winnebago Indians.
Composed by
WM. DOERFLINGER.
Published by
WM. DOERFLINGER.
LA CROSSE, WIS.

WHITE BEAVER'S MARCH. A tireless self-promoter, White Beaver advertised liberally both in Lanesboro and La Crosse, Wisconsin, where he moved in 1881, and served three terms as mayor. Specializing in women's disorders and complaints of the eye, one ad from 1880 stated, "Hundreds of women who have visited me almost crippled by diseases peculiar to their sex have been sent away cured." And, it promised, "I straighten cross eyes in less than one minute." On July 18, 1884, the *Lanesboro Journal* referenced the sheet music pictured here with the statement, "The Doctor is noted for surprises and his friends, on reception of this unique musical treat, remarked that it was just like Dr. Powell, always up to some reminder that he was alive and actively at work."

49

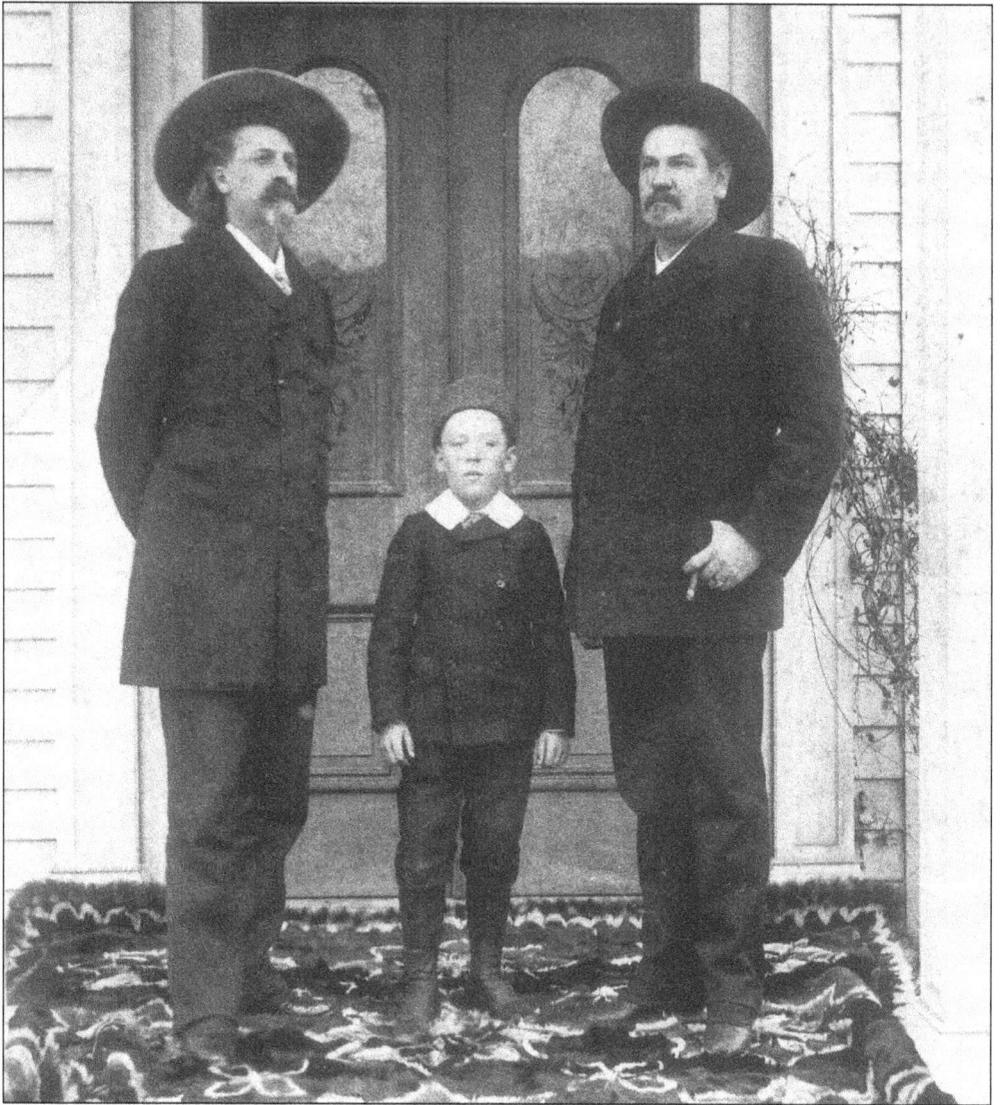

LANESBORO'S AMPHITHEATER. In the spring of 1877, White Beaver and Buffalo Bill climbed the bluffs overlooking Lanesboro and, remarking on the amphitheater-like view, sparked an idea for a revolutionary kind of wild west circus, one that would encompass western feats and spectacles too grand for the stage. Both noted marksmen, the two organized an exhibition of shooting, native horsemanship, and dancing in conjunction with a number of Dr. Powell's Native-American friends. B.A. Man was a part of that first Wild West Show and later recalled the show as, "composed of six Indians, two squaws and two white men, together with Buffalo Bill, White Beaver" and himself. "The first dance which the Indians essayed was in celebration of the dog feast." According to the Lanesboro newspaper, sharp-shooting displays were included in the exhibitions seen in Lanesboro: "Nickel's were shot out from between fingers, apples were shot off heads with both rifles and revolvers and the display of deadly aim and nerve exhibited kept the spectators breathless with amazement." Pictured from left to right are Buffalo Bill, unidentified boy, and White Beaver. The two natural showmen remained close friends and are today buried side by side atop a mountain crest overlooking Cody, Wyoming.

Five

COMMUNITY

Since the town's founding, Lanesboro has received numerous accolades for its natural beauty, economic resources, and healthful environment; but it is the people of Lanesboro that have made the community a place worth living in. Too many to mention are the citizens who have called Lanesboro home and who rightly deserve to be remembered.

The town has held clever entrepreneurs like John Beck who advertised his furniture business by noting, "always keeps coffins of all sizes," or veterinary surgeons Drs. Powell and Pulver who guaranteed, "no cure, no pay." There have been solid citizens like former mayor John Toomey, barber and mayor Alf Ward, businessman John Solberg, and longtime police officer Cordy Thompson. Lanesboro has seen colorful characters like Arnie Rank, who rid the area of over 2,000 rattlesnakes in his day. Beloved clergy such as Father James A Coyne and Reverend H.E. Rasmussen, and dedicated physicians such as Doctors Johan Hvoslef, F.A. Drake, A.P. Lommen, Ralph Johnson, and John Westrup.

The city has always been blessed with fine educators such as Principal K.W. Buell, who established a firm educational standard from 1882 to 1890; Angela McCarthy, who in 1920 began 40 years of teaching in Lanesboro; and Rose Bell with over 50 years of service with Lanesboro's Libraries. These are just a taste of the many wonderful people who have given to this community. Over the years, the notorious have been few and the noteworthy many. Every storefront and street in Lanesboro is thick with history, every history is filled with people, and every face holds a story.

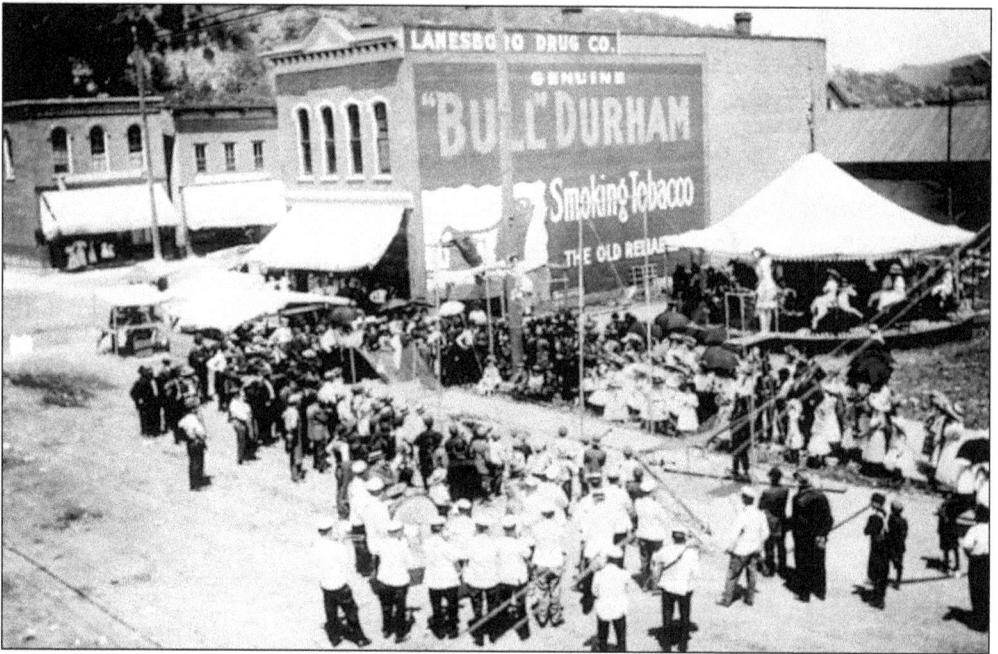

TRAPEZE ACT ON MAIN. Townsfolk gather on Lanesboro's main street for a traveling trapeze act during a June Jubilee near the turn of the century. One early circus act performing in Lanesboro promised, "The most pre-eminent of Champion Gymnasts, peerless acrobats, lofty leapers and fun-loving clowns," as well as, "a superb menagerie of exotic wild beasts and mastodonic mammals." They also warned, "No blacklegs, swindlers, or camp followers tolerated upon our grounds."

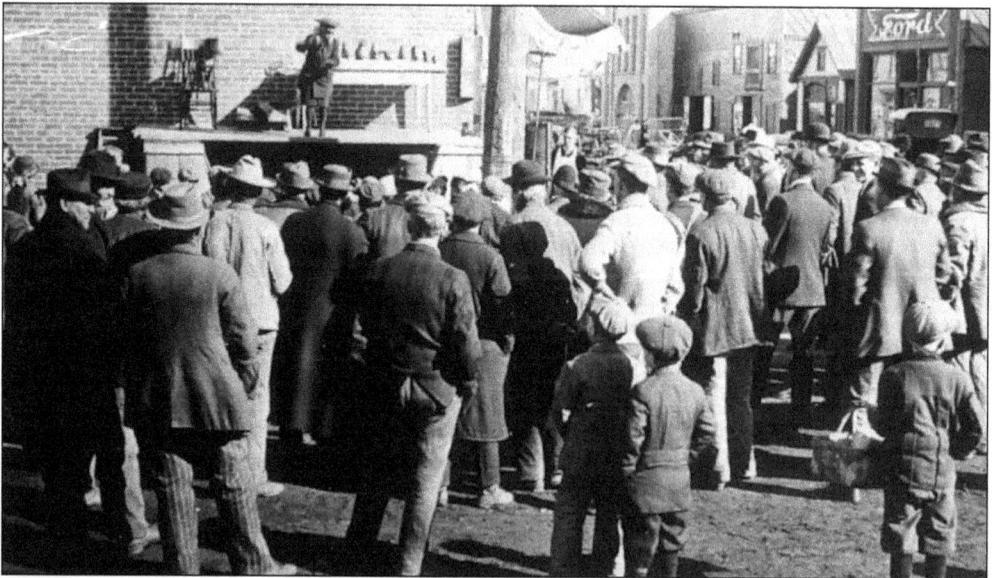

BUSTER BROWN COMES TO TOWN. Davidson's Mercantile sponsored this Buster Brown entertainment staged on the west side of their corner building, c. 1906. The product being advertised was the Buster Brown line of shoes. Note the buildings in the background, from left to right, the stone fire hall, the Moe Brothers Blacksmith Shop and Wagon Works, Ward's Barber Shop, and the Ford Garage.

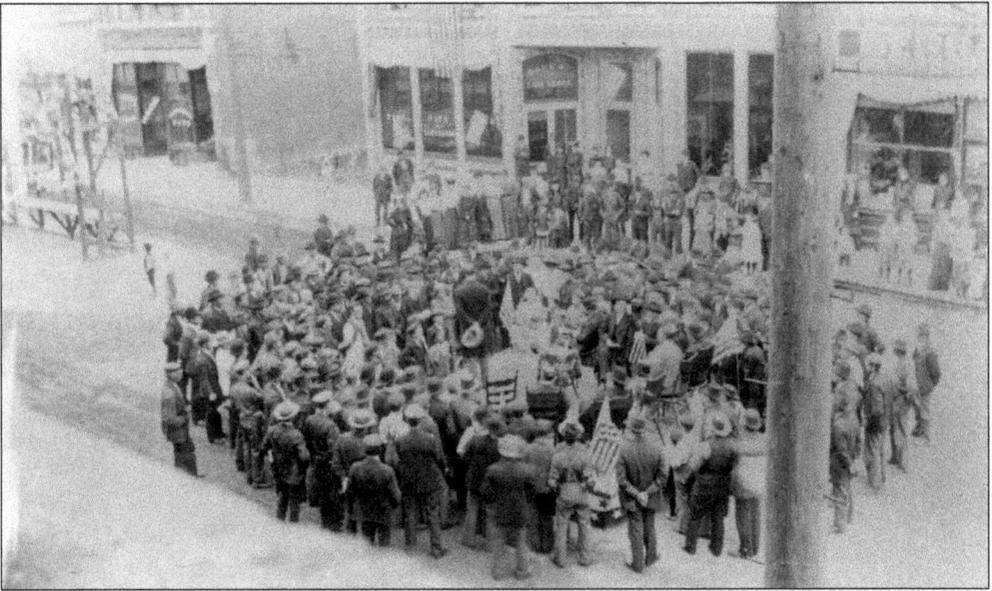

POLITICAL GATHERING. This political event, complete with a stage in the middle of the main street, attracted a crowd in about 1905. The buildings are, from left to right, the Galligan Building, the Lanesboro Bank Building, the Lanesboro Post Office Building, and Bersagel's Photo Gallery. The famous William Jennings Bryan made a "whistle stop" appearance in Lanesboro about this same time while campaigning for the Presidency of the United States.

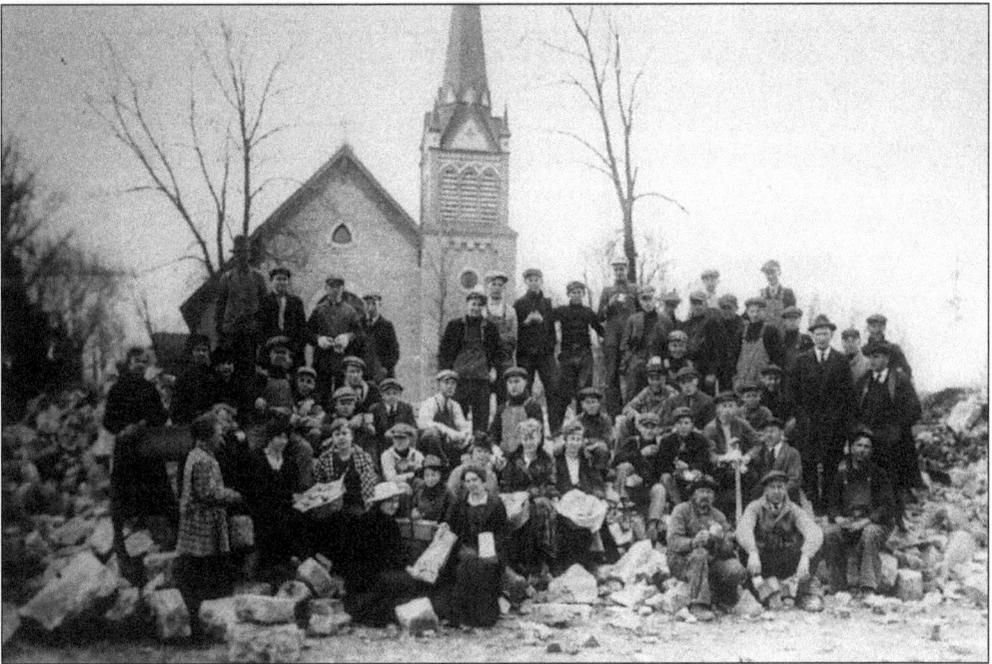

COMMUNITY IN ACTION. One of the truest tests of a community's character is how it responds to disaster. Then, as now, the people of Lanesboro rise to every challenge with dignity and charity. This group of hardy citizens gathered atop Church Hill in the aftermath of the tragic 1917 church and school fire to clean up the site in preparation for rebuilding.

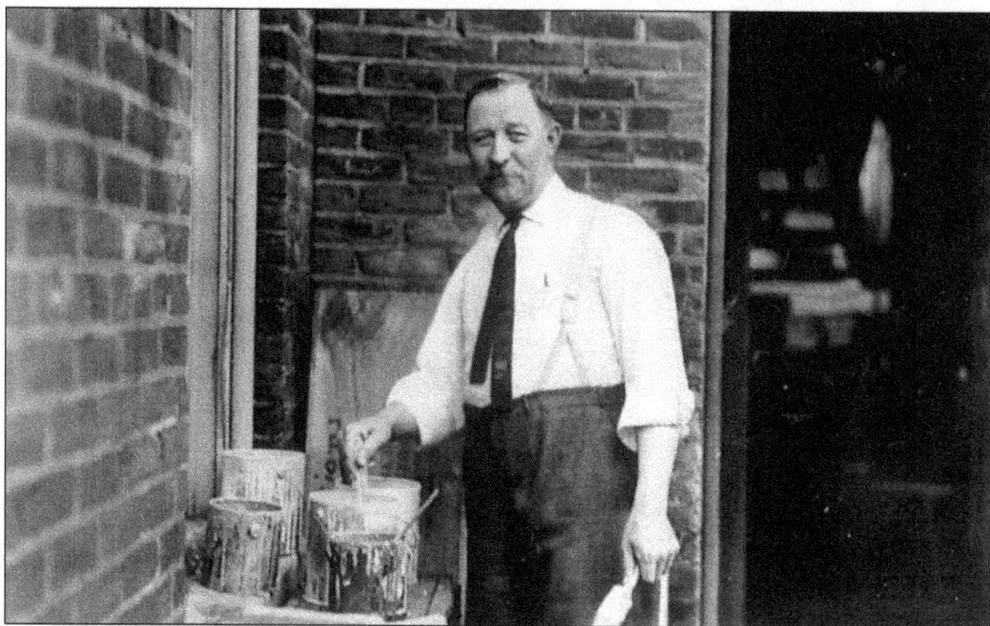

JULIUS OLSON. A prominent Lanesboro citizen, Julius Olson came to Lanesboro with his parents in 1872. During his more than 60 years in business, he clerked for Jacob Wahl's Grocery and later for the Nelson Bros. He helped establish the Langlie Olson and Fladager Co., which in the 1920s was the largest general store in Fillmore County, boasting, "Everything to eat and wear."

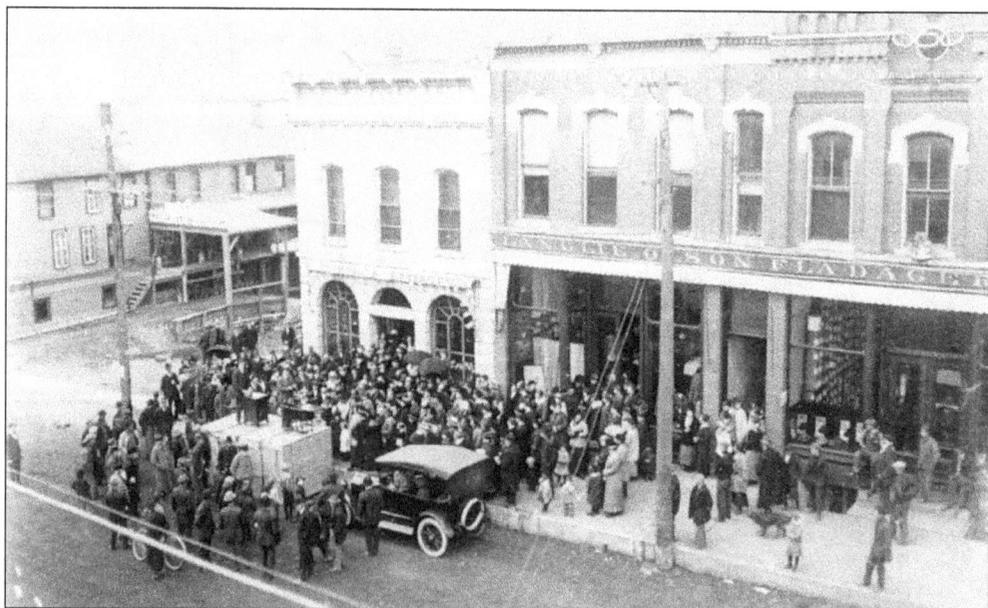

SEWING MACHINE SALE. This photo from April of 1916 shows a crowd gathered for a sale of sewing machines by the Thompson Brothers store on the corner. The two buildings of the Langlie Olson and Fladager Company are at right, and Christ Madson's Ice Cream factory can be seen at left in the background. A 1917 advertisement suggested, "For Up-to-date Goods call on Thompson Bros. Furniture and undertaking."

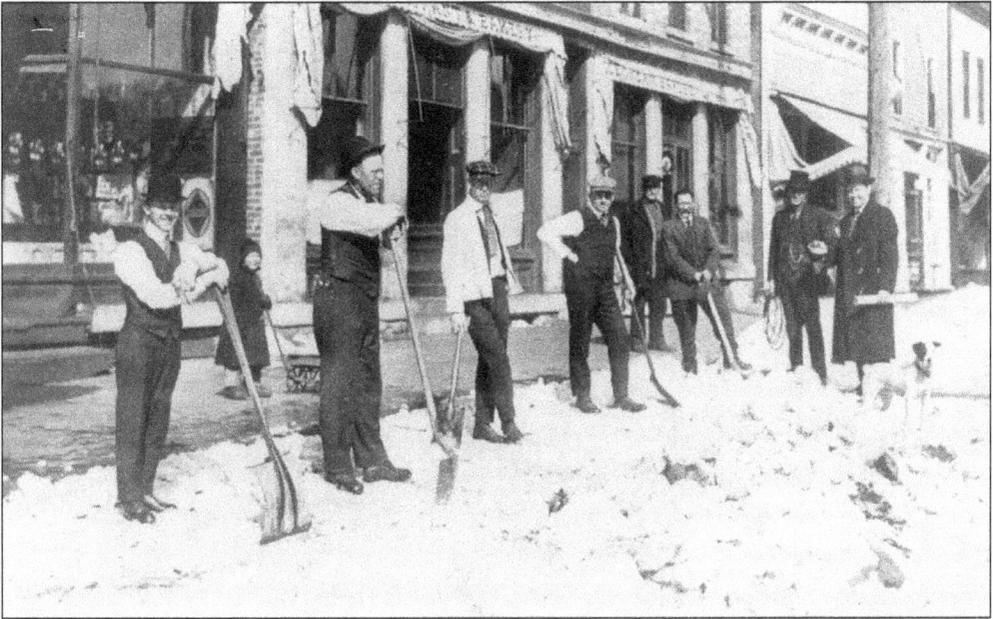

SHOULDER TO SHOULDER. The businessmen of Lanesboro turn out to clear the sidewalks of snow in this photo, c. 1925. The east side of Main Street (now Parkway Avenue) is shown and the legend "Restaurant & Bakery" appears on the closed awning of the second building from left.

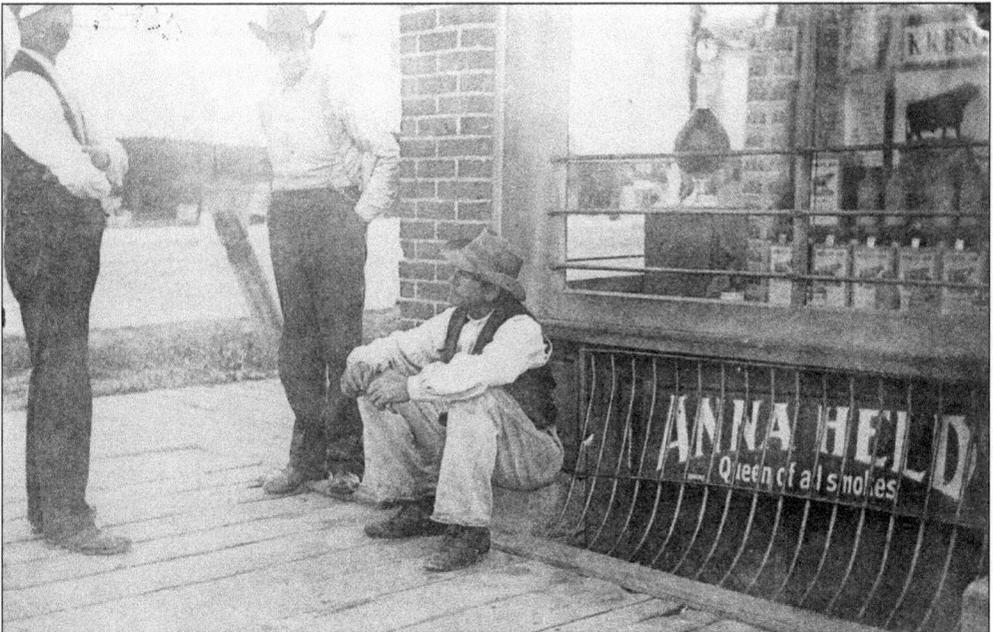

A PLACE ON THE BOARDWALK. From left to right are unidentified, Pat Casey (a street and road worker), and John Anderson (seated). The building is Lamb's Pharmacy on Lanesboro's main street and the boardwalk is typical of the time. The barred grating opens to admit heavy stock into the business's basement storeroom. Lamb's Pharmacy sold a variety of goods from schoolbooks to perfumeries and advertised "prescriptions carefully compounded."

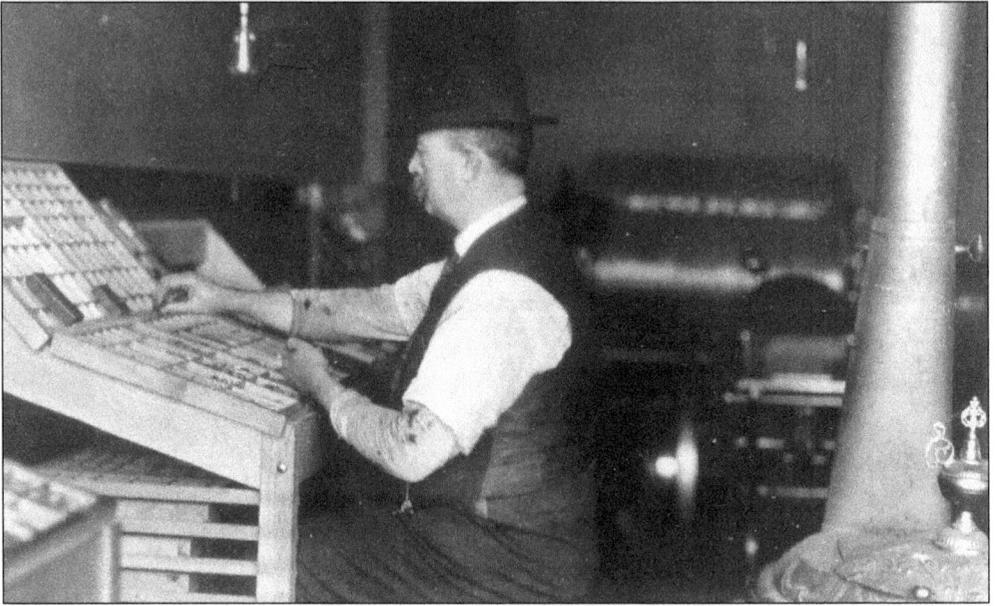

WEEKLY NEWS. Mr. Taylor sets type by hand in Lanesboro's newspaper office in 1914. Ola M. Levange first published the *Lanesboro Leader* on October 1, 1898. The paper, hailed as well edited and politically influential, grew to a circulation of over 22,500 in 1909, when Mr. Levange sold the concern to C.L. Foss. In about 1914, he repurchased the business and changed the name to *Levange's Weekly*.

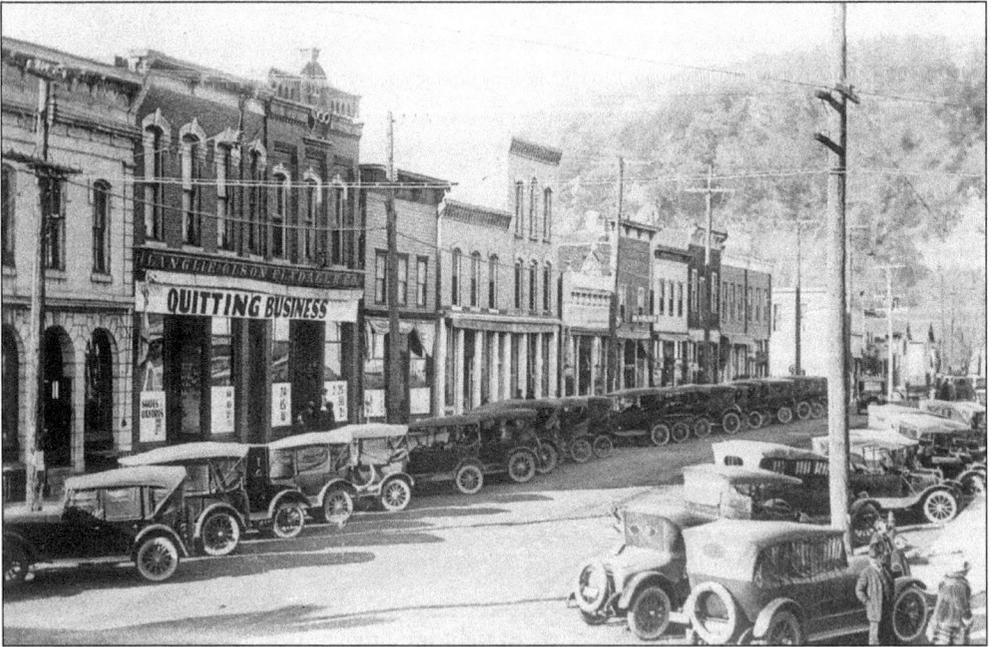

QUITTING BUSINESS. The Langlie, Olson & Fladager Co. advertises their quitting business sale in 1924. The families had been merchants in Lanesboro from its founding and often billed their business as, "Fillmore County's Greatest Store." They contended that, "Every day in the year we can serve your every want promptly and with the least expense to you."

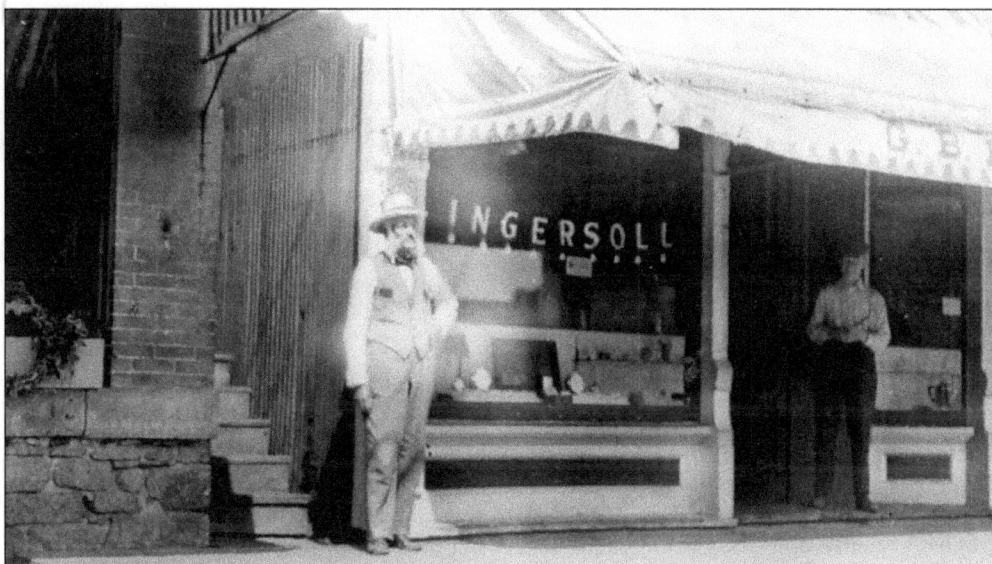

SMALL TOWN JUSTICE. Justice J.G. French stands by the stair to his third-floor courtroom above Lanesboro's Main Street. The large, sparsely furnished room held a plain table, an assortment of chairs, boxes, and benches made from nail kegs and planks. The Justice's own seat was a high-backed rocker. Squire French reportedly conducted all sessions with formality and dignity despite the smallness of his domain, popularly called the "high court."

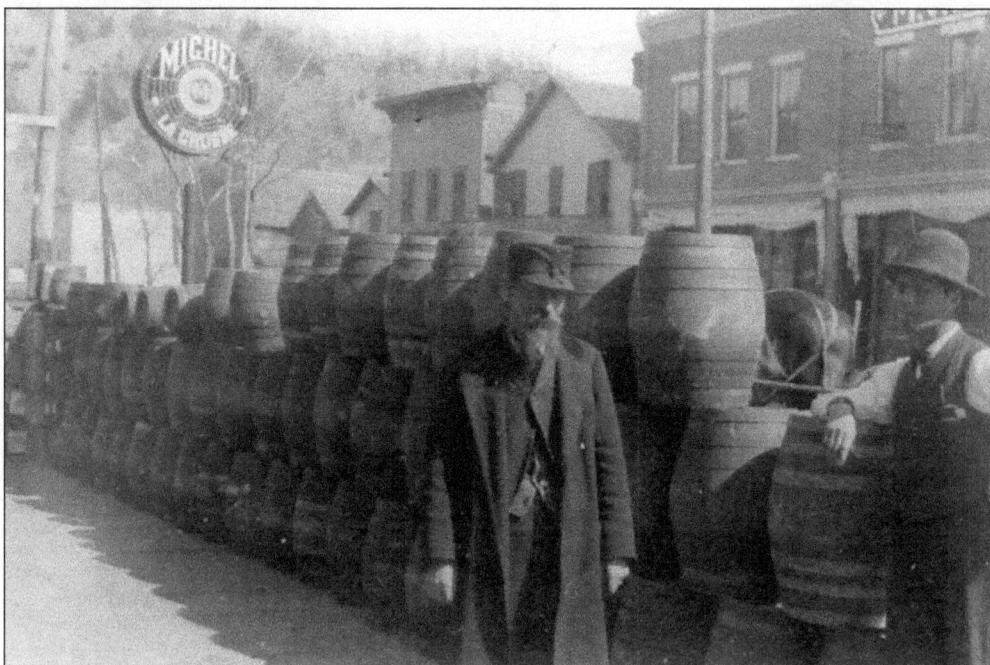

BEER ON THE BOARDWALK. Two unidentified men stand by wooden beer kegs outside a saloon on Main Street, *c.* 1910. In the 1880s, a dozen such saloons operated in Lanesboro, causing the *Lanesboro Leader* to complain, "Saloon license being only $100 induced many to go into this low and degrading business." From 1873 to 1879, the Lanesboro Brewery proudly produced the "best beer ever made in Lanesboro."

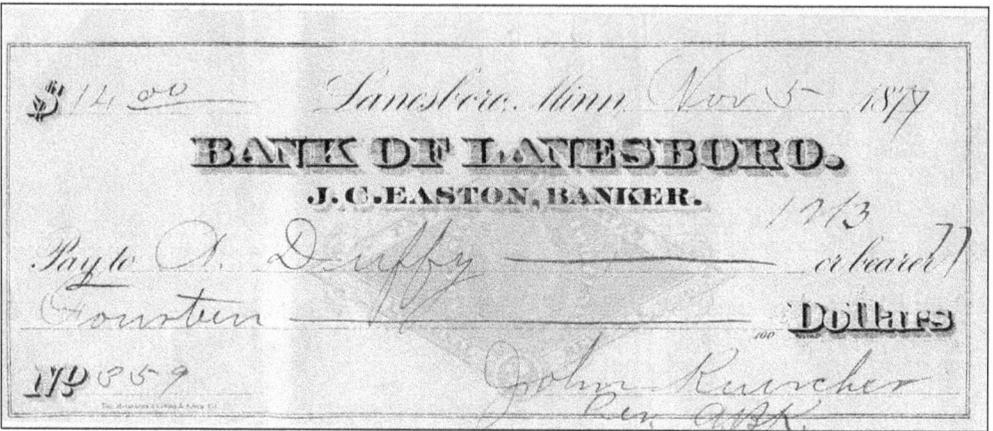

LANESBORO'S FIRST BANK. J.C. Easton established the town's first bank in 1868. Called the Bank of Lanesboro it was originally located in a wood frame building on the north side of what is now Coffee Street. In 1870 the bank was reestablished in a corner of the Phoenix Hotel. Michael Scanlan and O.G. Wall bought out Easton in 1880, continuing the bank in the same location until 1885.

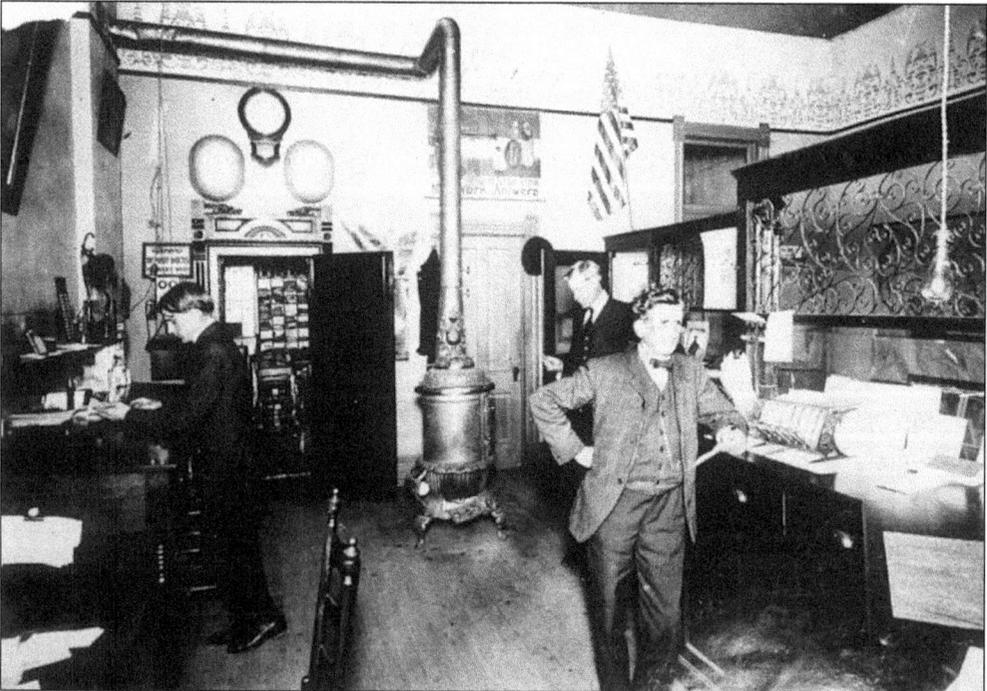

BANK INTERIOR, 1910. The Farmers & Merchants Bank of Lanesboro was started by brothers Sam and Peter Nelson. Located in the Galligan Building, the business was sold in 1913 to John T. Ask who incorporated it as The First National Bank of Lanesboro and relocated to the southwest corner of what are now Parkway Avenue and Coffee Street. From left to right are Bill Hanson, unidentified man, and Sam Nelson (in foreground).

58

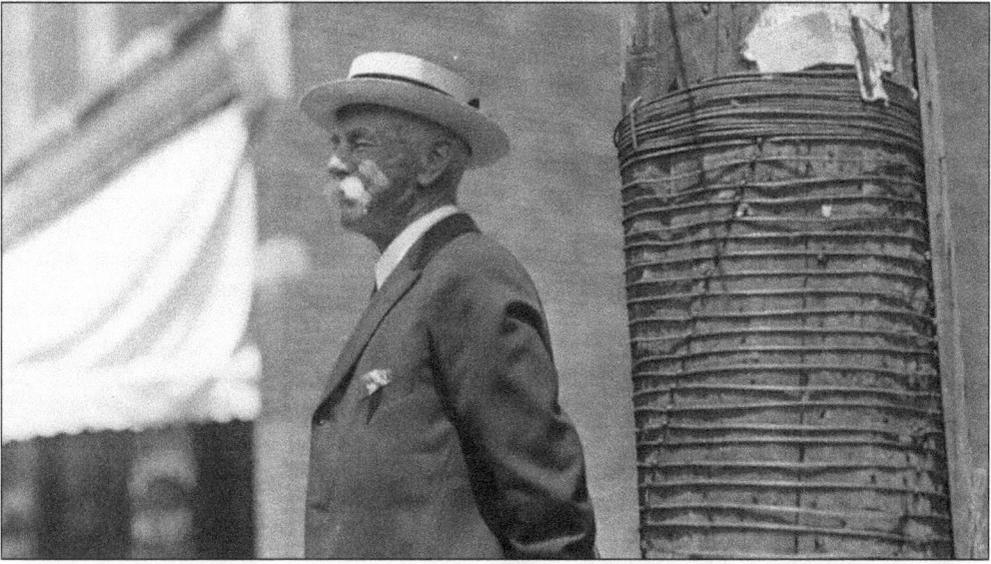

MICHAEL SCANLAN, 1914. An Irish immigrant, Mike Scanlan homesteaded land later purchased for the Lanesboro town site, after which he opened a hardware store, followed by a general merchandise concern. In 1880 he assumed ownership of the Bank of Lanesboro with O.G. Wall as partner. In 1897 the bank's name changed to the Lanesboro State Bank and in 1907 it became the Scanlan-Habberstad Bank. Mike Scanlan was the consistent element throughout.

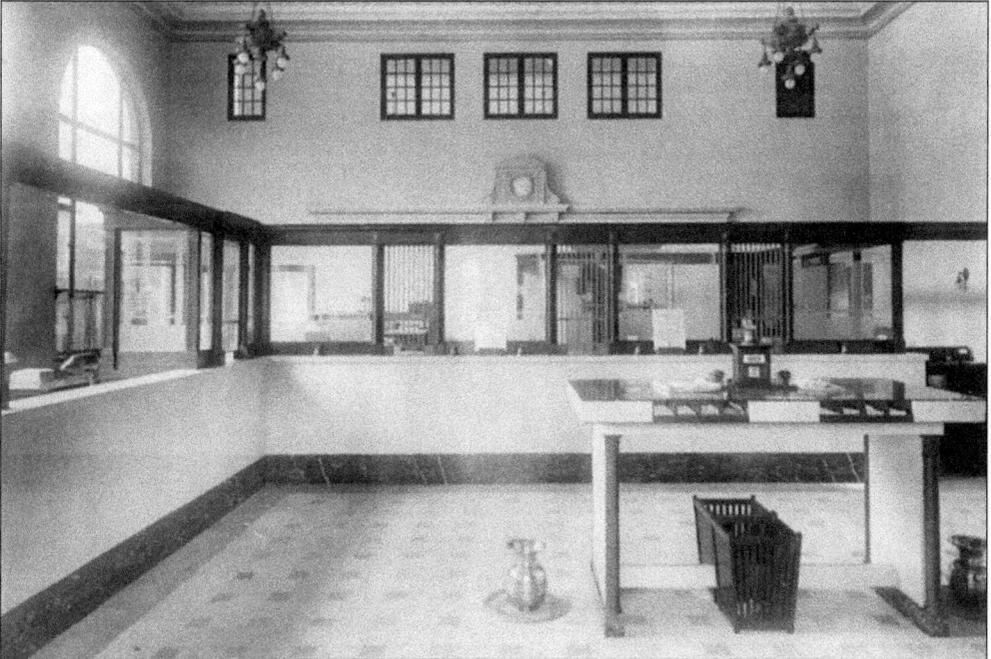

SCANLAN-HABBERSTAD BANK. Interior of the new Scanlan-Habberstad Bank is pictured in the mid-1920s. Bank president Michael Scanlan had a well-deserved reputation for honesty. In 1895, when the N.W. Guarantee Loan Company of Minneapolis defrauded a number of small banks by issuing fictitious paper, the Lanesboro bank lost $20,000. Scanlan personally assumed all liabilities eventually paying back every depositor in full. Note the two spittoons in this "modern" bank.

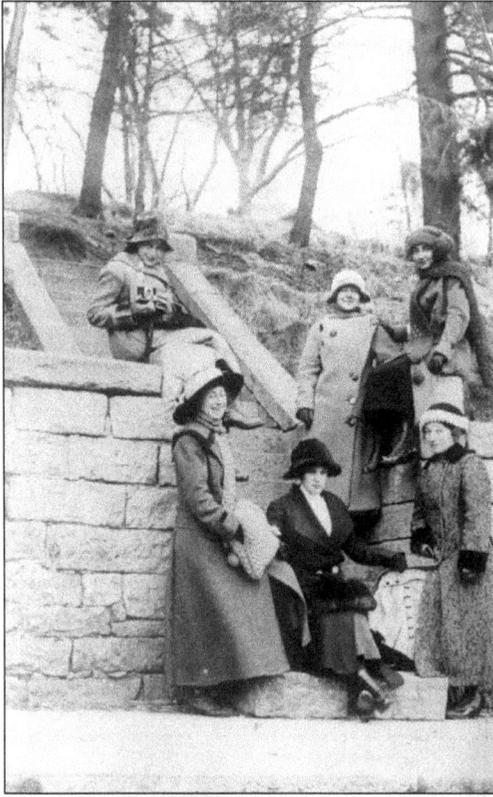

LANESBORO'S NEW WOMEN. Posing, c. 1900, these unidentified young ladies are on the stone steps leading to the home of R.R. Greer on the east side of what is now Parkway Avenue. At the turn of the century "new woman" was the term used to describe a generation of women who were more self-confident and independently minded. Still, two decades would pass before these women gained the vote.

THE LANESBORO LEADER. Editor Ola M. Levang pursued the newspaper business elsewhere before coming to Lanesboro and issuing the first *Lanesboro Leader* in 1898. "During the years Mr. Levang published this newspaper it was regarded generally as one of the most ably edited newspapers in the First Congressional District." Mr. Levang, pictured at right, c. 1904, had some 40 years of involvement with Lanesboro newspapers.

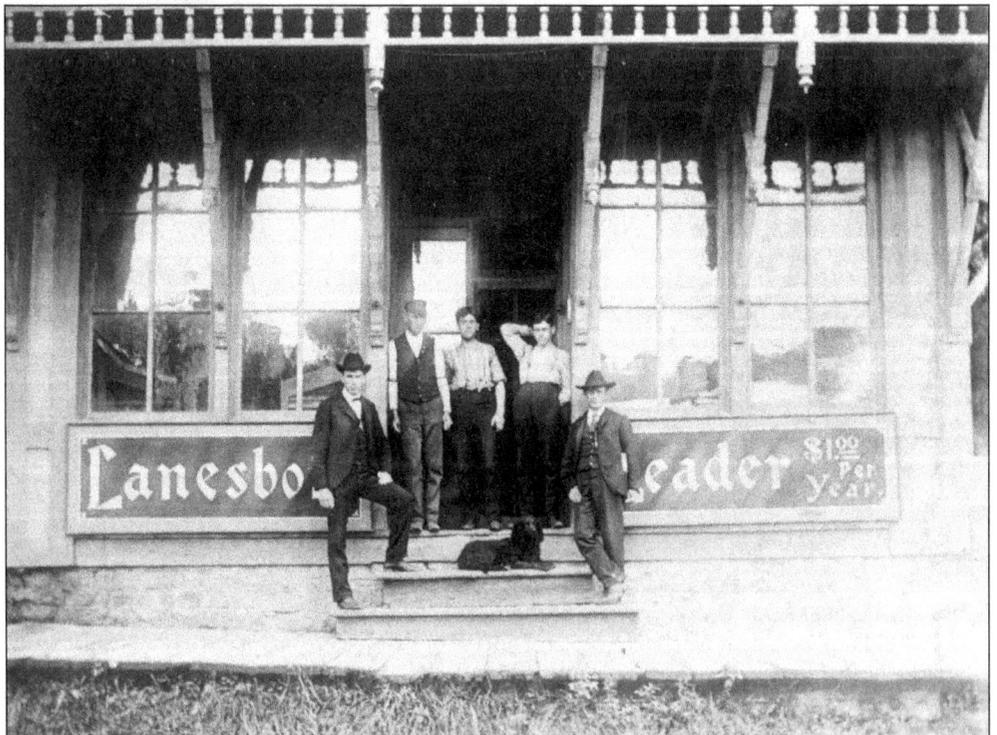

WOMANLESS WEDDING. Olaf Thompson and Howard Shattuck play the parts of "tough old bird" and "hen pecked husband," respectively, in this 1927 photo. Womanless Wedding plays were a popular entertainment of the time, enlisting good-humored local businessmen for the town's amusement. This play was held in the school gymnasium on Church Hill.

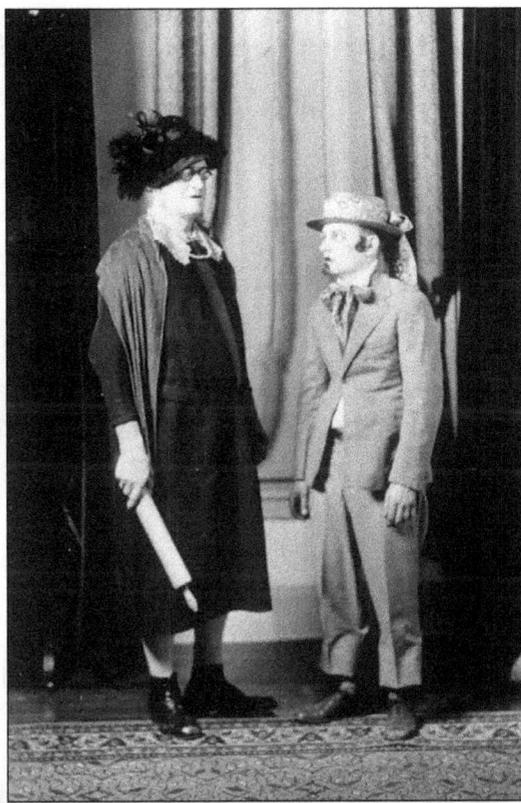

PACKING BARREL. Three unidentified young men retrieve wares from a large packing barrel in an alley behind Lanesboro's business district about 1910. General stores carried a wide array of merchandise for a population without access to big city markets. Travel to other towns was limited to train, carriage, or the new and rare automobile, the latter being likely the least desirable and reliable of the three.

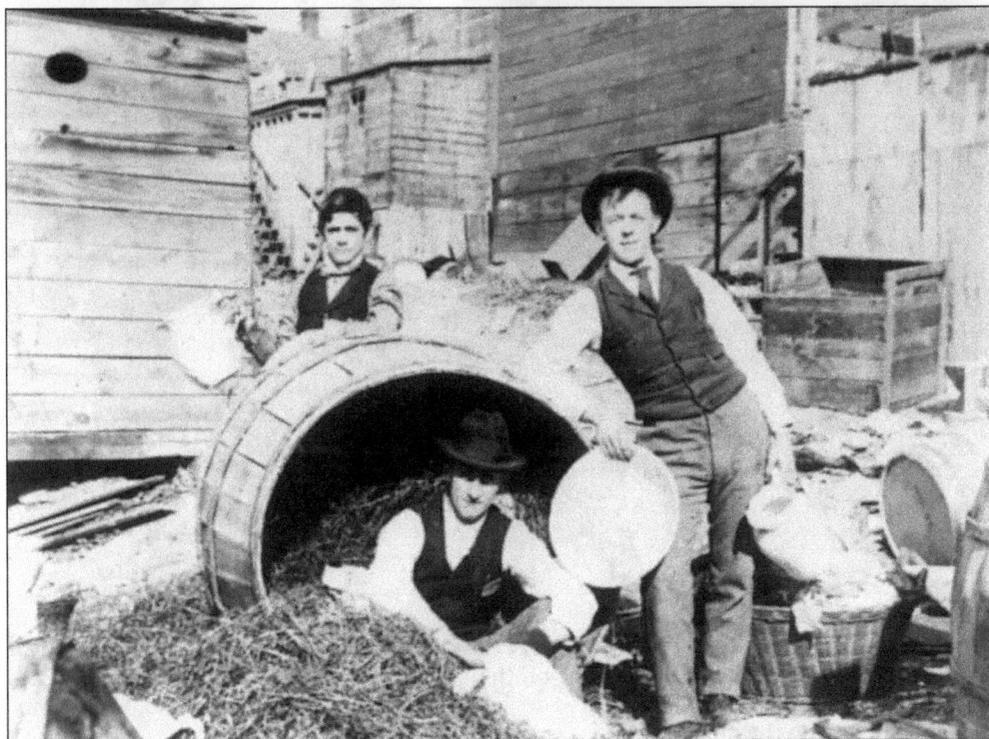

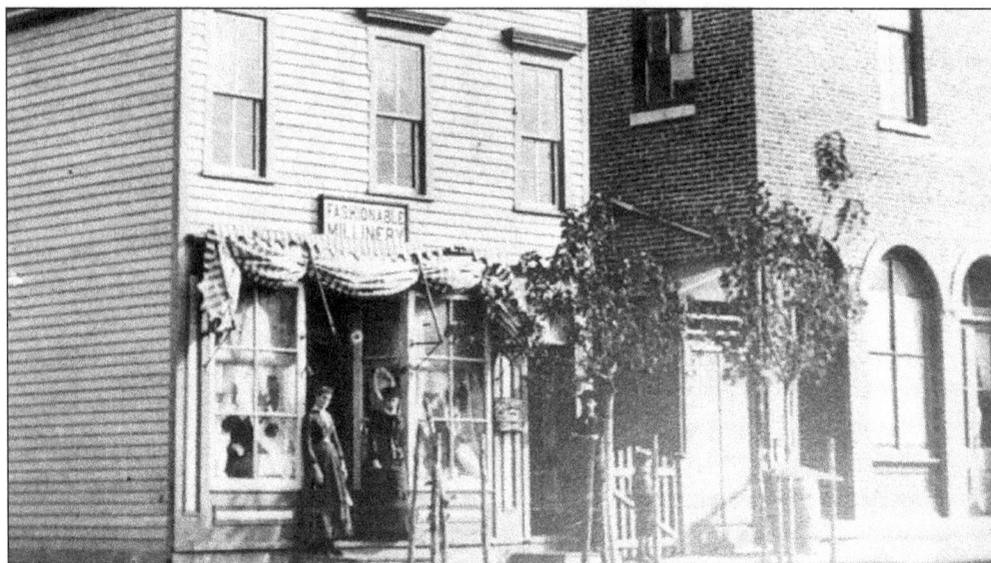

FASHIONABLE MILLINERY. Two women adorn the doorway of Lanesboro's Fashionable Millinery shop c. 1880. In the days before "off-the-rack" fashions, millinery was a widespread and important business. It was also one of the few business avenues open to women. Mrs. Hall, Miss Inglebritson, Mrs. G.H. Nepstad, and Mrs. Henrietta Henry were among the women who operated millinery shops in Lanesboro over the years.

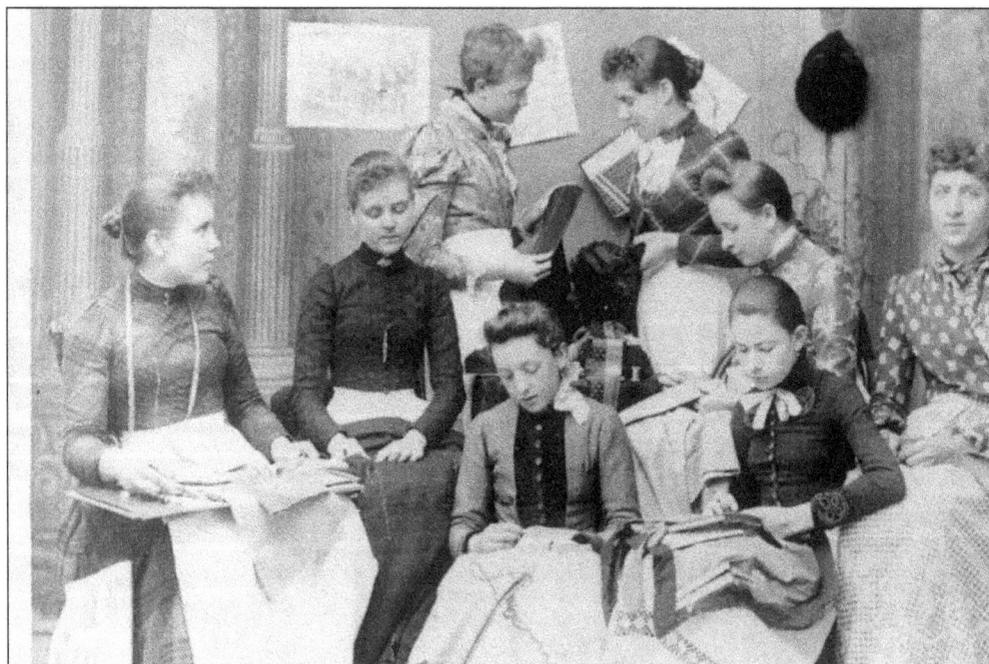

DRESS MAKING CLASS. These unidentified young women are embarked on learning the skills of dressmaking from Mrs. Henrietta Henry. Mrs. Henry conducted a millinery business and taught seamstress classes from the stone building on the west end of Slant Avenue for over 40 years. Said to be "a hard task-master but talented designer," Mrs. Henry and her husband, W.S. Henry, made their home in the same building.

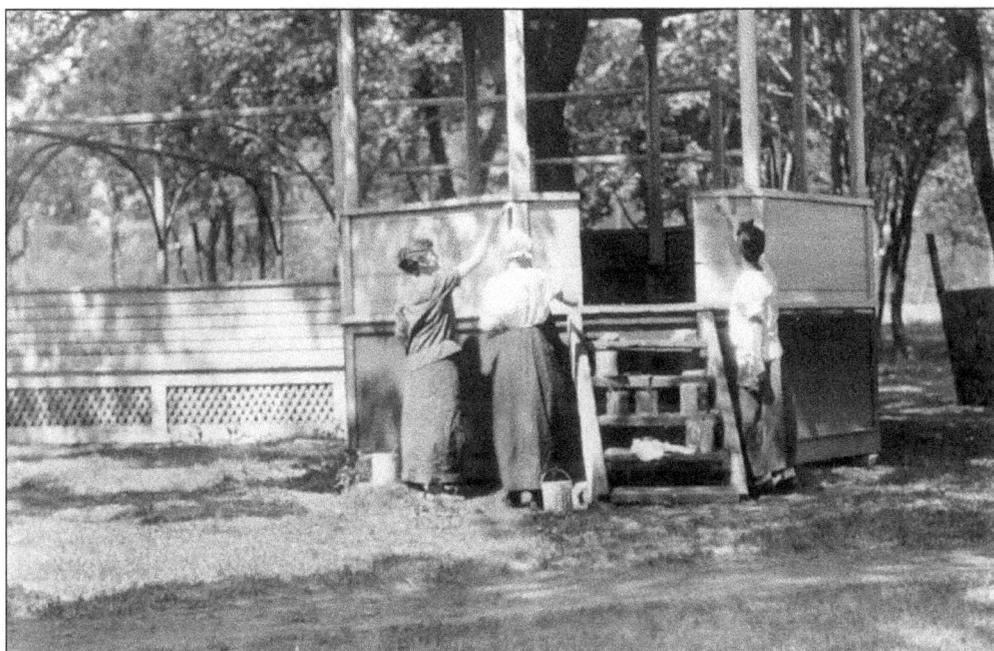

PAINTING THE GAZEBO. Ever active in the town's workforce, the women of Lanesboro contributed energy and vision to help shape a civilized community from the rough expanse of frontier. This picture, c. 1905, shows three unidentified women painting the gazebo in Lanesboro's Sylvan Park.

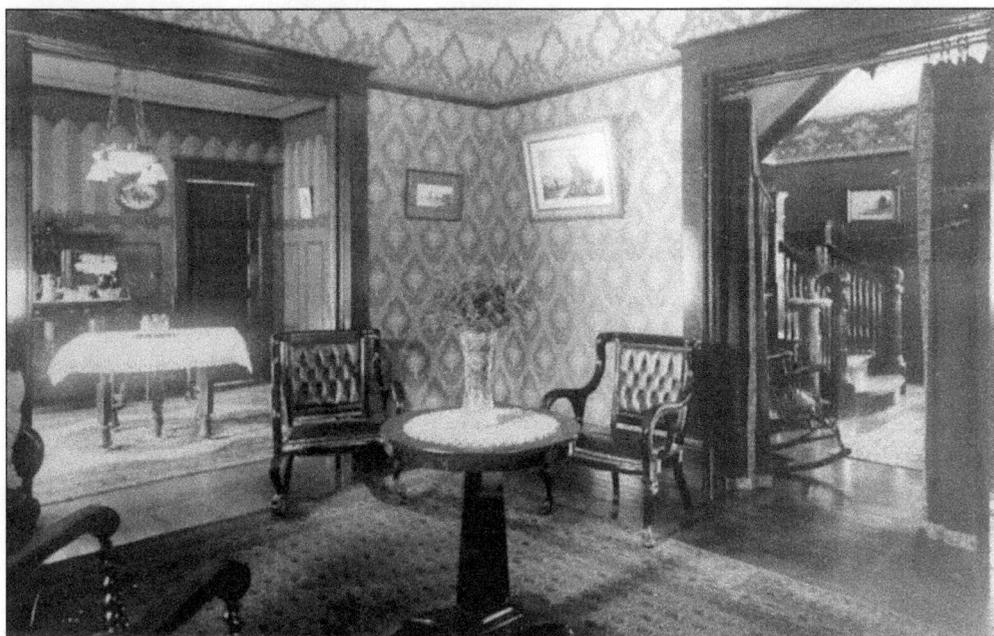

REFINED HOME LIVING. This photo of the Dr. A.P. Lommen home in Lanesboro's Brooklyn neighborhood in 1915 offers a good example of the fine homes built there. By some reports, the first house raised in Brooklyn was by Mr. Christopherson in 1874. The second belonged to Dr. Redmond, and the third home to appear in Brooklyn was constructed by Frank Freemire.

IN ROUTE TO THE POST OFFICE, 1914. Gilbert B. Ellestad came to Lanesboro in January of 1890 at the age of 29 for the purpose of opening a jewelry store. Ellestad had recently completed training in the jeweler's trade in Chicago. His first business was in a rented space but Lanesboro agreed with the enterprising jeweler and he prospered, establishing himself in his own building on Main Street in 1897.

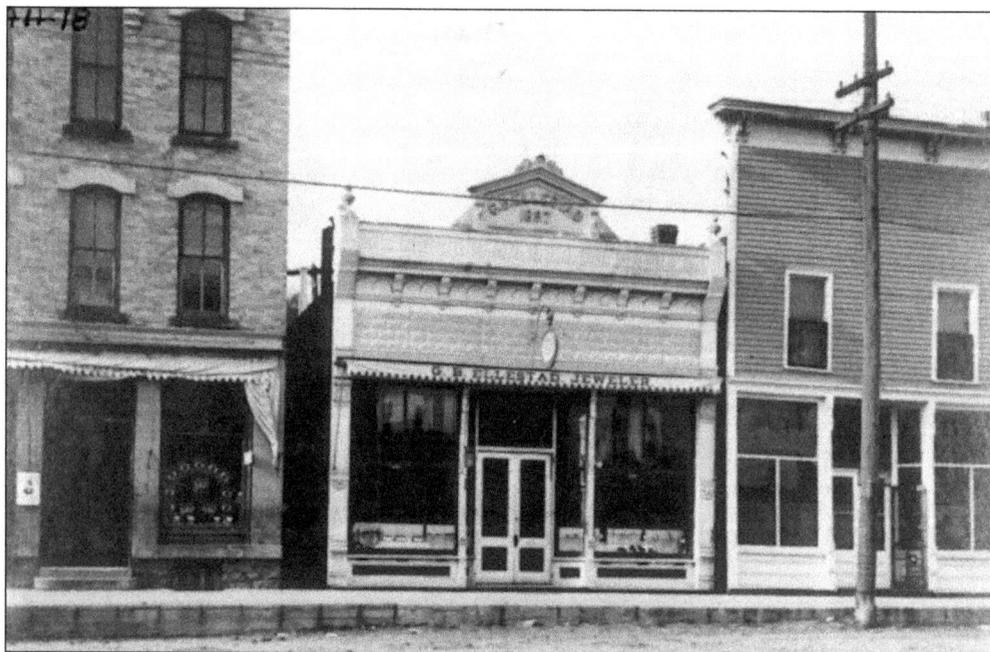

G.B. ELLESTAD JEWELRY STORE. Mr. Ellestad was fascinated by electrical applications and applied himself to each new technology that emerged. His store (center) was equipped with a hand-built telephone and private line to his home in Brooklyn as early as 1898, as well as electric lights and burglar alarms. The buildings pictured are still a part of Lanesboro's main business district today.

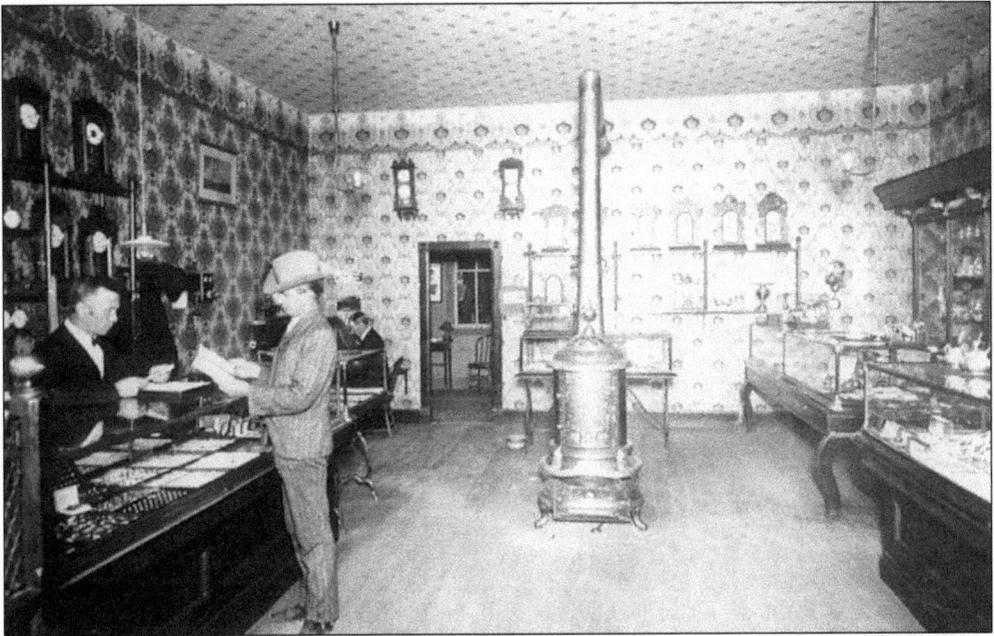

JEWELRY STORE INTERIOR, 1900. Conducting business in Lanesboro for over 30 years, G.B. Ellestad advertised, "Good, reliable time keepers in nickel cases at $4–$10," and a "Large assortment of chains, charms, lockets, silverware, spectacles, etc." Customers were assured that "all goods are guaranteed to be just as we represent them to be." Pictured, from left to right, are G.B Ellestad, Martin Sather, and J.O. Bleckre (in background).

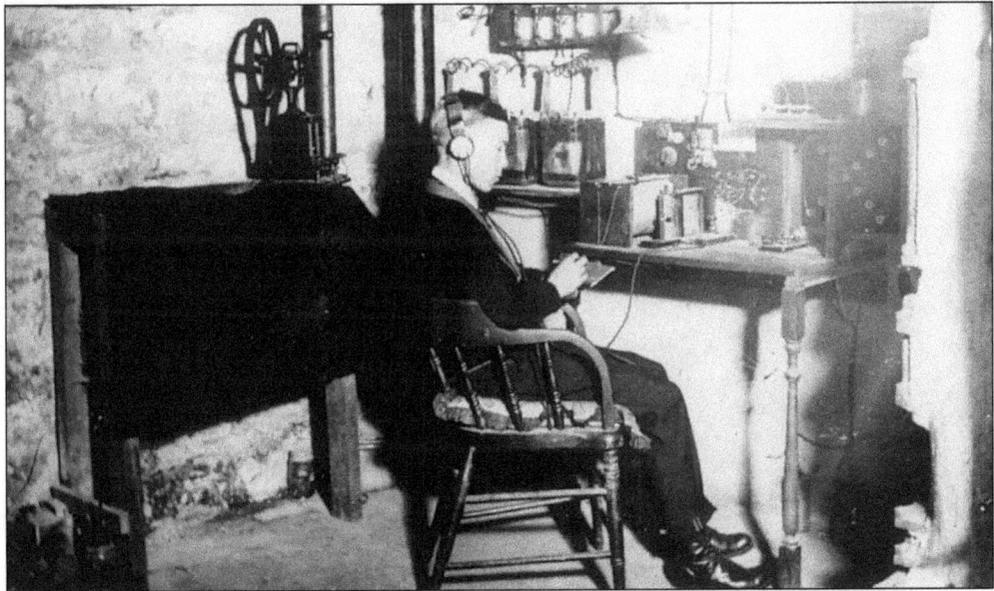

FOLLOWING AFTER FATHER. Irving Ellestad is pictured at a homemade wireless station built by he and brother Gerhard in the basement of their parents' home. The boys constructed Lanesboro's first primitive wireless in 1909. They improved this complete sending and receiving station one year later. The companion station was in the Ellestad store a half-mile distant. All but the key and headphones were homemade.

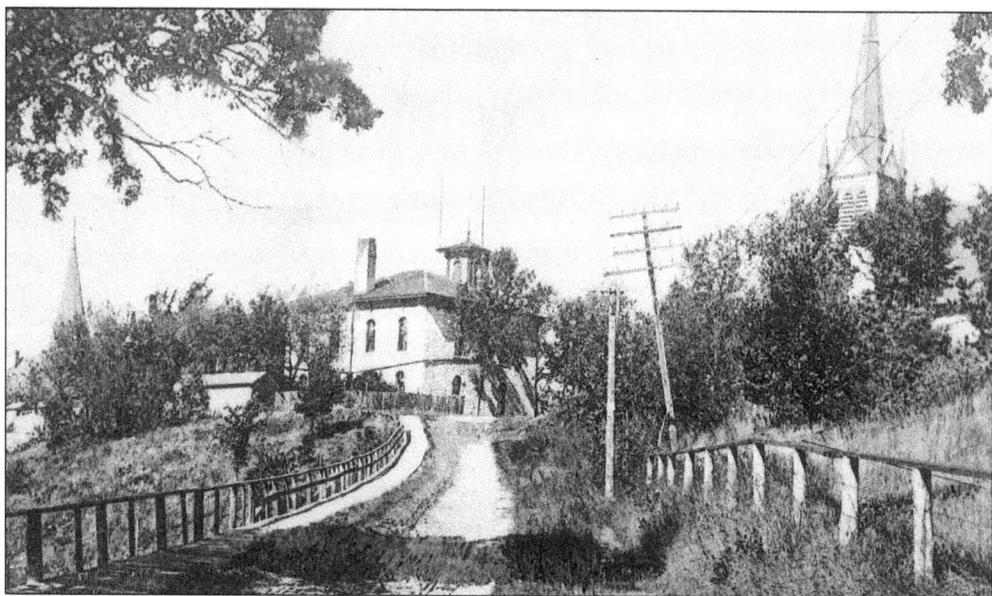

OLD STONE SCHOOL. Built atop Church Hill in 1870, the Stone School was meant to accommodate the growing number of students in the new town. The 111 pupils had overburdened earlier classrooms. Prior to its construction, classes had been held in Dunsmore's Hall (1868–1869), Duschee's Hall over Jacob Wahl's business (1869–1870), and finally the Methodist-Episcopal Chapel in the spring of 1870. Mrs. Dan Thompson was the first teacher in Lanesboro.

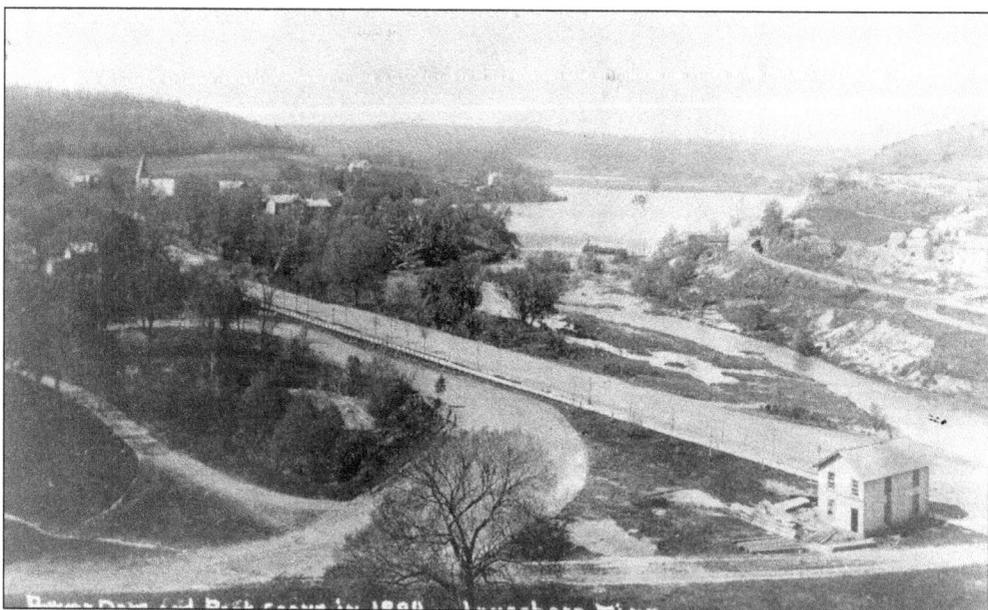

PARK SCHOOL HOUSE. In November of 1882, Lanesboro's school enrollment jumped from 196 to a seam-bursting 219, forcing the acquisition of additional classroom space. A two-story wood structure located at the edge of Sylvan Park was dedicated to primary education with Miss E.T. Campbell as its first teacher. Classes were later expanded into the second story of the Park School House, which operated until 1891.

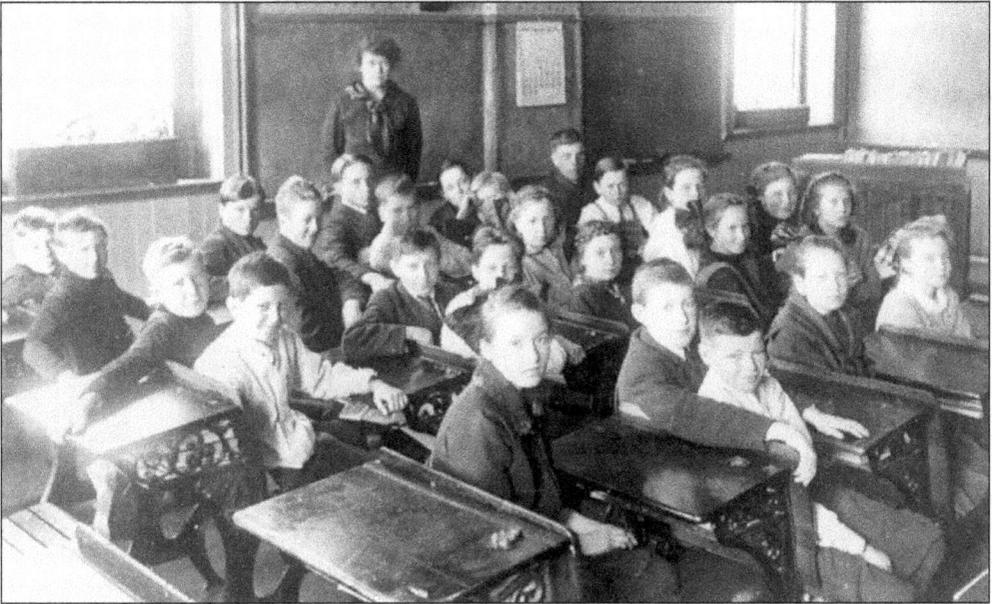

YOUNG AMERICA. A primary school class and teacher take a break from their studies in this photo. In early years, a majority of Lanesboro's residents were immigrants. Norway and Ireland supplied the greatest number, but there were representatives of many other places and languages in the little valley. Students ranged in age from 9 to 23, and a main task of early teachers was instruction in the English language.

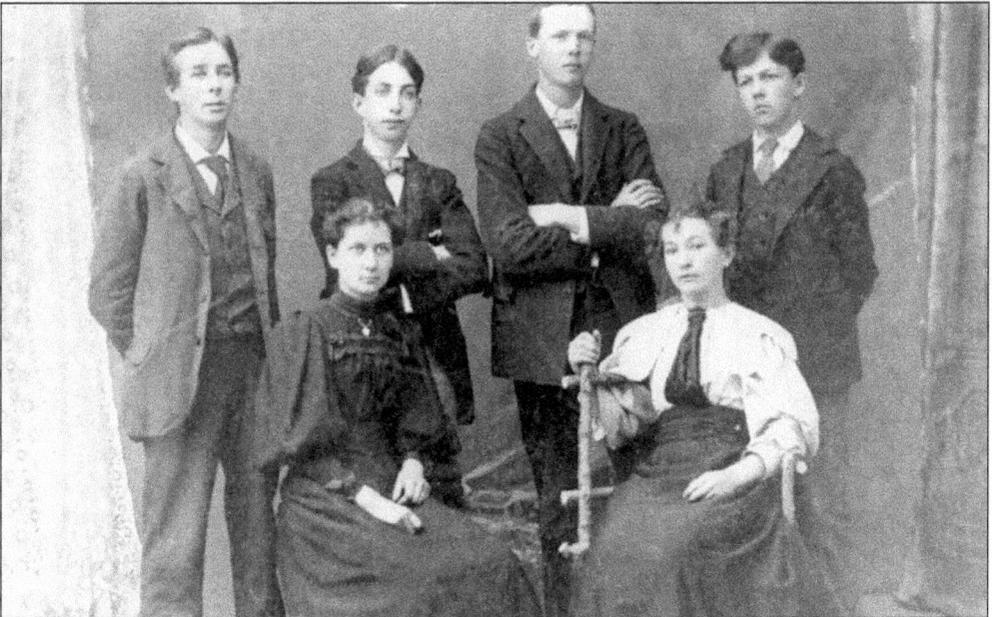

CLASS OF 1896. In 1878 the State High School Board, through examination, certified the Lanesboro Graded School as a State High School. The first class to apply for graduation was in 1880 and consisted of Kittie Hall, Linda Gilbert, and Nellie Hobart. Pictured is the LHS class of 1896, from left to right: (seated) Louise E. Johnson, and Matilda C. Helland; (standing) Irwin W. Harsh, Harton Thompson, Henry H. Wilbery, and Henry A. Allen.

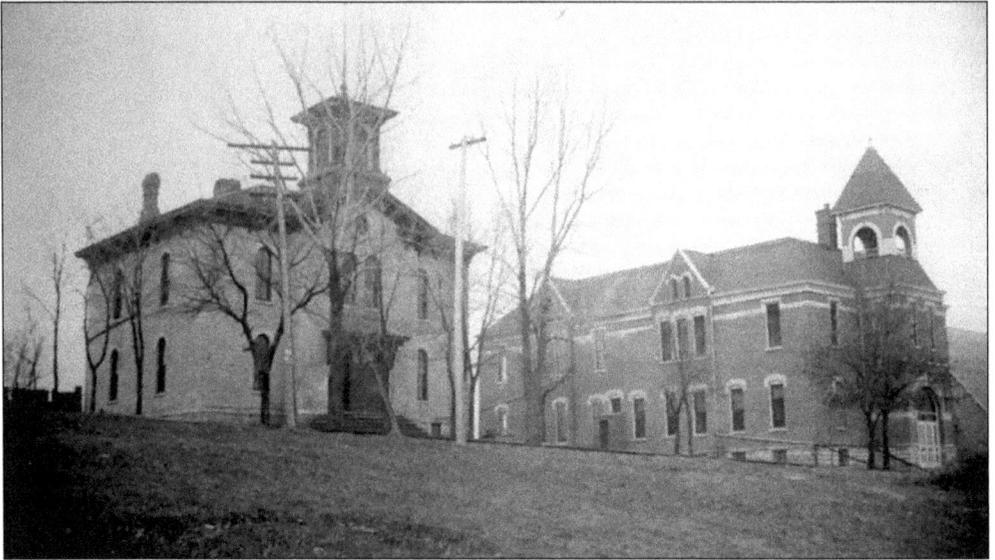

SCHOOLS ATOP CHURCH HILL. The Old Stone School is seen at left with the Lanesboro High School building at right, *c.* 1910. The brick high school building was completed mid-way through the 1891–1892 school year and consisted of four classrooms. It was improved and doubled in size in 1903 and again expanded in 1912. Both of these fine schools were destroyed by fire on the night of February 23, 1917.

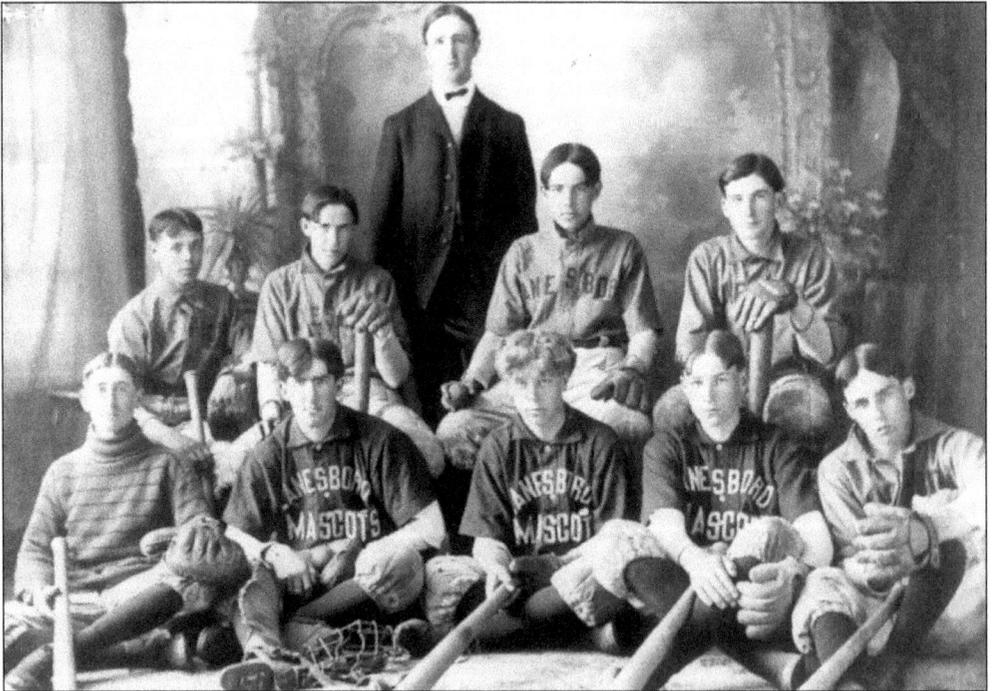

THE LANESBORO MASCOTS. Near the turn of the century, baseball was an American sensation with not only school, but also town teams playing before enthusiastic fans. Pictured here are the Lanesboro High School baseball team, known as the Mascots, *c.* 1905. All players and coach are unidentified.

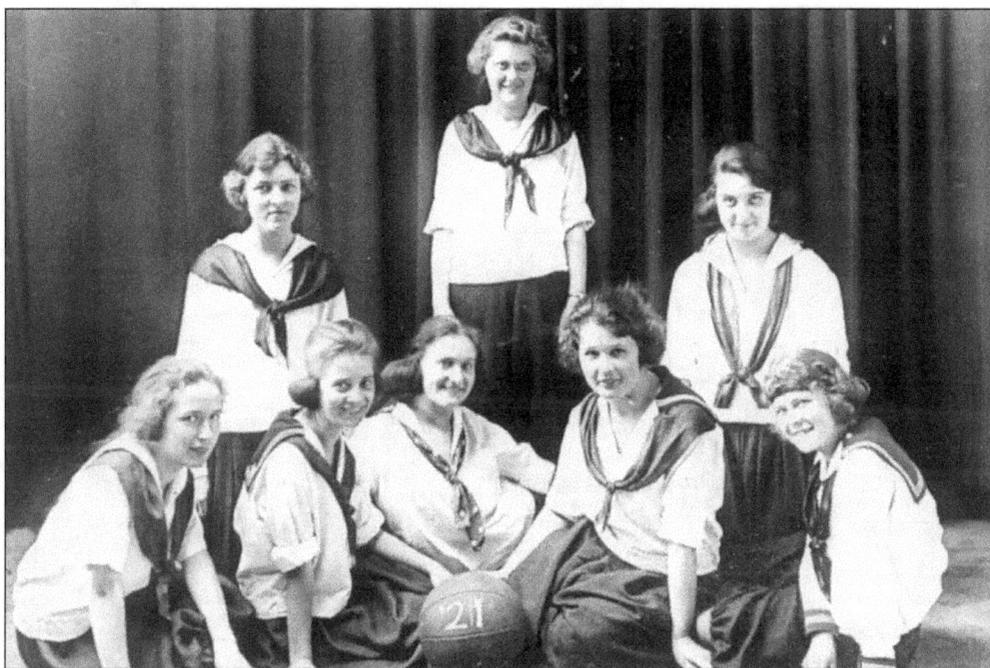

GIRLS BASKETBALL, C. 1921. Basketball was invented in America in 1891 and soon became a major high school and college sport. The members of this Lanesboro Basketball Team from 1921 are, from left to right: (front row) Margaret Horihan, Sadie Bartlett, Louise Semon, Clare Ferden, and Esther Moen; (back row) Alice Stromme, Elmira Boyum, and Josephine Wood.

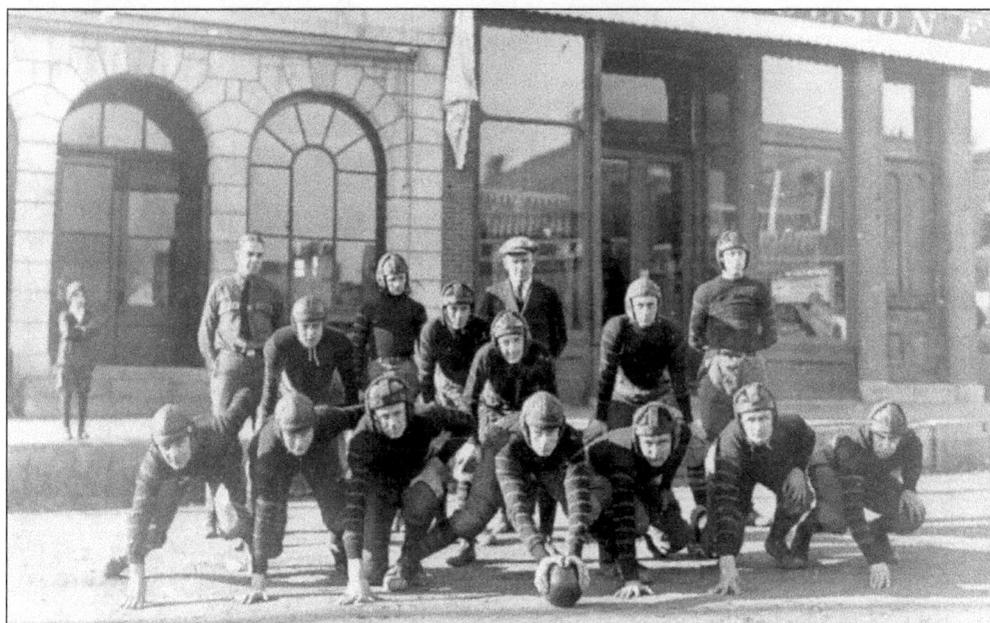

FOOTBALL ON MAIN. Early in the last century, just as today, school sports were hailed as physically and mentally healthy and important for instilling a sense of teamwork and other positive character traits. This Lanesboro High School football team, pictured on Main Street in 1921, was unbeaten in Minnesota both that year and the next. Their coach was J.H. "Duffy" Lewis.

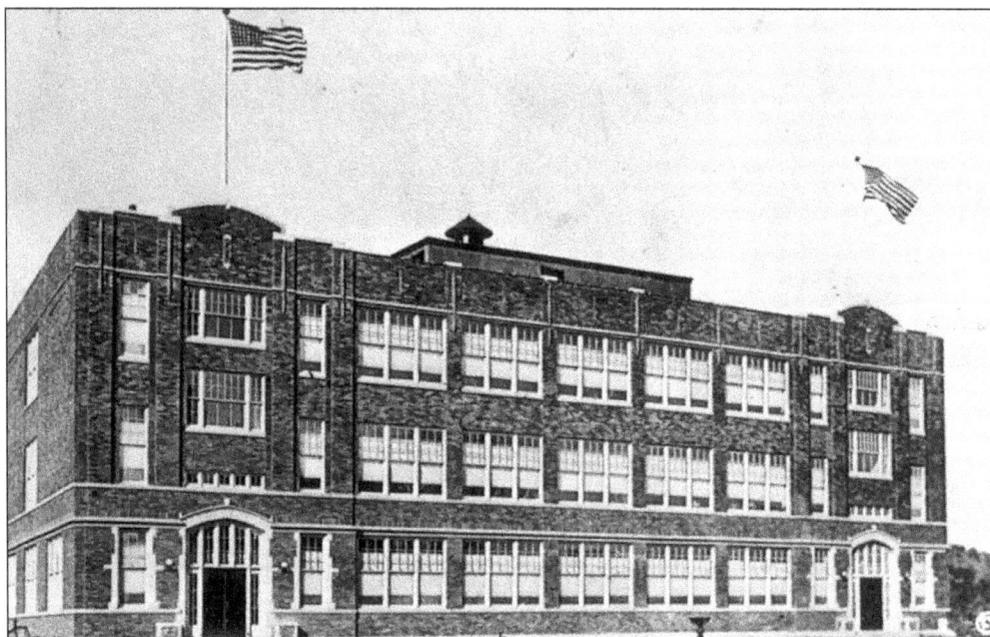

LANESBORO PUBLIC SCHOOLS. This new building, housing both primary and high school classes, was constructed on the site of the school buildings destroyed in 1917. On August 5, 1919, another fire struck at Lanesboro's educational center destroying the top floor of the new building. Photographer Matt Bue likely reflected the general dismay of citizens when he entitled his photo from that night: "Fire Fiend's Return Engagement At Lanesboro."

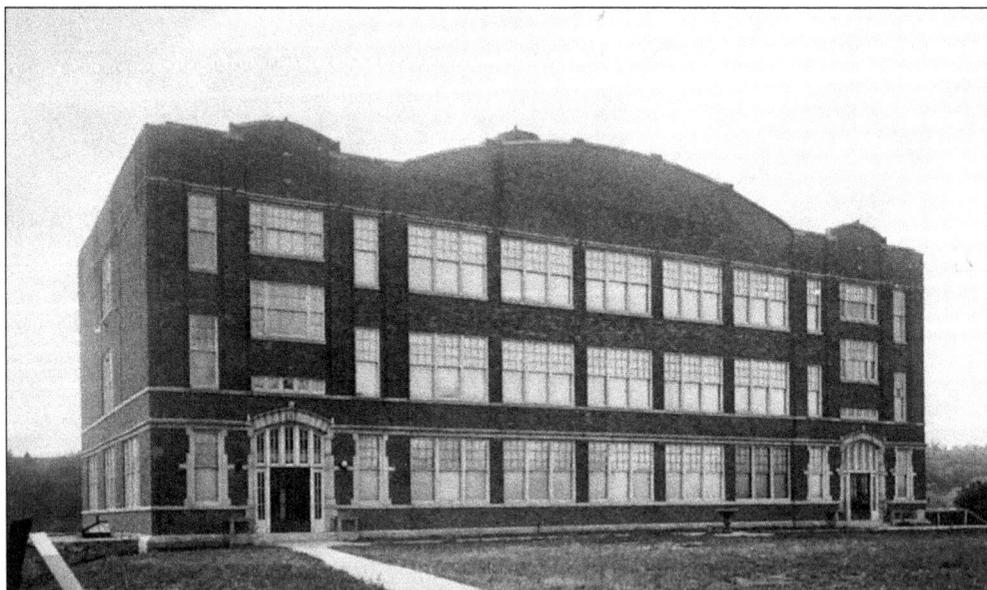

REBUILT SCHOOL. Rebuilt in 1919 following the third floor fire, the Lanesboro Public School building continued as Lanesboro's only school until the addition of students from the consolidation of the country schools into Lanesboro necessitated the construction of a new high school in Brooklyn in 1960. From 1960 to 1990, this hilltop school served grades K–6. The elementary classes were then consolidated into the remodeled and expanded Brooklyn school.

Six

TEAMS, TRAINS, AND AUTOMOBILES

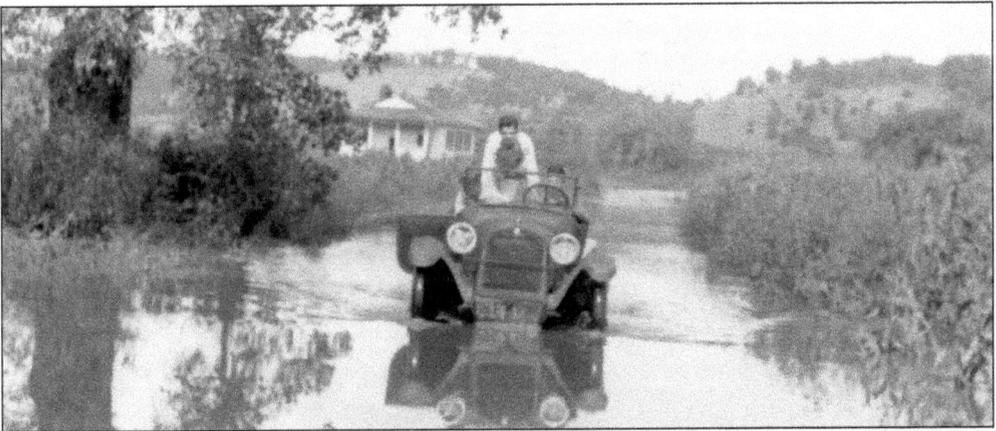

The modes of transportation available to a community hold vast influence over the type and scope of growth achieved. In 1882 it was observed that, "It was a grand epoch in the history of this locality when the iron horse woke the silence of the surrounding heights with the echoes of its shrill whistle. It gave the car of progress such a forward movement that certain success and measurable prosperity could be predicted for the young and growing town." A huge celebration was thrown in December of 1868, when the Southern Minnesota Railroad completed its line into Lanesboro. The hallmark of progress and prosperity, the railroad promised rapid transportation of people and goods. Eventually, multiple trains passed through the town each day, year round.

Before the railroad made its way to this chosen spot in the Root River Valley, it was by horse and oxen teams that the first lumber and the first people were conveyed to Lanesboro. Such teams also carried farm crops to the Mississippi for transport to distant markets. Even after the advent of the railroad, horsepower remained essential to the community's life for several more decades.

The development of more and more sophisticated and reliable automobiles and motorized farm implements eventually replaced both the railroad and the horse. One of several transportation revolutions in the 20th century, the rise of the automobile affected nearly every aspect of business and social life in Lanesboro and around the country.

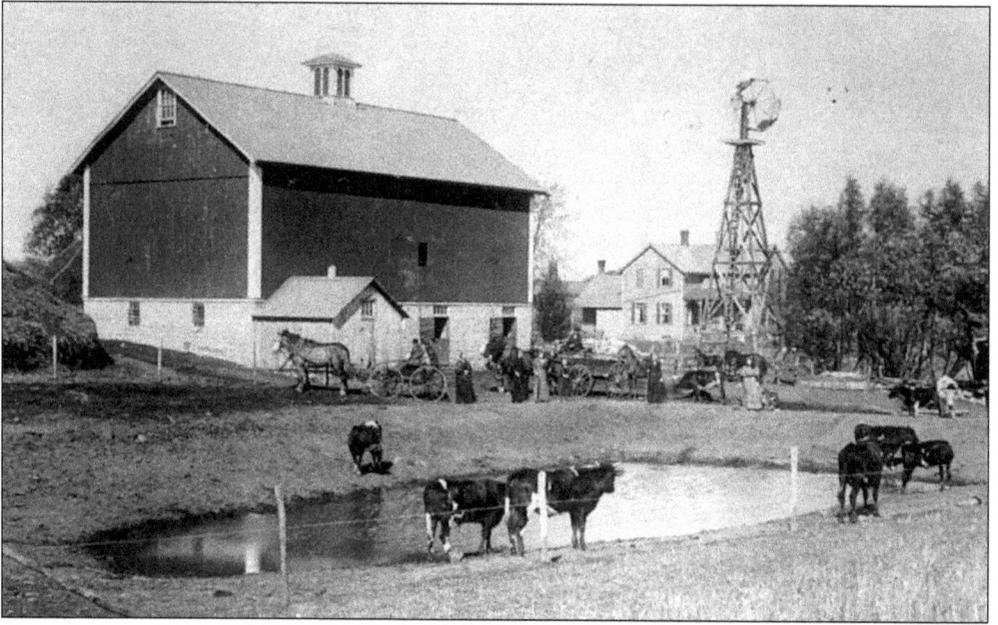

Two Teams, Seven Horses. Two horse teams are seen in this photo of the Victor Flattum farm taken Southeast of Lanesboro, *c.* 1900. Three other horses are also visible. Buggies and wagons were essential for transport and the working of the farms. The number of horses required meant steady business for tradesmen such as harness makers and blacksmiths, and retailers with horse-related products.

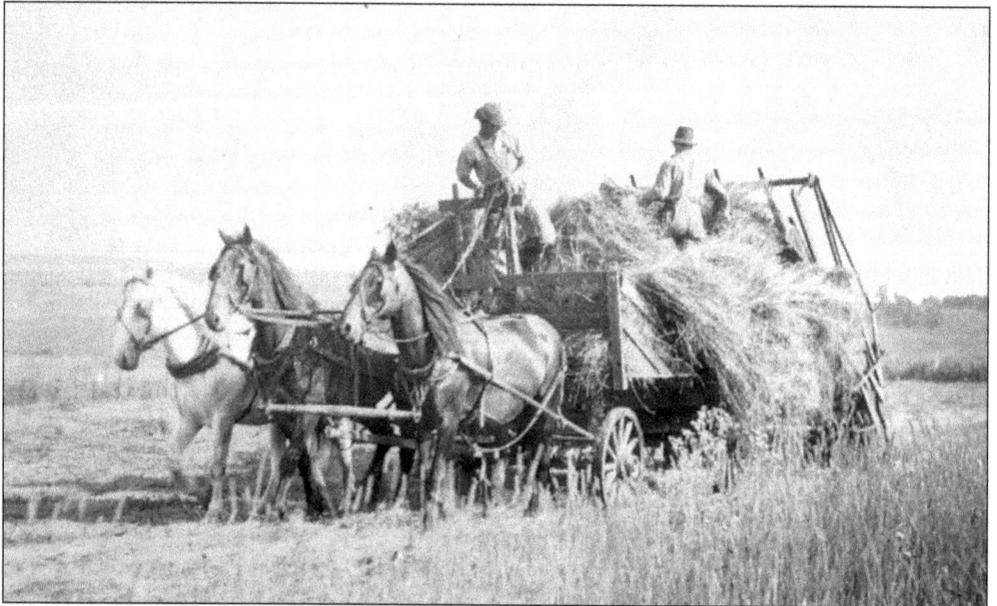

Triple Horse Team. Three horses provide pull for this bottomless hay loader on the M.O. Blogsvedt farm south of Lanesboro in 1912. Henry Knutson (left) and Oscar Knutson (right) are pictured. The same year, the Waterloo Gas Engine Company produced the first Waterloo Boy Model N tractors, selling a total of 118. Other companies were also producing gas tractors, but steam engines and horse teams were still far more prevalent.

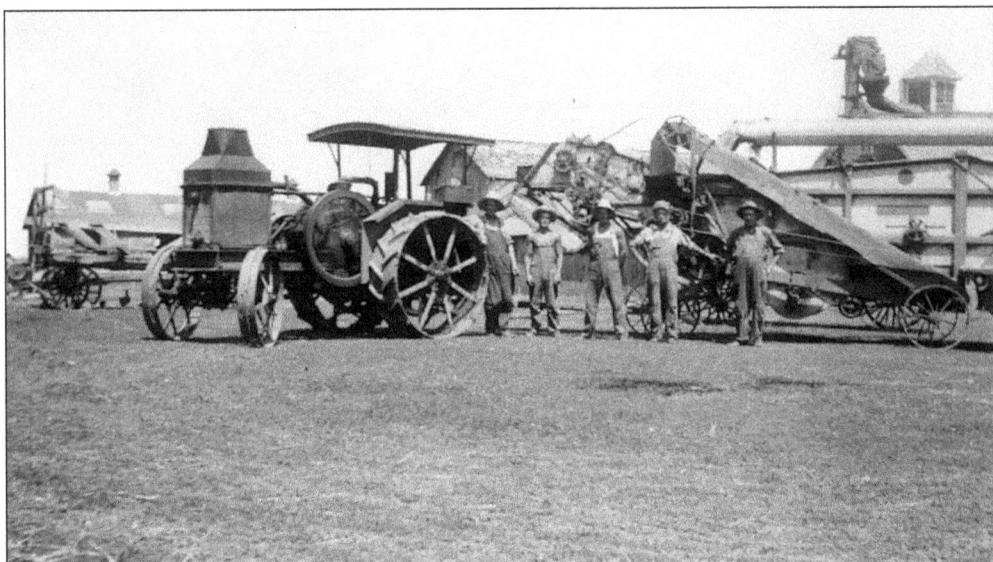

THRESHING CREW AND EQUIPMENT. Taken by Lanesboro photographer Matt Bue at his brother Hans' farm north of Lanesboro, this photograph shows a grand example of an early steam engine and threshing machine. Despite the impressive machinery, the horse and harness was still of utmost importance in accomplishing the general work of the farm. The man second from left is Odell Bue; all others are unidentified.

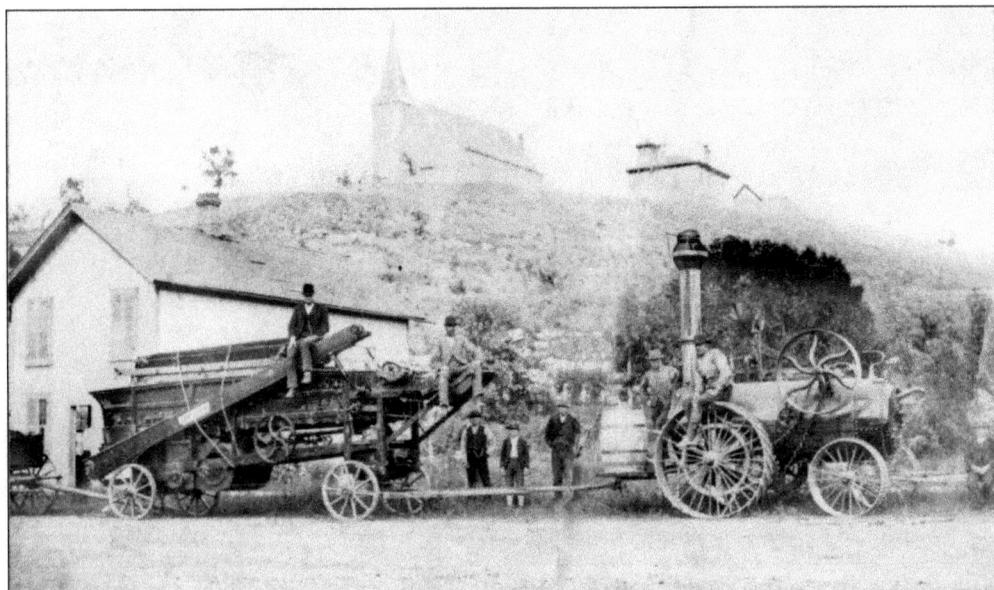

THE THRESHER COMES TO TOWN. An early threshing machine and horse drawn steam engine sit in front of the Park School House in Lanesboro. The Old Stone School and both churches appear on Church Hill in the background of this photo, c. 1890.

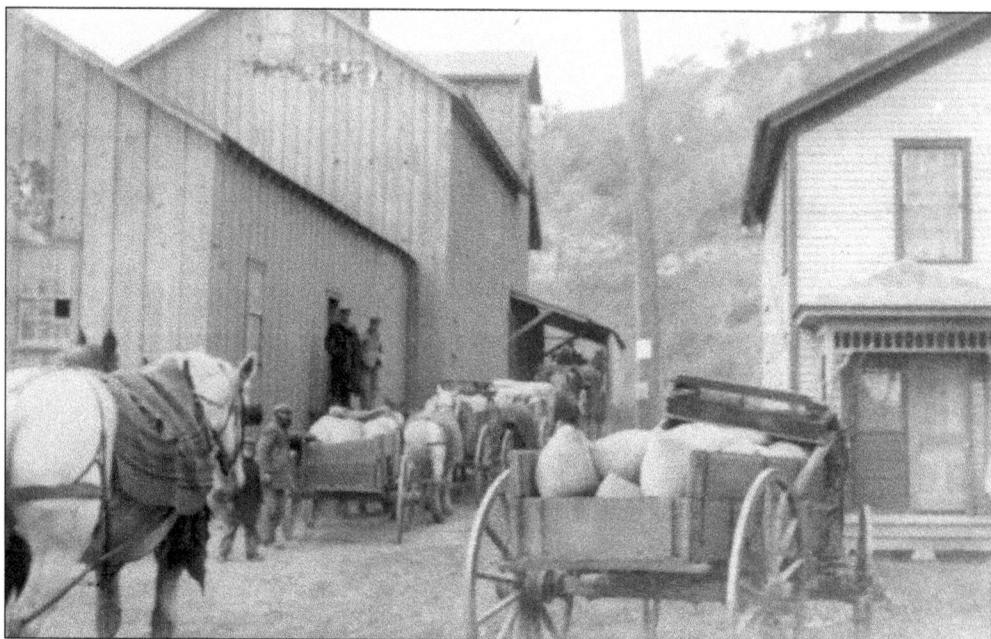

WAITING TO UNLOAD. A line of wagons sits outside the Boyum Elevator in the 1920s. The horses are blanketed to ward off chills during the inactivity following the long haul from surrounding farms. Farmers and farm workers wait for their turn to unload the heavily laden grain wagons. The elevator later burned, but the house at right still stands on Lanesboro's flats today.

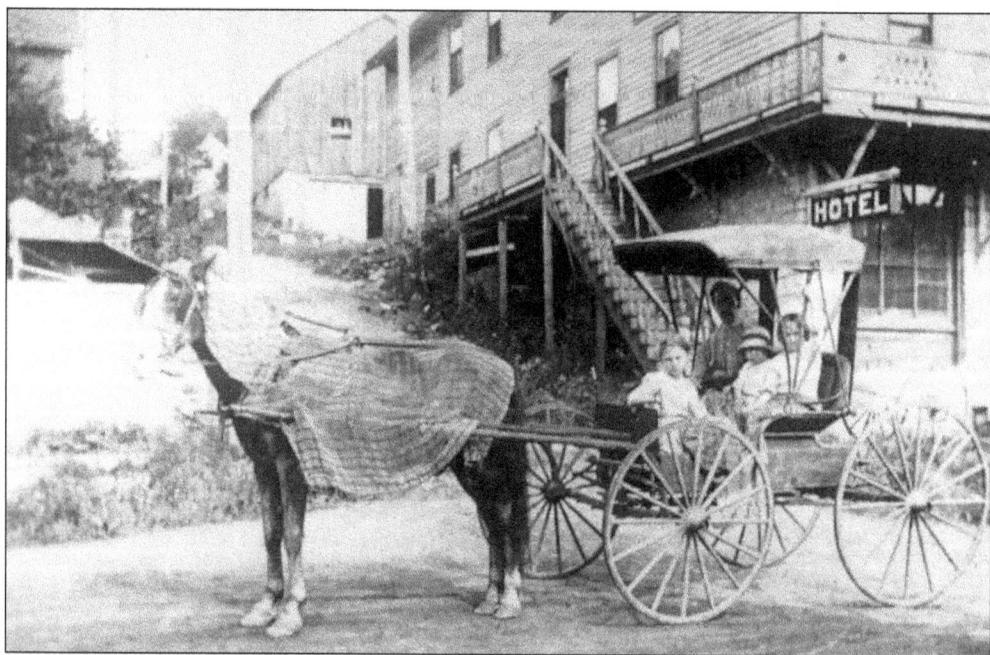

THE BUGGY RIDE. This family group is stopped in front of the Devy Hotel, built in 1870 by William Kane. The building was later expanded and continued to serve travelers and boarders for over 100 years. From the 1940s to the 1970s, the hotel was operated by Andrew and Emma Thoen, and later Andrew and Grace Tuftin. It was the last of Lanesboro's original hotels in operation.

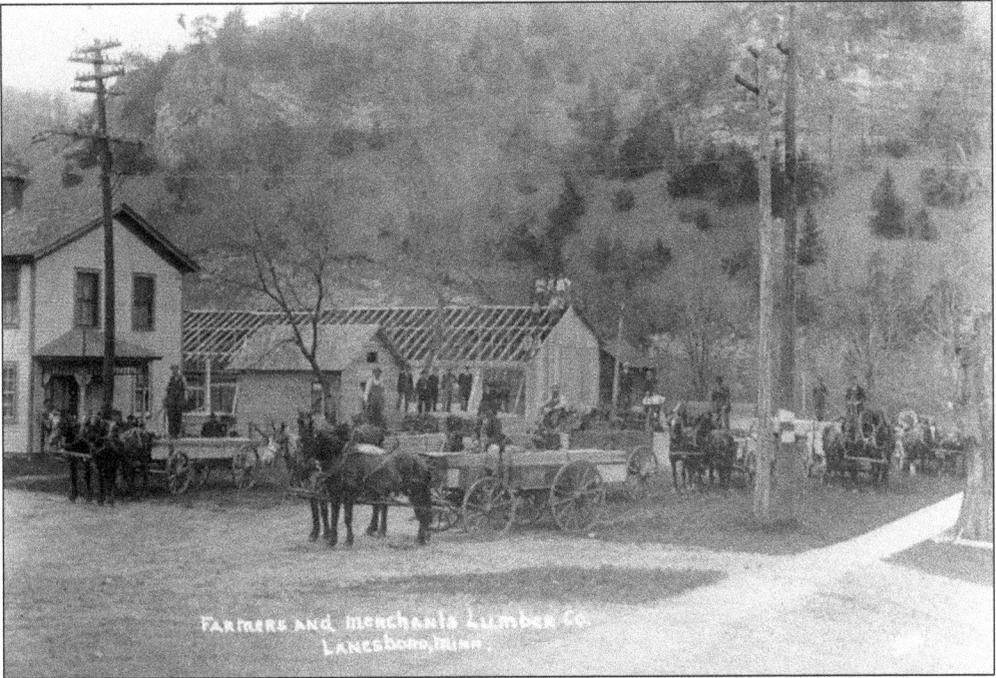

WAGON LOADS OF LUMBER. Seven wagon teams stand loaded with lumber outside the Farmers and Merchants Lumber Co. buildings on the flats in Lanesboro, c. 1905. The house at left is also seen in the picture opposite, next to the Boyum Elevator.

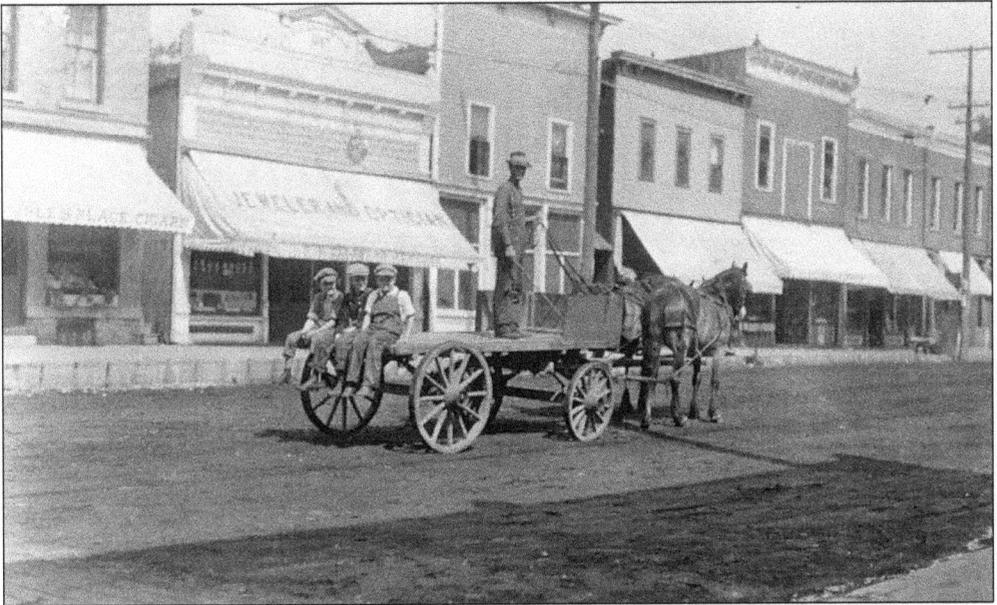

DRAY WAGON ON MAIN. Taken around 1915, this photo shows Iver Brekke's dray wagon and team on Lanesboro's Main Street. Iver bought blind horses and trained them to stop and stand when he released the reins to deliver goods. Dray wagons such as this one carried merchandise to and from the town's business establishments and were a community fixture for well over 50 years.

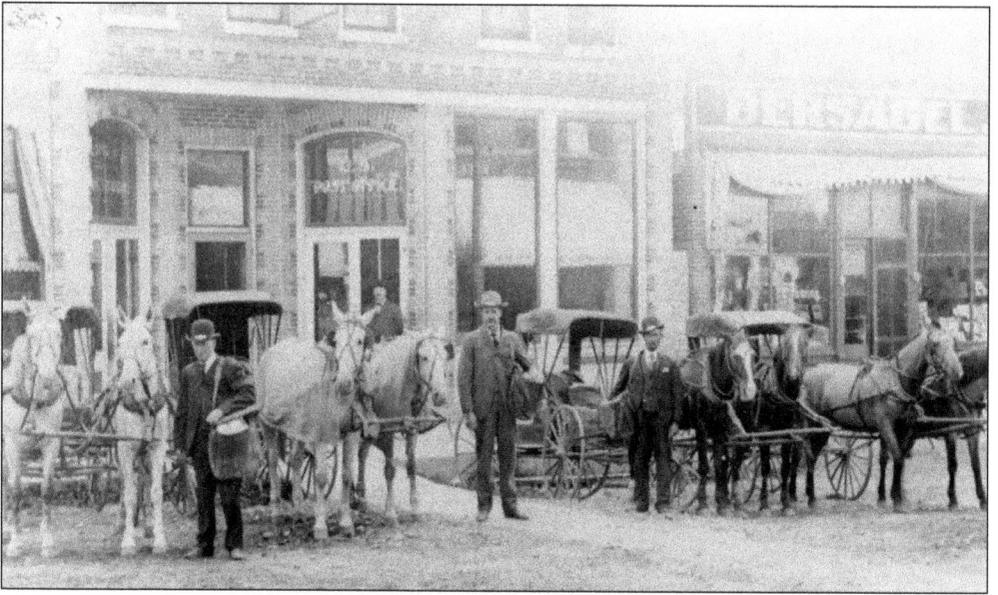

POSTAL CARRIERS AND CONVEYANCES. "Neither snow nor rain nor heat nor gloom of night stays these couriers from the swift completion of their appointed rounds." While not an official motto, these words have become synonymous with U.S. postal carriers. Pictured in front of the Lanesboro Post Office, *c.* 1910, from left to right, are Christ Highum, Postmaster Hakon Glasoe (by door), Carl Anderson, and Mike Highum.

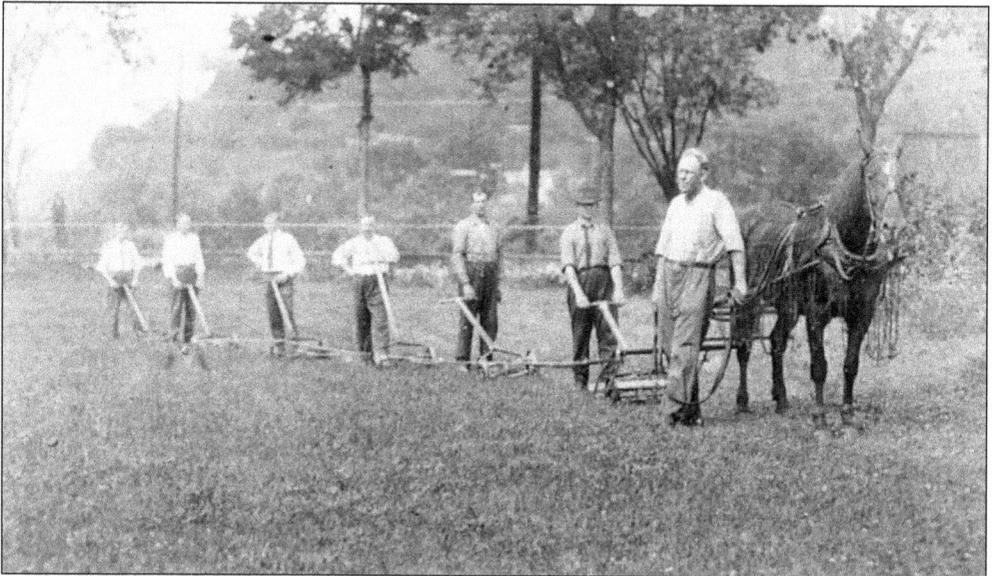

HORSE AND MAN POWER. Local businessmen lend a hand to a hoof for the mowing of Lanesboro's Sylvan Park, *c.* 1925. The men with mowers are, from left to right, unidentified, unidentified, unidentified, Julius Olson, unidentified, Ted Bell Sr., and Olaf Thompson with the horse.

FOOTLOOSE WAGONEER. The young person pictured seems carefree enough to be out on a lark. He may have been a farm boy sent into town for supplies, giddy with the freedom of being master of his own transportation. The street shown is Main (now Parkway Avenue) just north of Sylvan Park with the railroad bridge in the background.

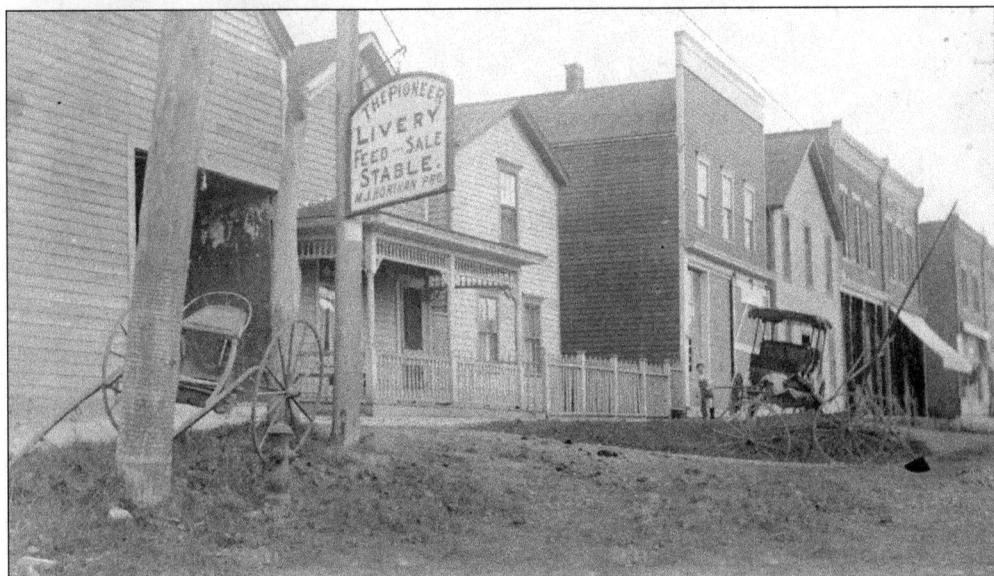

LIVERY. Two liveries and the M.V. Bean Harness Shop are seen in this stretch of street. The view is of east 'E' Street (now Parkway) looking south. The sign declares: "The Pioneer Livery, Feed and Sale, Stable. M.J. Horihan Proprietor." Sandwiched between commercial buildings are two houses complete with picket fences. Lanesboro stonemason Engebret Enger built the house third from the left.

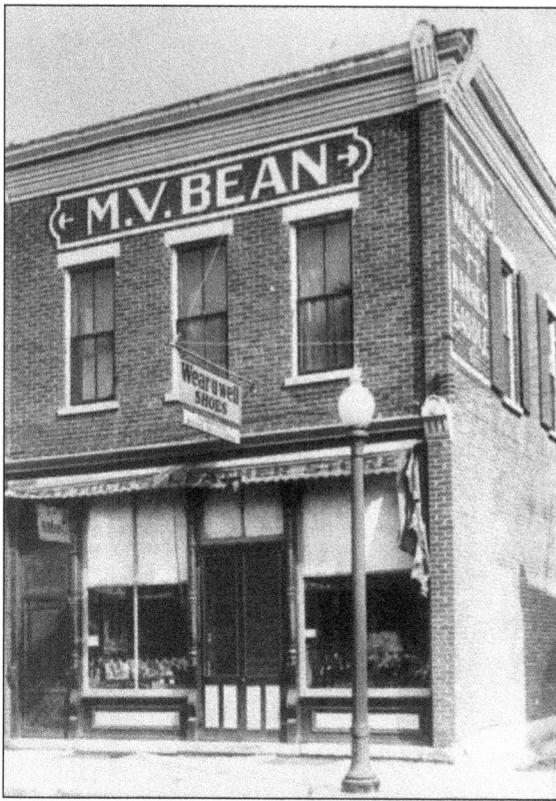

M.V. Bean Building. Mr. Drake owned Lanesboro's first harness maker shop, located on Slant Avenue. In 1869 he sold out to M.V. Bean who established his business there but eventually remodeled the building into a "handsome and commodious dwelling." He later operated his harness business from the brick building he constructed, shown at left. This photo from 1926 shows the Shattuck 'Wear-U-Well' shoe store occupying the business space.

M.V. Bean Harness Shop. Piles of leather luggage and horse blankets reside beneath a sky of horse collars in this photo of the M.V. Bean Harness Shop in the 1890s. A dealer in saddles, whips, trunks, valises, and more, Bean also specialized in the manufacture of heavy-duty horse harnesses sold mail order to hard tasking Klondike miners. Mr. Bean was remembered as, "a skilled harness maker and an impressive genial man."

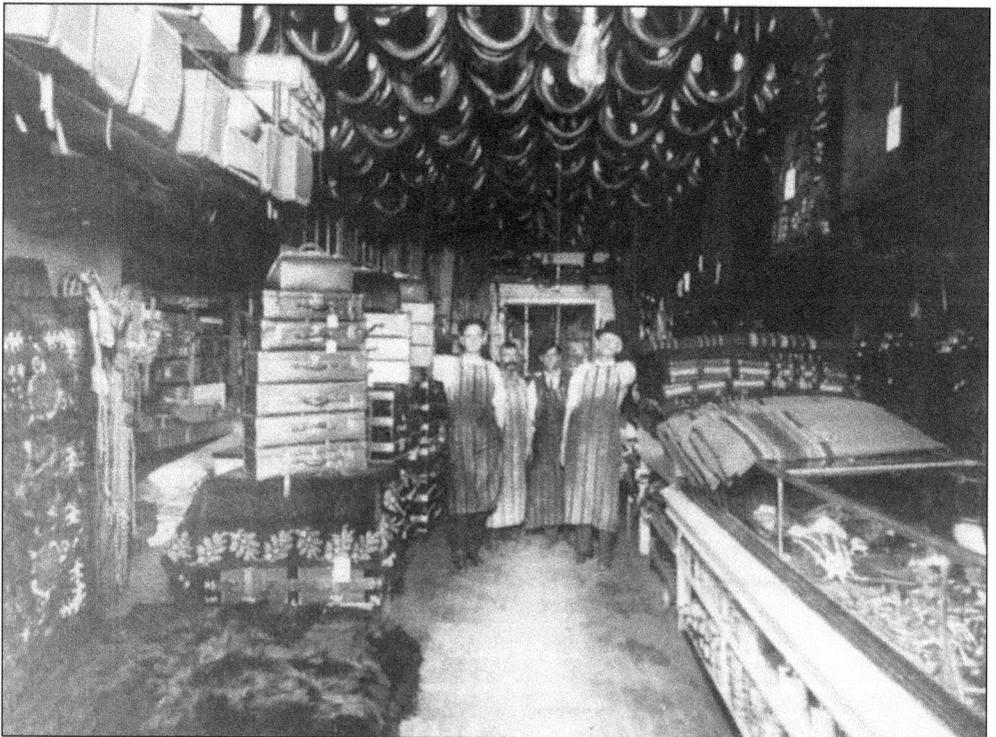

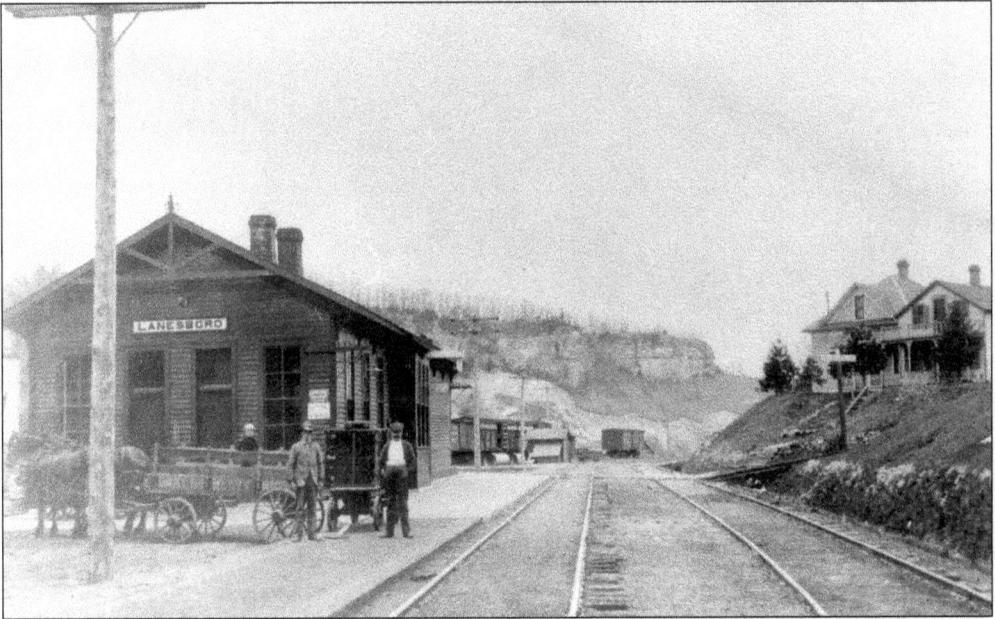

THE LANESBORO TRAIN DEPOT. A dray wagon and operator await the arrival of one of the daily trains through Lanesboro. The depot building was built around 1886 and remained in use until the 1970s, when the rail line was abandoned and the building destroyed. Twenty years later, the depot was rebuilt through the efforts of local volunteers such as organizer Don Ward, construction foreman Gene Larson, and many others.

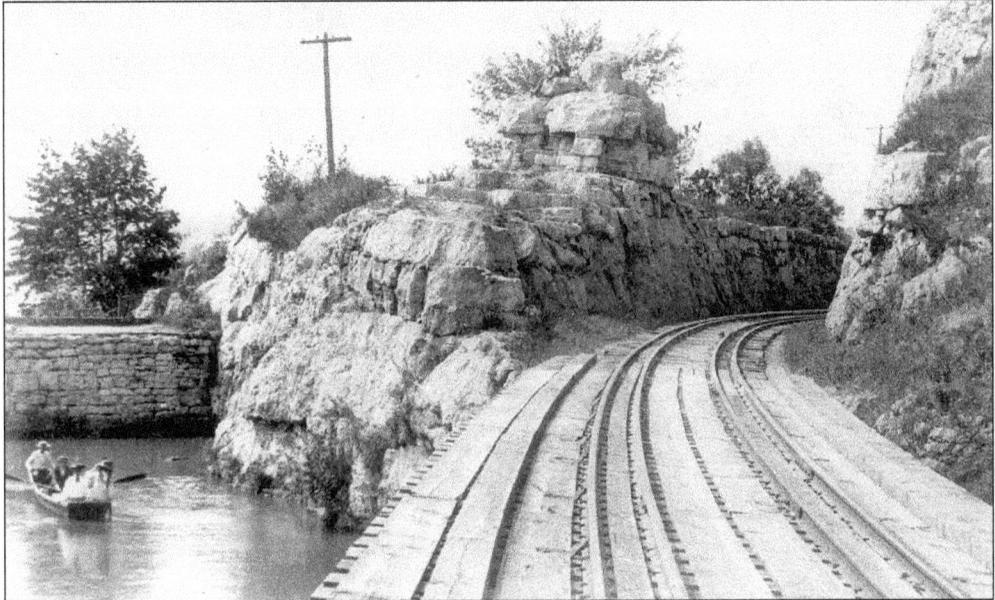

THE RAILROAD CUT. Boaters are seen enjoying a row down the channel beneath the railroad cut and trestle. Dynamited through the south end of Lanesboro's West Bluff, the railroad cut allowed the line to run west along the Root River Valley before turning north up the ravine to Fountain. This same route is today followed by the popular Root River State Trail, known to bicyclists and nature lovers throughout the region.

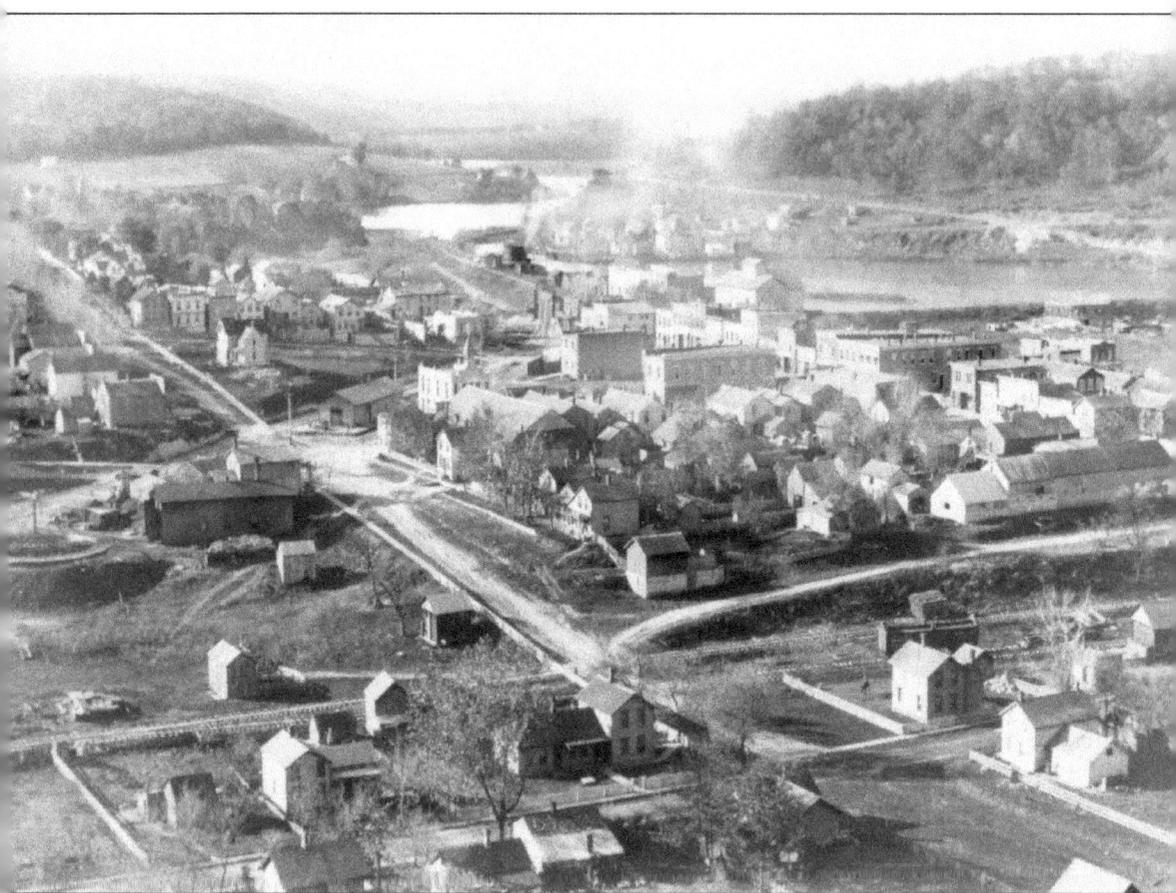

THE LANESBORO RAIL CENTER. From 1868 until 1872, Lanesboro remained the terminus of the Southern Minnesota Rail Road, and a turntable was built just north of the tracks, seen here at extreme left. Next to the turntable is an engine house for the shelter and repair of locomotives. Track spurs can be seen running through the "flats" at bottom as well as an additional line just to the north of the old depot building. Other features of note in this rare photo, taken around 1893, are the water tower on the rail line approaching the dam and the condition of the mill buildings on Mill Pond. One is a burned out shell and another, at right, is under re-construction.

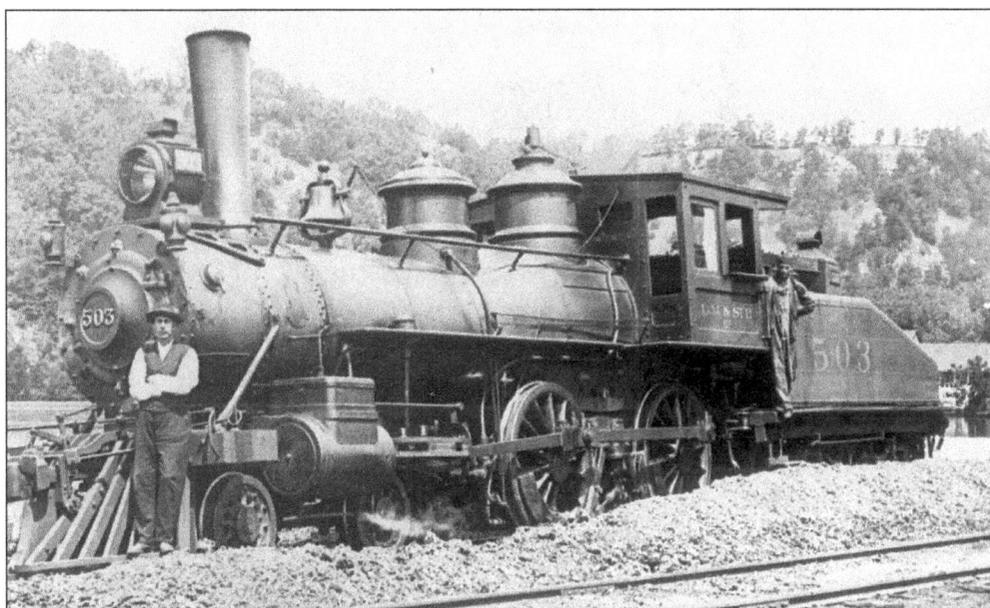

LANESBORO'S "PUSHER" ENGINE. For many years the Chicago, Milwaukee & St. Paul Railroad kept this "pusher" stationed in Lanesboro. The engine's job was to assist heavily-loaded freight trains in climbing the hill out of the valley and up to Fountain. Engineer Pat McCarthy is shown at left in this photo, c. 1900. The coalman is unidentified. Mr. McCarthy was engineer of this locomotive for many years.

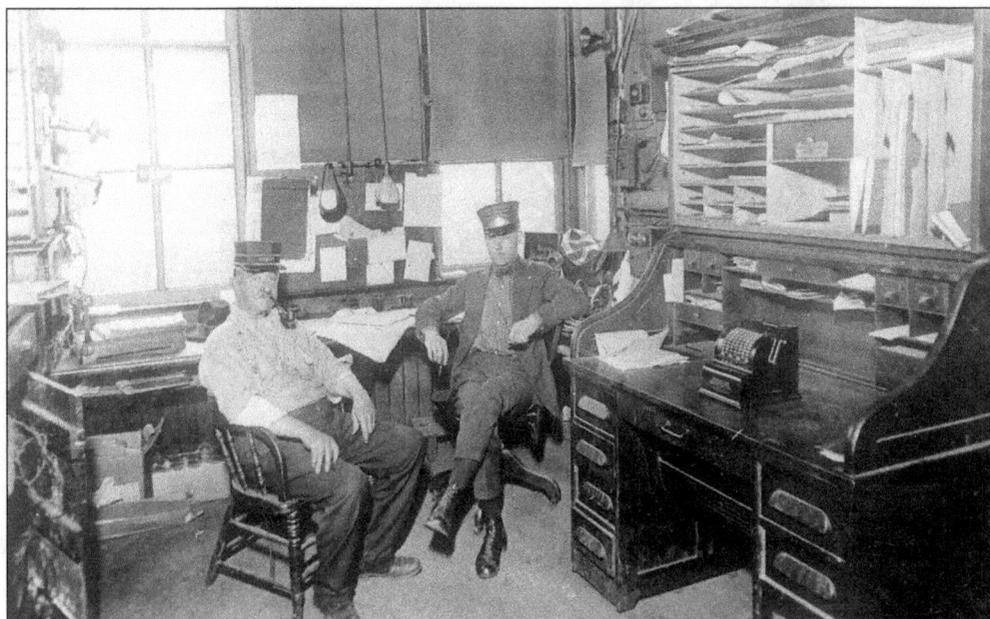

DEPOT OFFICE. Railroad agents H.R. Wood (left) and H.S. Hoff (right) take a break in this photo from April 25, 1921. Both long time Lanesboro agents, Mr. Hoff contributed 50 years service before retiring. Lanesboro's first railroad office was in the Phoenix Hotel. The first agent was Billy Case followed by Charles Judd, William Galvin, P.J. Hawley, W.E. Lockerby, and Charles Reynolds—all prior to 1893.

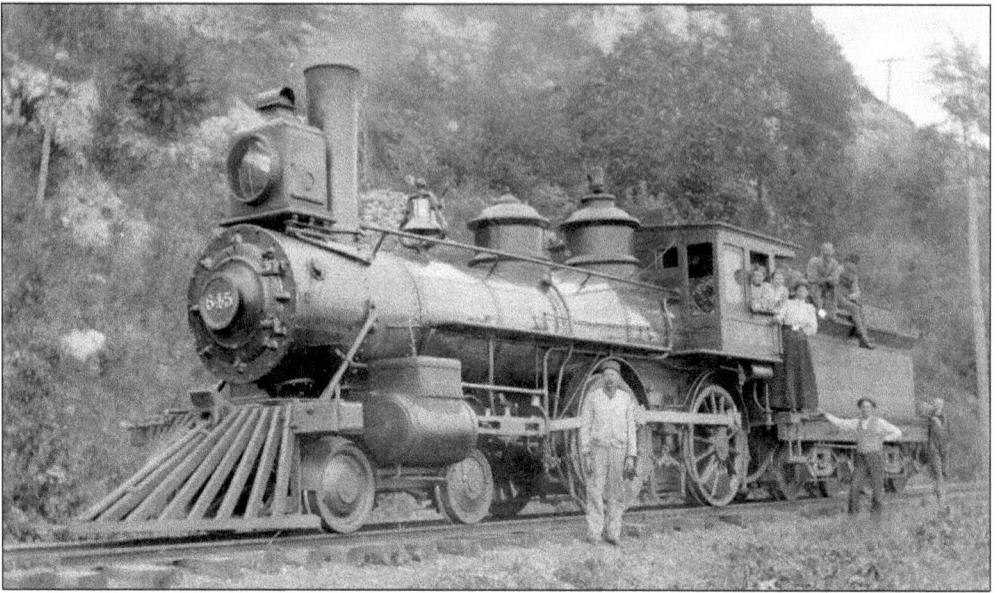

THE FLEET 645. Three young women seem to be on an excursion with the crew of this steam locomotive, seen at the cut near the Lanesboro dam. The man with hat on the coal car is Angus MacCormack of Fountain, a railroad employee. All others are unidentified. During the height of the railroad's importance in Lanesboro, as many as a dozen trains passed through town daily.

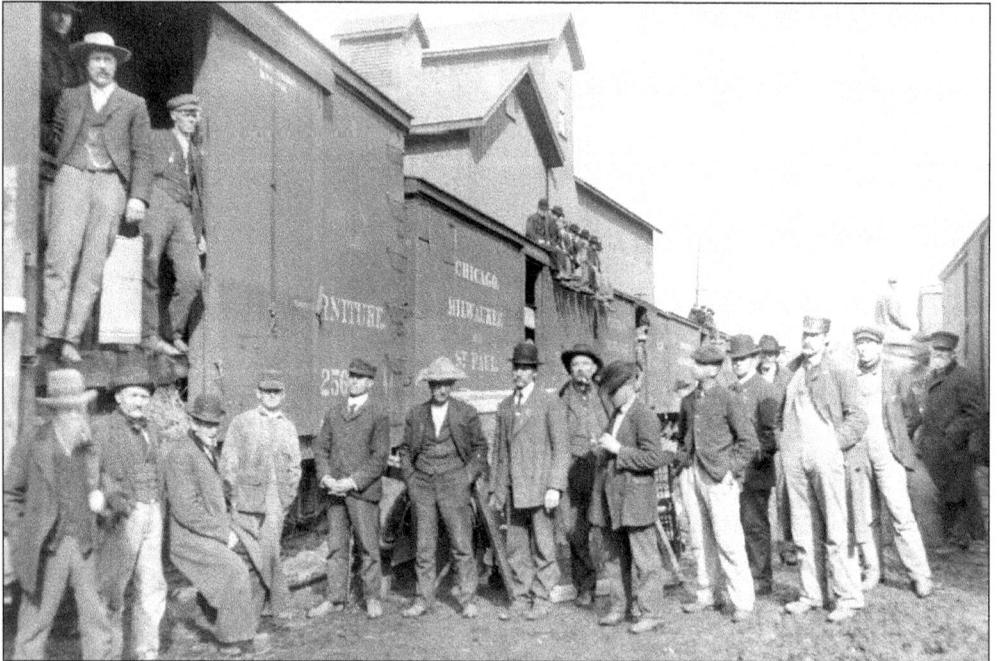

WESTWARD BOUND. These Norwegian immigrants are setting out by boxcar for the Dakotas to homestead claims. Taken around 1905, the scene was often repeated as large numbers of such settlers came through Lanesboro during these years. They often left their families in town while they established the homestead, then came back for them in the winter. Some returned to find their wives quite taken with Lanesboro and never did manage to leave.

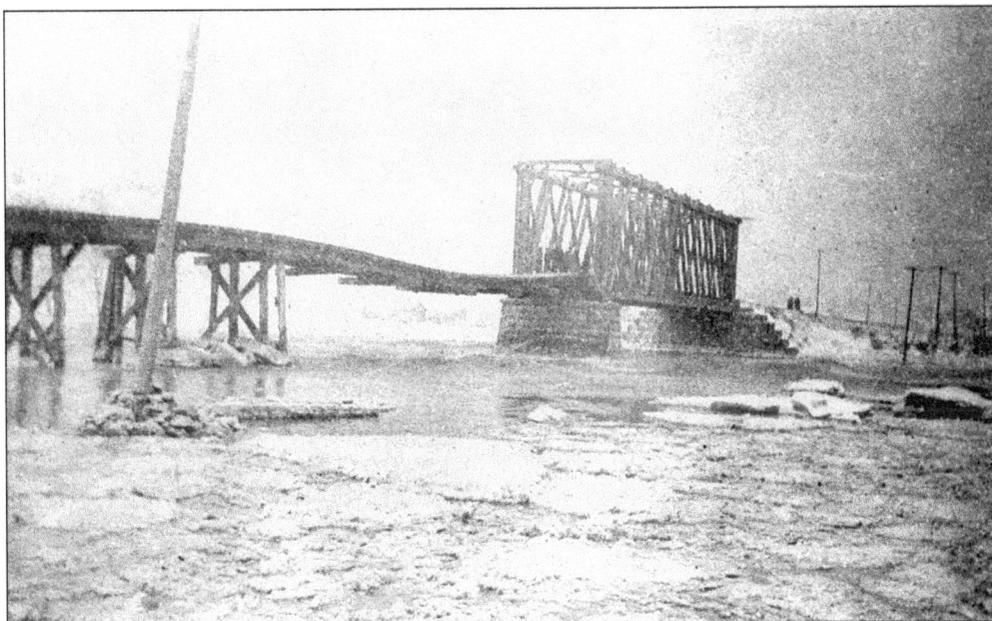

MIRACULOUS ACCIDENTS. The *Lanesboro Journal* reported on January 19, 1894, that this railroad bridge on the east edge of Lanesboro, shown here after being damaged by floodwaters, was the site of numerous accidents made miraculous by their outcomes.

The first occurred on February 7, 1875, when an engine ferrying workers and spectators back to town from a train wreck that had occurred east of Lanesboro the previous day crossed the bridge at high speed. The engineer suddenly applied the caboose brakes, causing the caboose to jump from the track and sail off the 20-foot high trestle to crash upside down on the frozen earth below! Despite the crushing fall and the load of dangerous wrecking tools carried within, the eight occupants of the caboose escaped any serious injury.

Just as marvelous was the case of Walter Nelson and his "best girl," Miss Jennie Olson, who were strolling across the trestle one Sunday afternoon when a fast-approaching train surprised them. With disaster imminent and no boards on the bridge to allow running, Walter climbed out to the edge of the trestlework and, taking Miss Jennie in hand, clung dangling from the trestle supporting both their weights with one arm until the train had passed! He then safely returned them to the trestle. The two were soon married.

Shortly after this mishap, a team of horses belonging to Peter Abrahamson ran loose down the tracks heading east out of town just ahead of a heavy freight train. Rather than leave the tracks, the spooked horses continued ahead of the freight until reaching the bridge. With only the bare cross-timbers beneath their hooves the horses bolted out onto the structure at full speed! The first reached the far end without a misstep and leapt from the trestle to the rocky bottom 20 feet below. Those who saw this amazing jump were even more amazed when the horse got up and walked off uninjured! The second horse made a more sensible but equally miraculous escape by getting outside the track and leaning over against the outside framework of the bridge while the long freight train rumbled past.

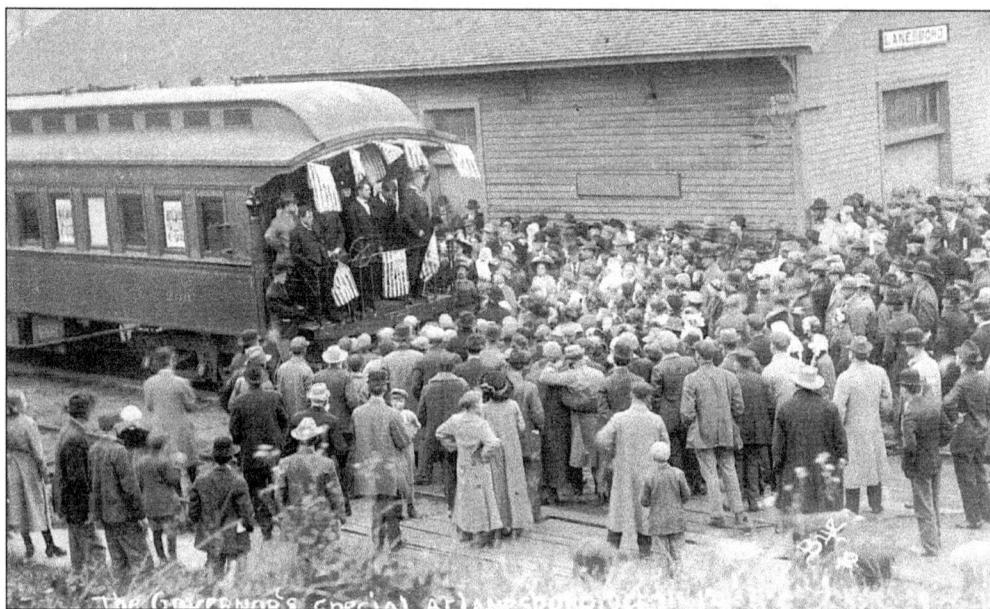

GOVERNOR'S SPECIAL. Minnesota Governor Adolph O. Eberhart, a Republican from Mankato, addresses Lanesboro citizens from the back of his train on October 21, 1912.

NORTH BLUFF LANDSLIDE, 1904. Running along Lanesboro's North Bluff, this road, now Hwy 250, suffered numerous spring landslides during early years. Tired of the Herculean efforts required to clear the road, townspeople accomplished another amazing feat. During the hard freeze of mid-winter, they erected timber supports on skids beneath the bridge and used teams to haul the bridge about 500 feet down river over thick ice to its present location.

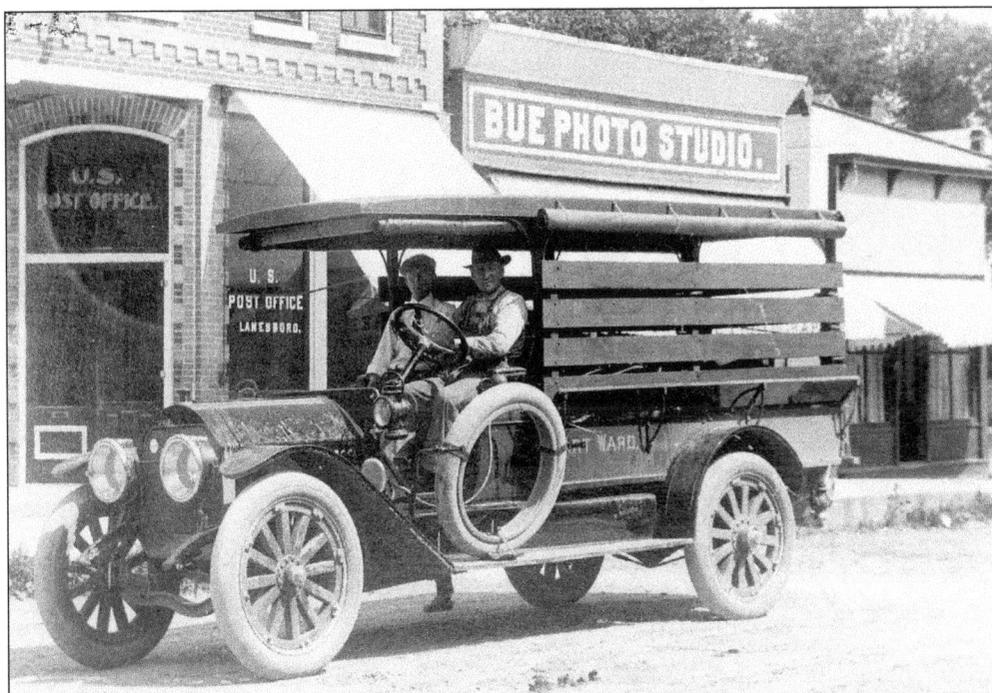

KISSEL TRUCK ON MAIN. Art Ward at the wheel of his Kissel Truck on Lanesboro's Main Street, c. 1915. Art was a "city farmer" who owned land near Henrytown. He used the truck for hauling grain and livestock. Art was at one time a partner with George McMaster in auto sales. (Art Ward is also pictured behind the burro on page 6.)

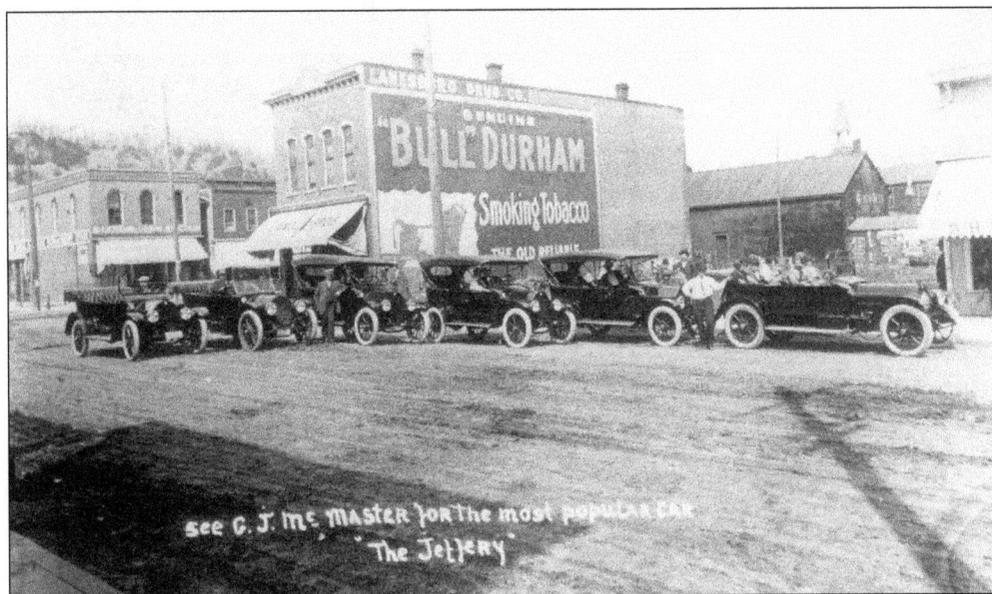

THE JEFFERY. The line of automobiles sold by George J. McMaster is displayed on Main Street in this promotional photo from 1912. The advertisement read, "See G.J. McMaster for the most popular car, 'The Jeffery'." It has been reported that only eight of Lanesboro's citizens were auto owners in 1912.

RESCUE OF THE HEARSE, 1928. Just as the automobile eventually spelled the end of industries such as harness making, new businesses emerged to meet the needs of the burgeoning automobile age. Here a tow truck lifts the local hearse while an attendant from Ray Lee's Garage examines its tire. Lee's Garage offered Firestone tires, Red Crown Gasoline, and, according to the sign, rented cars.

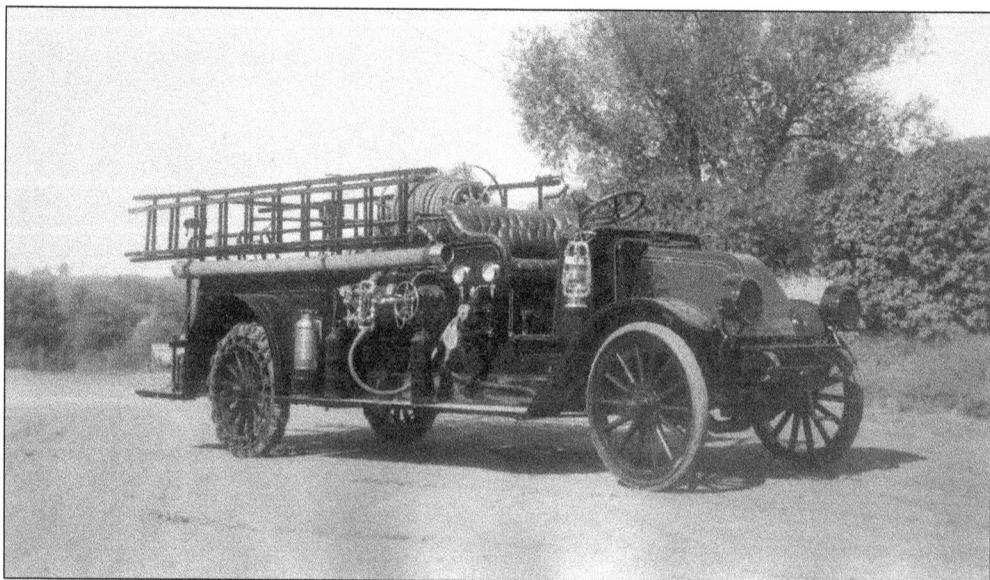

SHINY 'RED' FIRE TRUCK? This fine vehicle, built by the International Company, was Lanesboro's first "modern" fire truck. The picture was taken on September 10, 1923. Such vehicles were no doubt a boon to Lanesboro's Fire Department, staffed then as now by volunteers from the community.

Seven

THE TEENS AND TWENTIES

Around the world, the years 1913 to 1919 were amazing and turbulent. Women struggled for equality while all of Europe, and eventually the world, devolved into a riot of war. Even Lanesboro, isolated amid the mid-continental landscape of America, felt the weight of world affairs as the townspeople gave up their young men to battle and sought to adjust to a socially challenging 20th century.

From the "teens" through the "twenties," change—rapid change—was the watchword. Henry Ford unveiled the revolutionary assembly line, trans-Atlantic phone service and commercial radio were introduced, silent movies gave way to "talkies," and the Panama Canal opened for business. A 1917 Pocket Directory of Lanesboro put the population at 1,000 and reported, "Lanesboro is one of the most progressive towns in Southeastern Minnesota. It is one of the richest farming communities of the state, the principle products being corn and livestock. Lanesboro is a model residence town, the majority of families owning their own homes and take great pride in keeping them attractive. If you want to locate in a 'live' town come to Lanesboro." The directory also listed the town's services: 2 banks, 2 grain elevators, 4 physicians, 2 dentists, electric lights, 1 furniture store, grade and high school, 4 churches, 1 weekly paper, 1 photographer, 2 garages, 2 lumber yards, and up-to-date retail stores carrying all lines.

THE BIRD DOCTOR. Beloved Lanesboro doctor, Johan Hvoslef, M.D., was an experienced ornithologist. When not tending to Lanesboro's ill he would take long walks through the beautiful countryside recording careful notes on the various birds he observed. A contemporary of the colorful Dr. D.F. Powell, Dr. Hvoslef served Lanesboro's residents for 48 years.

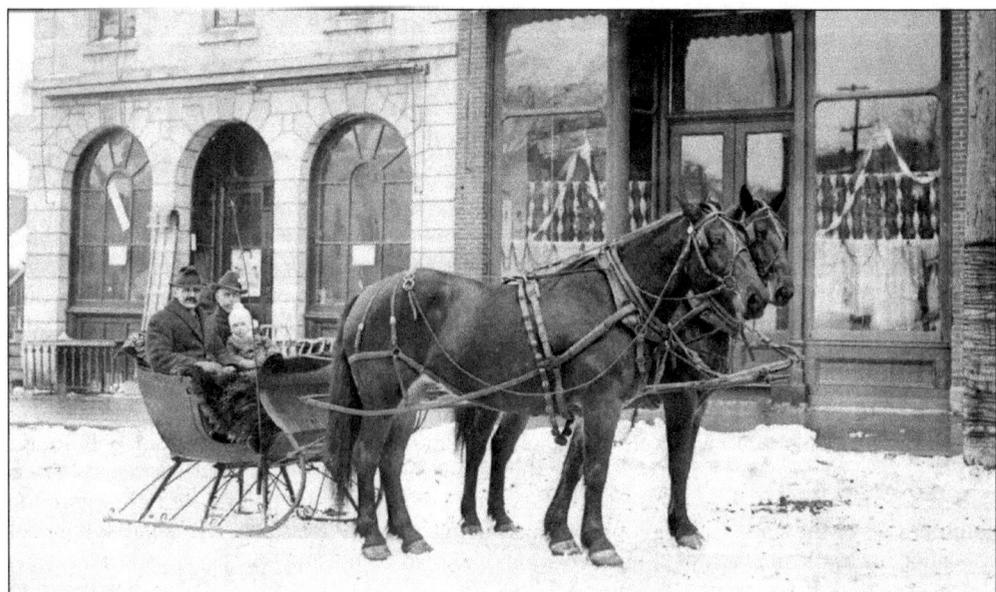

SLEIGHING IN TOWN. Viewed as a romantic slice of Americana today, the sleigh ride was also a practical means of transportation well into the twentieth century. Here a heavy fur blanket protects these unidentified riders against the winter chill on New Year's Eve, 1920.

FARMERS' AND MERCHANTS' TELEPHONE EXCHANGE. The Bell Telephone Company established Lanesboro's first phone service in the early 1890s. In 1911 several farmers and local businessmen established the Farmers' and Merchants' Telephone Exchange to improve service. The phone system was gradually expanded with a building constructed and underground cables installed in 1929. Pictured, from left to right, are Maude Bergey, Lou Scanlan, Lillie Bergey, and Irwin M. Ellestad, *c.* 1915.

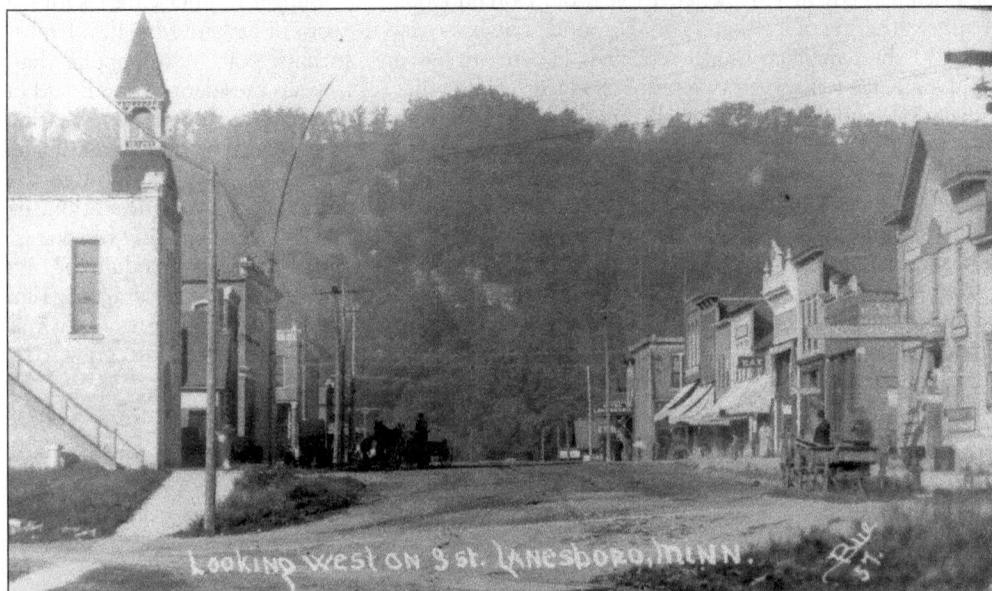

LOOKING WEST ON COFFEE STREET. Matt Bue snapped this photo of Lanesboro's Coffee Street, then called Second Street, around 1915. The Village Hall is at left. Among the other businesses shown are, from left to right, N.C. Moe Blacksmithing and Repair, Henry Langley's Grocery, The First National Bank, the Hotel Lanesboro, De Villier's Confections, Skaug Grocery, Larson Café, and others.

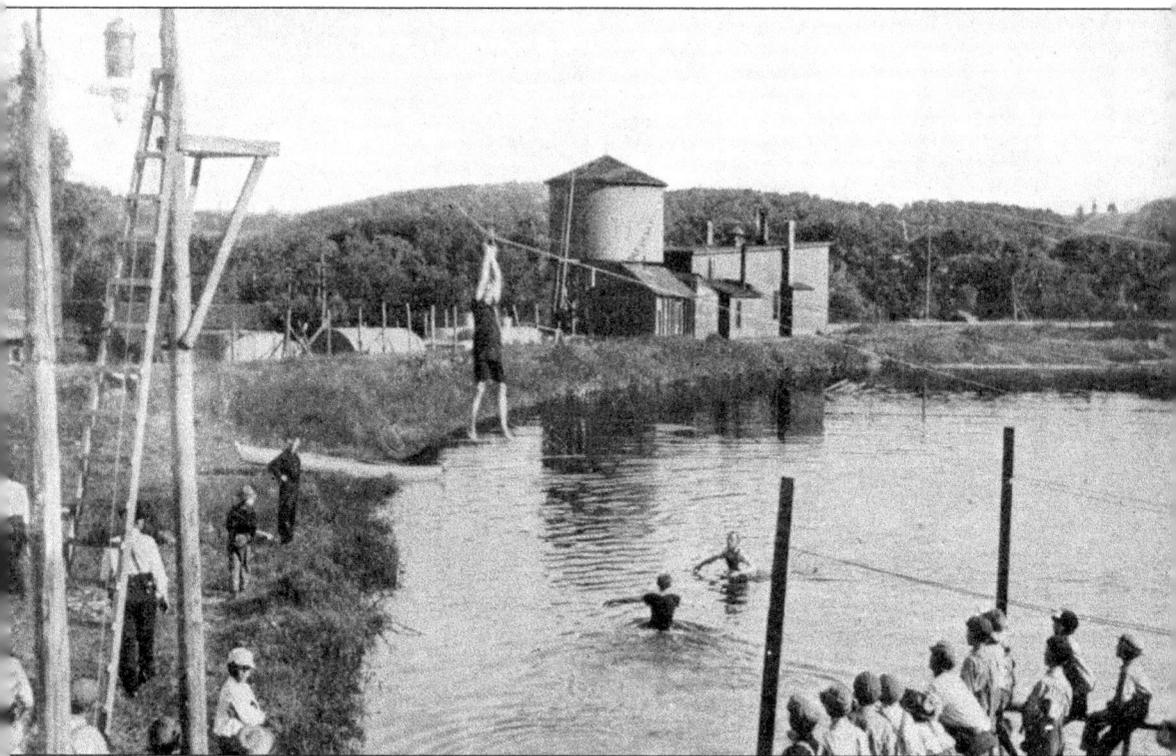

WATER HAZARD. Mill Pond, used for swimming in summer and skating in winter, was the site of a near tragedy in 1916 when 15-year-old Donald Drake and younger brother Charles joined a large gathering of ice skaters on the pond. The boys were the sons of Dr. and Mrs. F.A. Drake. In 1913 the *Lanesboro Leader* reported, "There are few men in Lanesboro more popular than Dr. Drake. He has served two terms as mayor of the village, has been president of the Board of Education, and always and at all times a great worker for the welfare of the village." Skating out onto the ice the boys separated, and Charles and a few others headed toward the millrace. Suddenly the ice gave way and Charles was plunged into the frigid water! Responding to the panicked cries of the other skaters, Donald Drake rushed to the spot. Without hesitation, he threw off his cap and sweater and leapt into the icy water, without even removing his skates! Charles had already gone down three times, and the older brother was forced to dive for him repeatedly in the ice-laden water before grabbing hold of the drowning boy and dragging him to shore. Unconscious, young Charles was brought into the nearby mill office were he was thankfully revived. Both boys recovered and Charles Drake, who was so nearly lost, grew to be a prominent and respected life-long resident of Lanesboro.

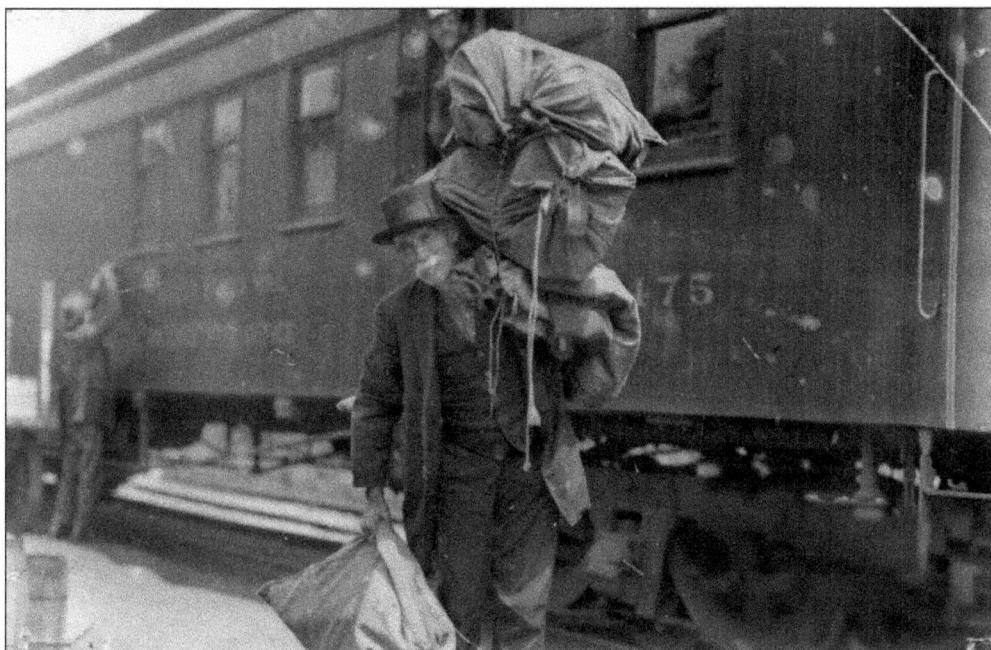

MAIL ARRIVING BY TRAIN. The U.S. Mail still arrived by train in 1918, as attested to by this photo of an unidentified old gent carrying a quadruple load of mailbags from the train to the station. Lanesboro's Post Masters during this period included Hakon E. Glasoe (1879–1916), James Lynch (1916–1924), and Arthur M. Enger (1924–1934).

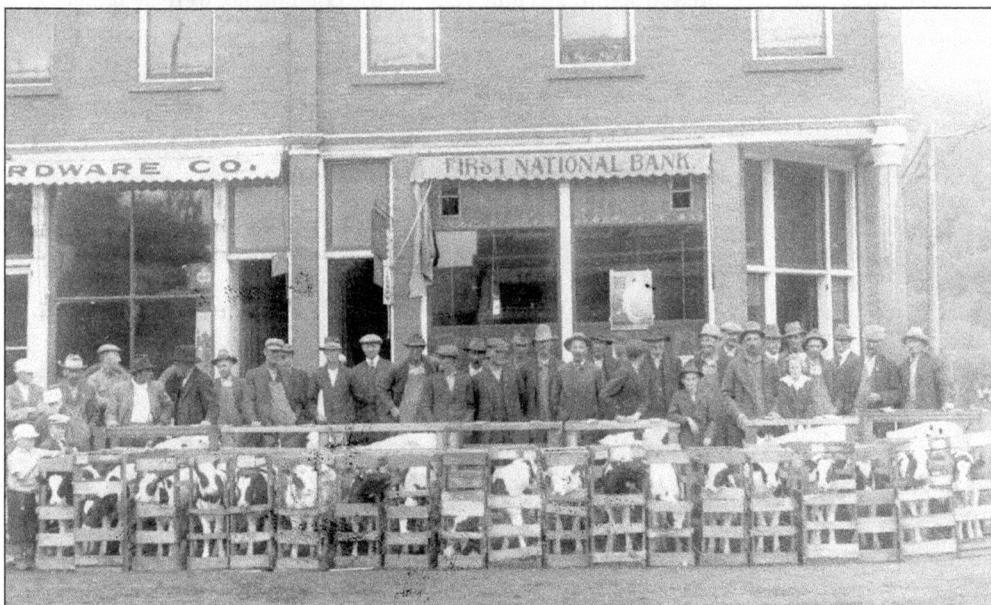

CALVES ON DISPLAY. The many farm families who lived and worked around Lanesboro throughout the years were as essential to the life and history of the town as any other group. Agriculture and the support of this noble endeavor was the community's lifeblood throughout a century of change. The men and boys (and one girl) shown here are gathered in front of the First National Bank of Lanesboro in 1918.

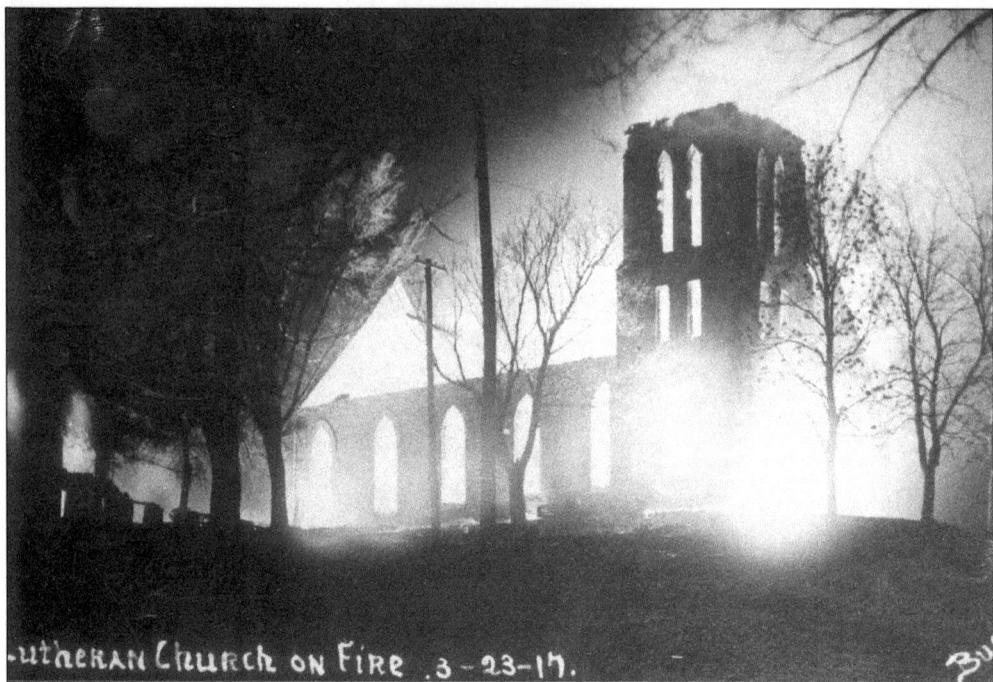

utheRAN Church oN FiRe .3 - 23 - 17.

A DISASTROUS FIRE. On March 23, 1917, a lightning strike ignited the Lutheran Church at the west end of Church Hill. Lanesboro's Fire Department responded, but to no avail. Wind spread the fire to the neighboring brick high school building and from there to the Old Stone School beyond. Soon all three structures, so important to the community, were ablaze.

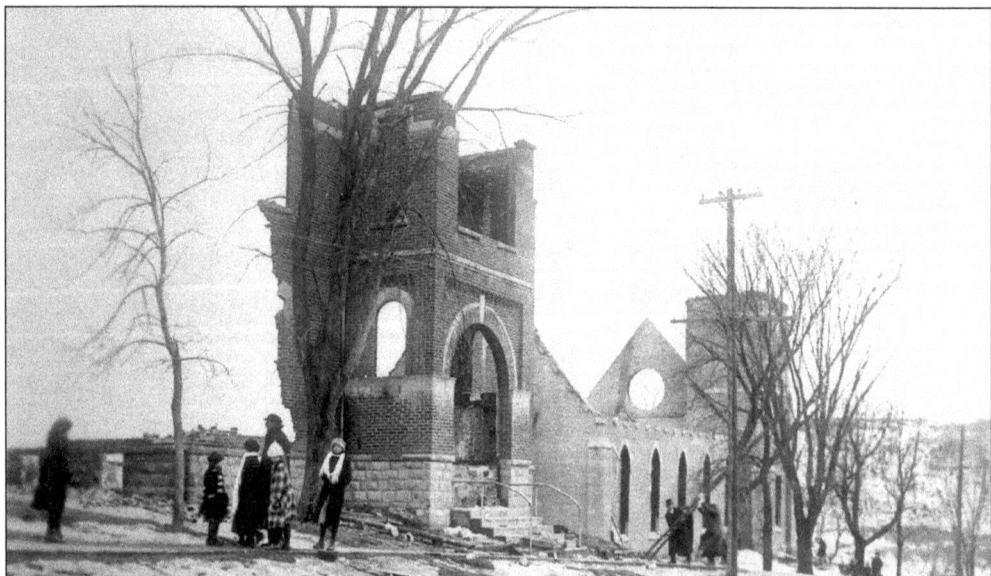

RUINS ON CHURCH HILL. Residents survey the damage in the aftermath of the Massive Church Hill Fire. Only the entrance hall of the once grand high school building still stands in the foreground while the Lutheran Church is seen gutted beyond. The fire also gutted the Old Stone School building. Justifiably proud of their school and church buildings, the people of Lanesboro were stricken by the extent of the loss.

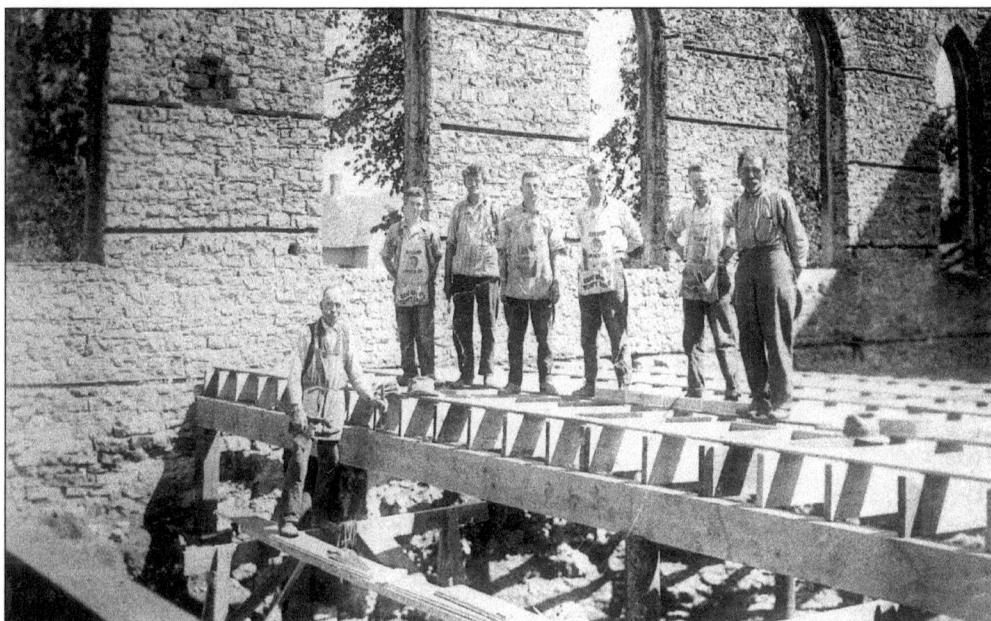

REBUILDING BEGINS. Rising to the challenges presented by the 1917 fire, the community began rebuilding almost immediately. Here volunteers work to set in place a new floor for the Lutheran Church building. The impressive end result of this reconstruction effort stands atop Church Hill today. From left to right are Sever Severson, Abner Ask, Oscar Hegna, and Morris Ask. The last three workers are unidentified.

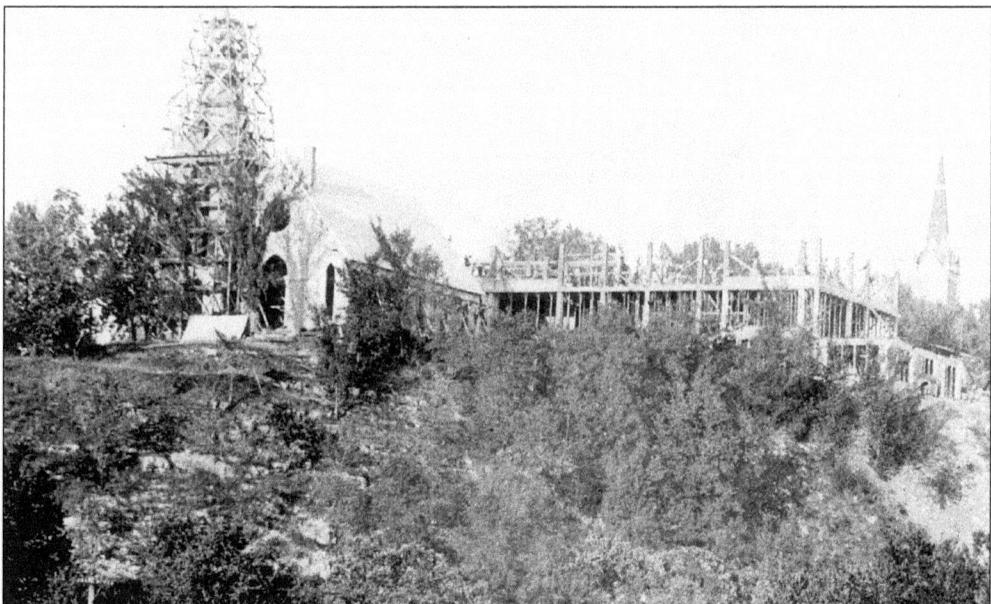

LUTHERAN CHURCH AND LANESBORO SCHOOL RECONSTRUCTION. Scaffolding engulfs the steeple of Lanesboro's Lutheran Church in this photo from 1917, while the framework for the new public school building rises at center. St. Patrick's Catholic Church, undamaged in the March 23 fire, is seen at right. Prior to completion of the new school building, classes were held in various locations around town.

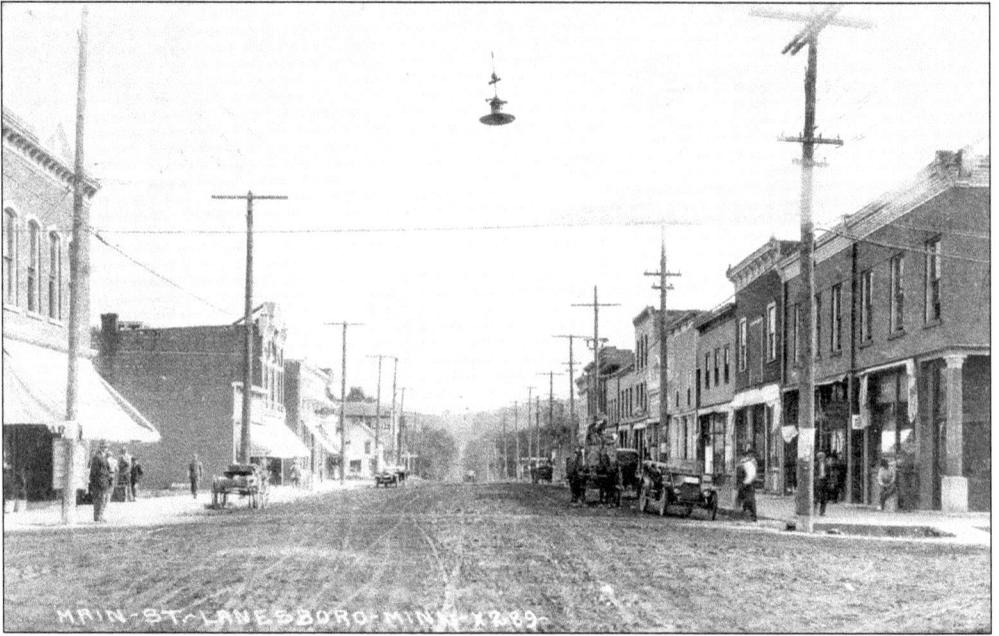

LOOKING SOUTH ON MAIN. Wagon teams and early automobiles share Lanesboro's dirt streets in this photo, c. 1915. Note the single streetlight suspended above the intersection and the power line poles extending down both sides of the street.

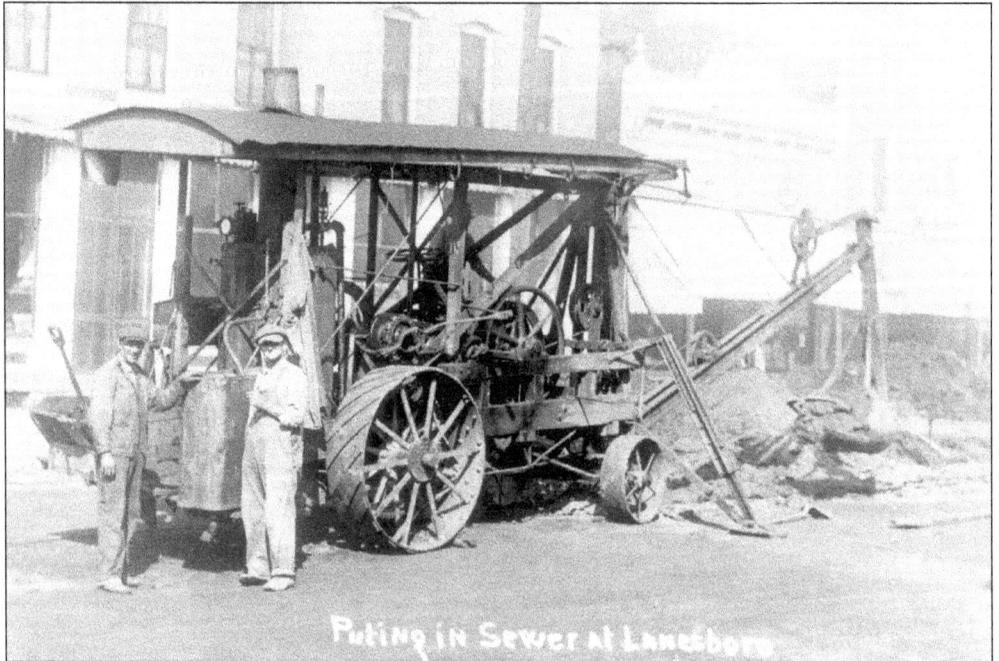

SEWER INSTALLATION. A steam-powered backhoe digs a trench along Lanesboro's Main Street (now Parkway Avenue), c. 1918, for the installation of sewer pipe. The operators of this amazing looking machine are unidentified.

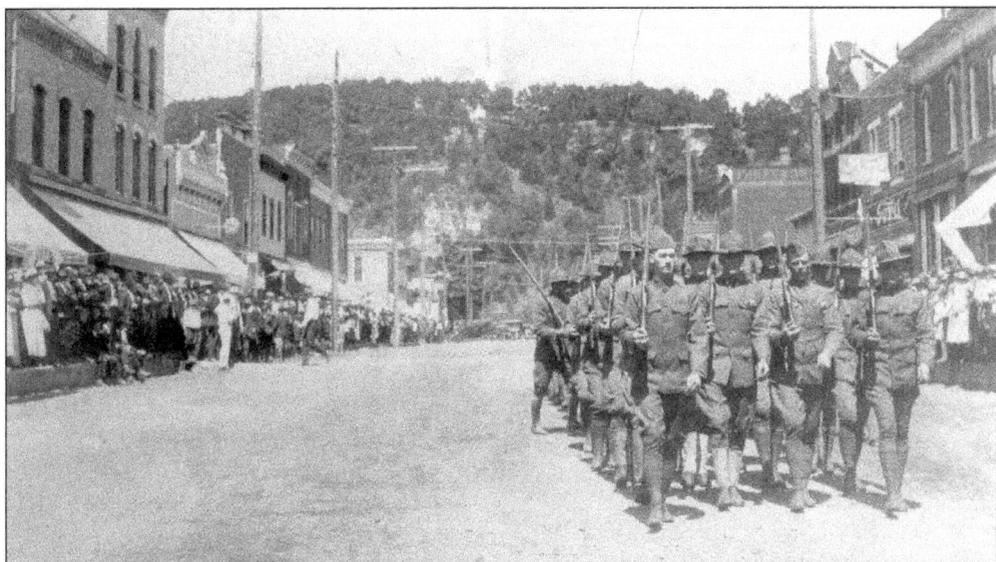

JOHNNY COMES MARCHING HOME AGAIN. As in the popular patriotic song of that time, the men, boys, and women have all turned out to celebrate the return of soldiers from France after the close of the First World War. This homecoming parade was held in Lanesboro on August 21, 1919.

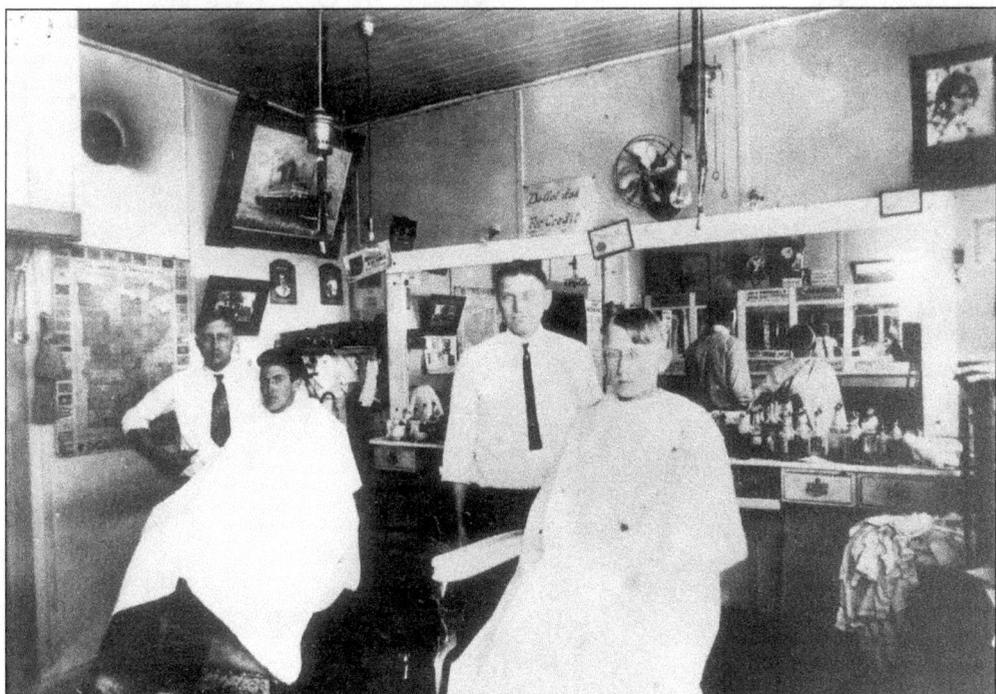

HANS OLSON'S BARBER SHOP. Ing Thorson owned a barbershop without a barber. When Hans Olson, a veteran of the 27th Infantry Div. in France, stopped in Lanesboro for a visit on his way home to the Dakotas following World War I, Ing invited Hans (third from left) to take the position temporarily until a barber to buy the business could be found. Thus commenced Hans' five-decade barbering career in Lanesboro.

95

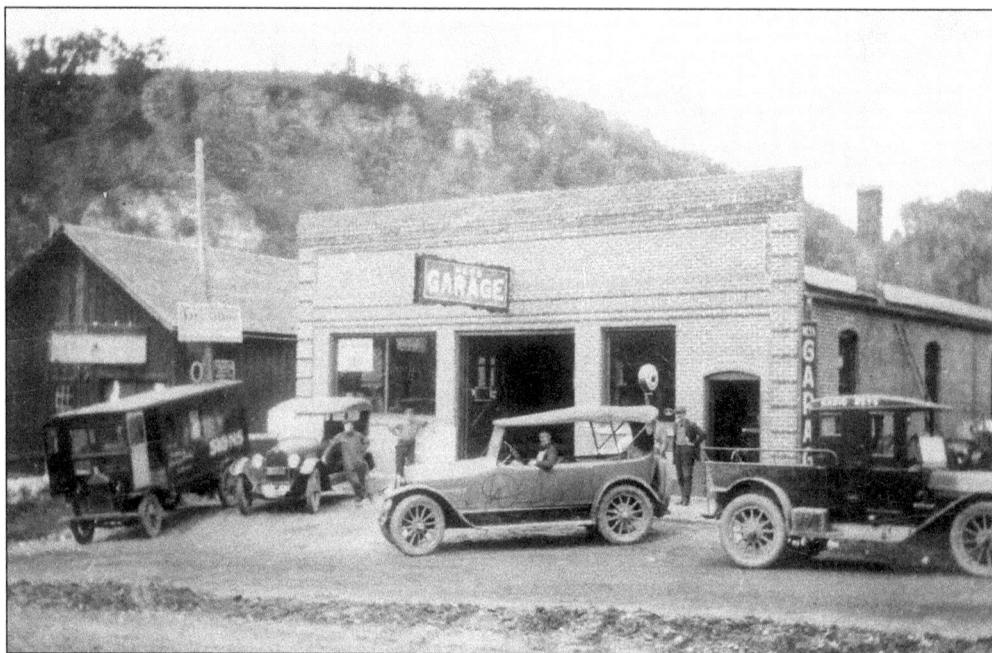

THE NESS GARAGE. Owned and operated by Ole Ness, this garage was built in 1912 and later sold to Ray Lee who also ran a garage from the location. Ted Opem is the driver of the open touring car at center. Note the "sign" truck at left and the auto at right advertising "Radio Sets." Such garages sported curb-side fuel pumps and were the forerunner of the modern gas station.

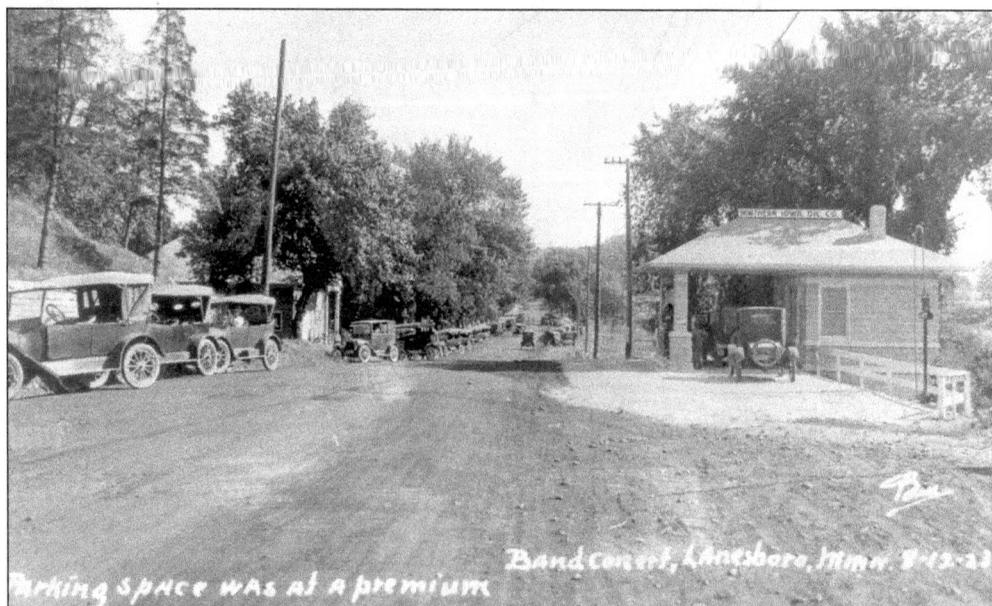

PARKING SPACE AT A PREMIUM. The cars have changed, but the parking issue is common again today in Lanesboro. A band concert in Sylvan Park caused this glut of vehicles on August 12, 1923. The Northern Iowa Oil Co. station pictured at right was Lanesboro's first filling station and was operated by Frank Tousley. This structure, greatly remodeled, is still in use on Lanesboro's Parkway Avenue.

96

THE FORD BUILDING. The Ford Thunderbird stands out on the front of this building on Lanesboro's Main Street. Built in 1916 as a Ford garage and dealership, it was operated by L.T. Tolefson. An elevator near the rear of the building lifted Model As to second-floor repair stalls while the main floor had a drive-through service bay and showroom. The unusual vehicle in front may be a street grader.

GAS STATION IN BROOKLYN. Lanesboro's Brooklyn neighborhood held this Standard Oil Co. gas station in 1929. Located on the northwest corner of today's Parkway Avenue and Highway 16, the station helped service the automobile phenomenon. In the 1920s the automobile industry was growing by leaps and bounds with three out of every four cars purchased on credit.

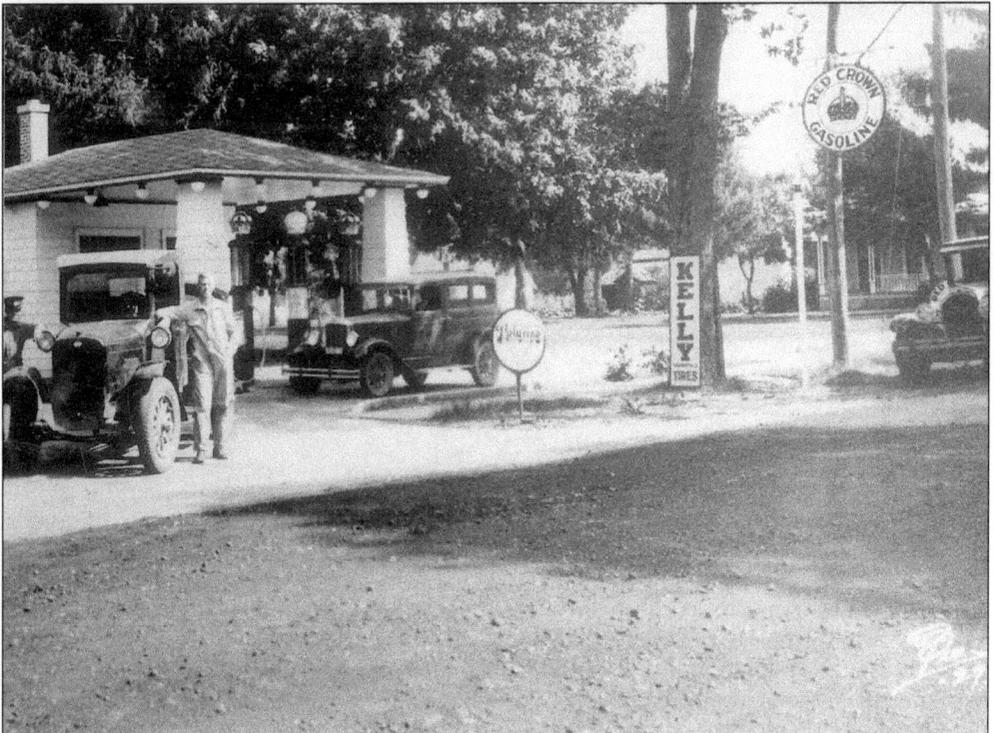

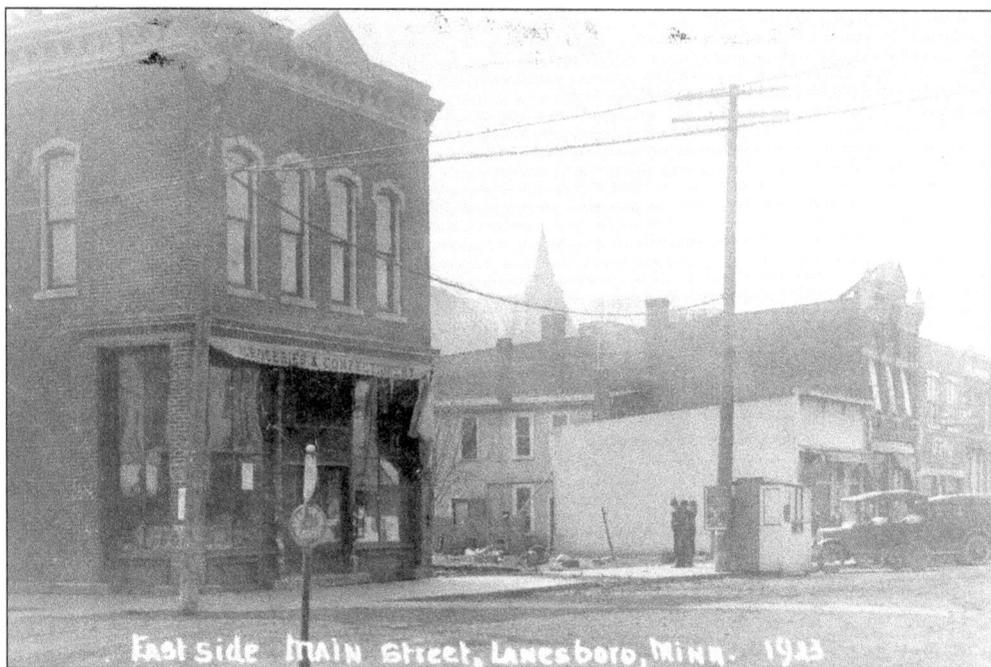

LANESBORO'S CORNER STORE. Henry Langley's Grocery sits at the corner of Lanesboro's Main (Parkway) and Second (Coffee) Streets in 1923. Mr. Langlie maintained that, "the most essential thing to good health is good food," and billed himself as, "the pure food grocer." The Scanlan-Habberstad Bank purchased the building with the goal of constructing a new bank building at the desirable corner location.

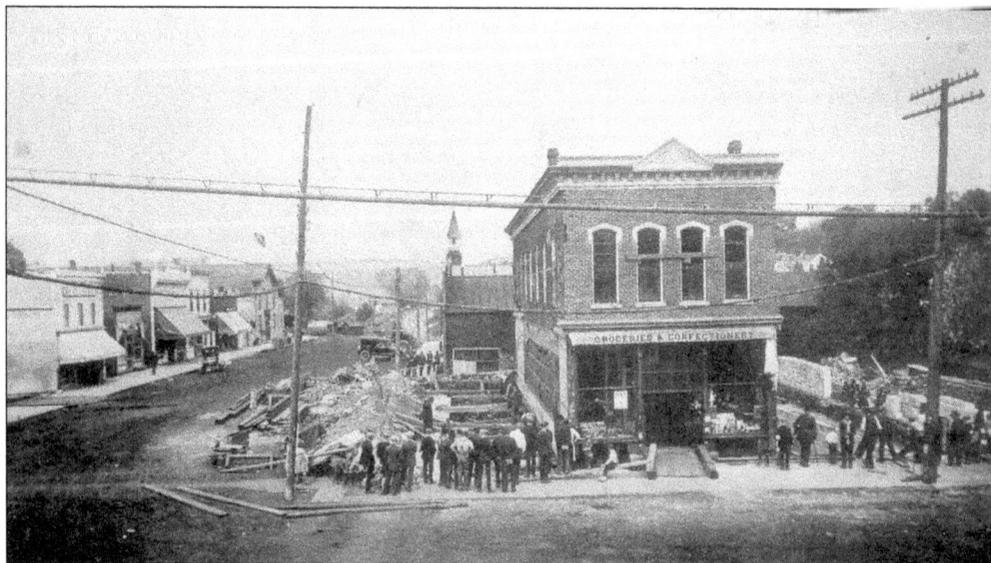

AMBITIOUS UNDERTAKING. The Corner Store building is painstakingly moved to a new foundation on the next lot south to make way for the new Scanlan-Habberstad Bank building in 1923. The north and south walls of the structure were stripped of bricks and bracing was rigged for the 45-foot trip to the building's new home. Temporary planking allowed access to the store interior during the operation.

98

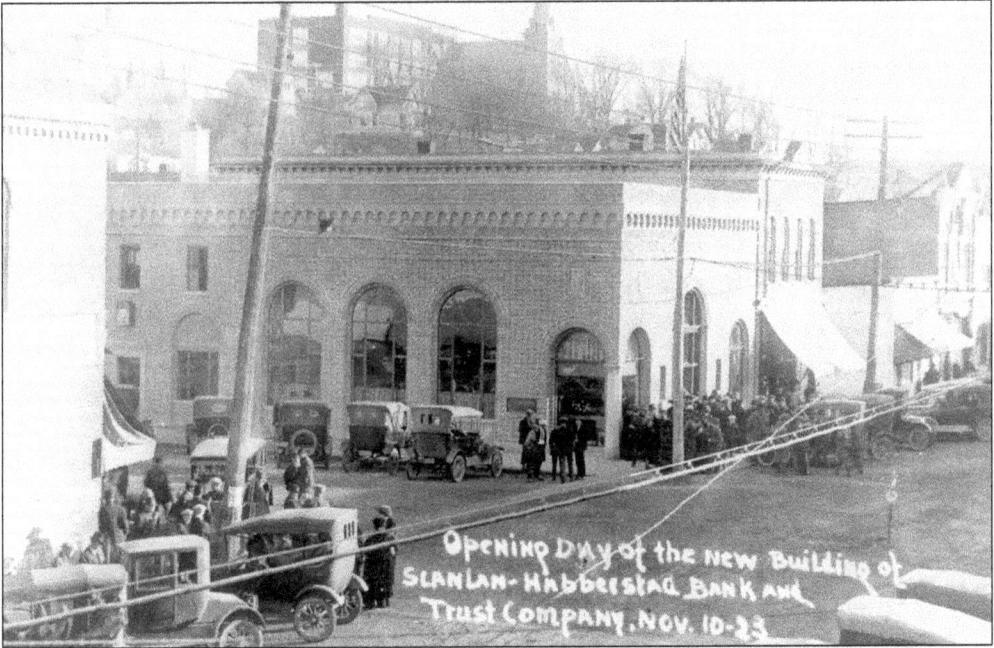

OPENING DAY. November 10, 1923, was the official opening day for the new Scanlan-Habberstad Bank and Trust Company building in Lanesboro. A crowd gathered to look over the new bank and the former Corner Store building, safely ensconced in its new location. In 1922 a Lanesboro bank advised that $2 banked every week would provide a savings of $1,040 after ten years "plus a nice fat sum for interest."

GREAT STEEL MOVERS. Three pair of large steel mover's wheels rest near the Corner Store building while two men pause under the awning of the First National Bank of Lanesboro. The Capron & Brekke Hardware store next door advertised in 1922, "hardware that stays hard, cutting tools that hold their temper and edge, most of the best and none of the worst in our line."

NORTHERN IOWA OIL CO. Author Donald Ward rides the fender of a Northern Iowa Oil Co. truck on the Fourth of July 1927. The truck is decorated for Lanesboro's Independence Day parade and is driven by Merlin J. Ward, Donald's father. The elder Ward was a bulk truck driver for the Northern Iowa Oil Company, delivering fuel to filling stations and farms around the area. During the summers, young Don would often ride along with his dad and was sometimes allowed the privilege of filling the tank truck from the bulk tanks near the Mill Pond. On one occasion a freight train happened along during the filling operation. As Don watched the train rattling past, his attention wandered and failing to release the pull cord for the bulk tank, he overflowed the truck's tank! This was the end of his tank filling privileges.

Eight

BUE'S VISUAL HISTORY

Buggs' South pole Expedition.

Hanson, Bersagel, Bue—these are the best remembered of Lanesboro's photographers. Mr. Hanson opened the first photographic gallery in Lanesboro. He had the distinction of photographing Buffalo Bill Cody and Dr. 'White Beaver' Powell while in Lanesboro. His gallery was a modest wood structure that stood on the lower west side of Church Hill just above the railroad tracks. In 1887, Hanson sold out to T.F. Bersagel who moved his business to a building on Main Street. Bersagel billed himself as a "portrait and landscape photographer." Around 1910, Bersagel happened upon several Lanesboro boys playing hooky from school and indulging in the forbidden pastimes of smoking and card playing. The savvy photographer snapped a candid photo of the boys, later displaying the prints for sale in his shop much, one might imagine, to the chagrin of both the boys and their parents.

Bersagel sold out to Matt O. Bue in 1912. Seventy years later, Lanesboro resident Randolph O. Huus recalled the arrival of Matt Bue to Lanesboro, "It was immediately apparent that he was more than just a picture taker. He was an artist." This view was shared by a great many of the local population and Mr. Bue's business thrived. He continued in the community for more than 60 years, establishing here a family, a great many friends, and a lasting visual history of the town through his numerous and skillful photographs of Lanesboro and its citizens.

M.O. Bue. Born on March 5, 1889, Mathias O. Bue immigrated to the United States from Norway prior to 1909. He pursued the still emerging art of photography and in 1912, bought out the T.F. Bersagel Gallery in Lanesboro. Bue is shown seated in his new studio in 1912, just at the start of the long career that would make him Lanesboro's most beloved and respected photographer.

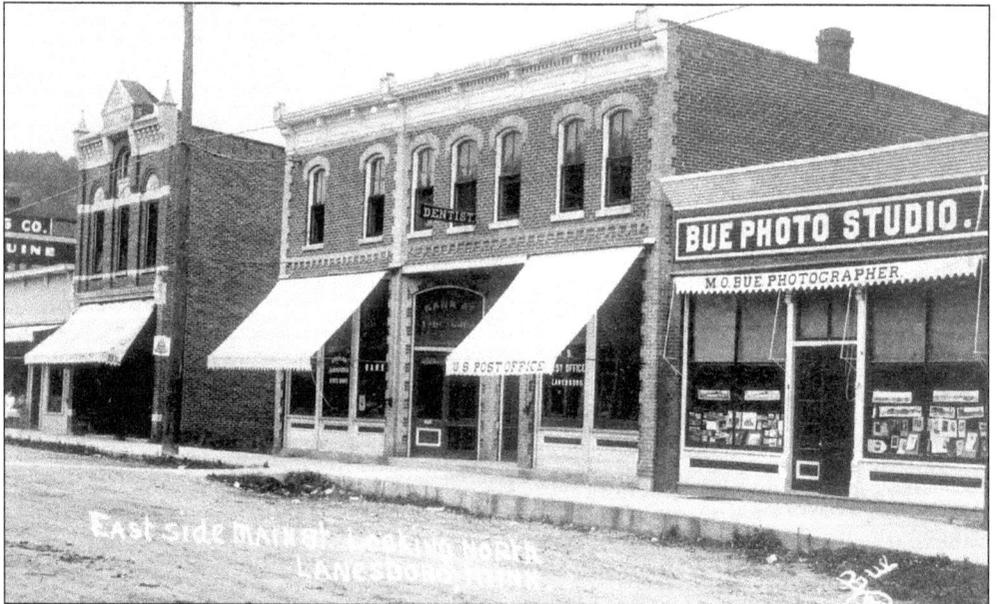

Bue Photo Studio. A fresh coat of paint and a new name brighten the former home of the Bersagel Studio in this picture from 1912. Bue's location put him at the heart of Lanesboro's activity with the post office and Bank of Lanesboro just next door. Besides portrait photography, Bue offered a line of products that by 1922 included Victrolas, Kodaks, hand carved photo frames, and wall pictures.

102

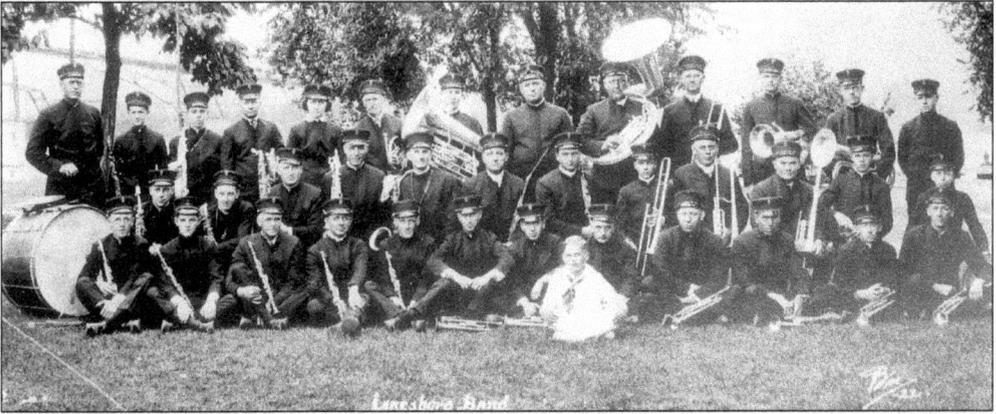

THE BUE SIGNATURE. Many people regarded Matt Bue as an artist. He may have shared that view for he signed many of his photographs, something that was not common among his contemporaries. Today the Bue signature is a sought-after feature in post card collecting. All 37 members of the Lanesboro Band are immortalized in this Bue photograph from 1922.

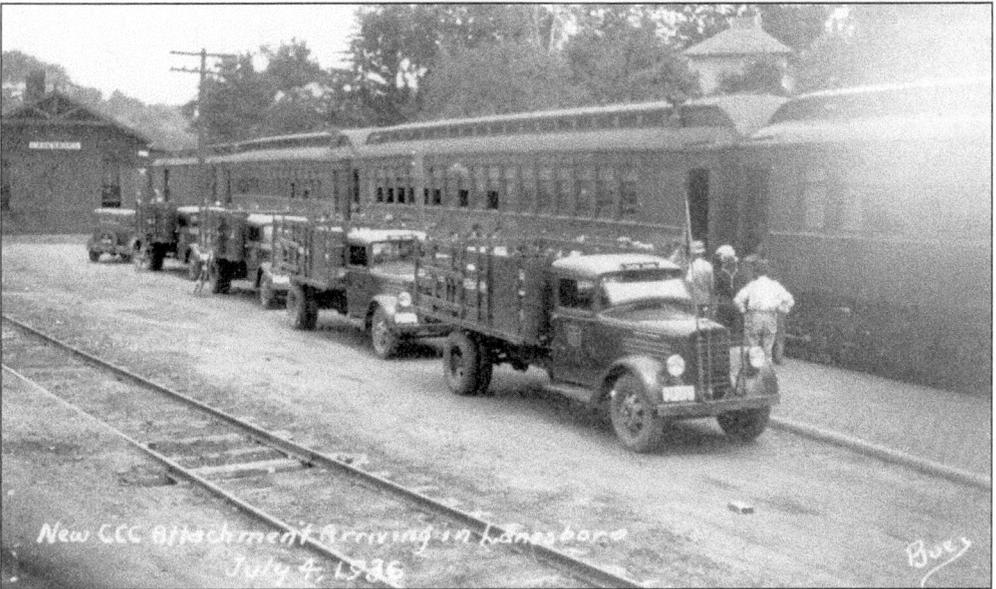

CAPTURING LANESBORO'S HISTORY. Perhaps the most important aspect of the work done by Matt Bue during his many years in Lanesboro is that of historic documentation. His skillfully rendered photographs have created a pictorial history of Lanesboro and its citizens from 1912 to his retirement in 1946. Here a new CCC attachment is shown arriving in Lanesboro by passenger train on July 4, 1936.

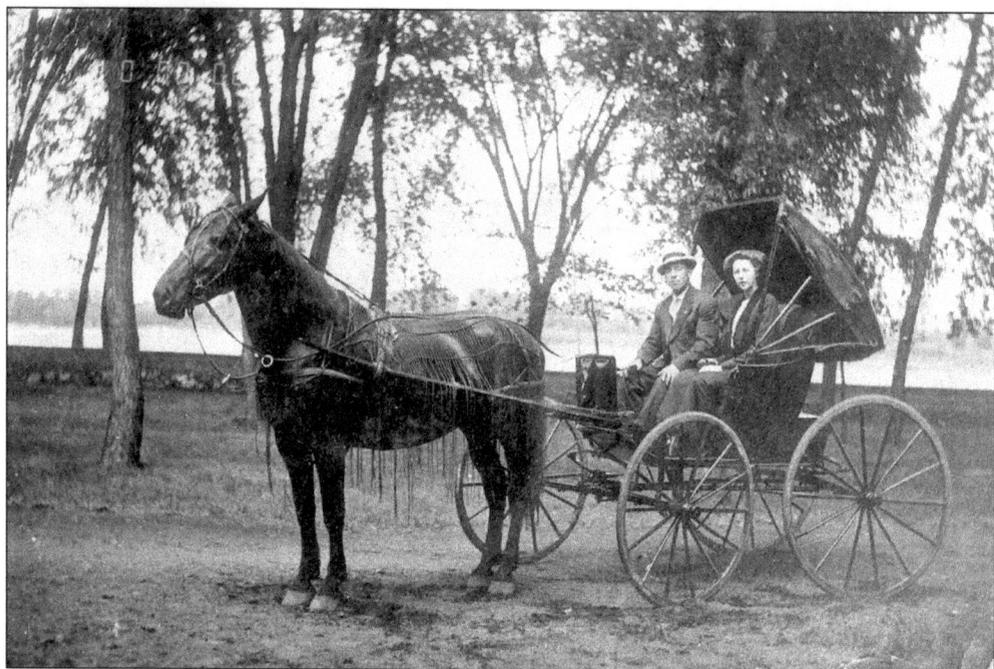

BEFORE LANESBORO. Prior to arriving in Lanesboro, Matt worked as a photographer in Granite Falls, Minnesota, from 1909 to 1912. He occasionally referred to having done farm work and may have been thus employed at sometime. Here he is seen *c.* 1910. The young lady is unidentified.

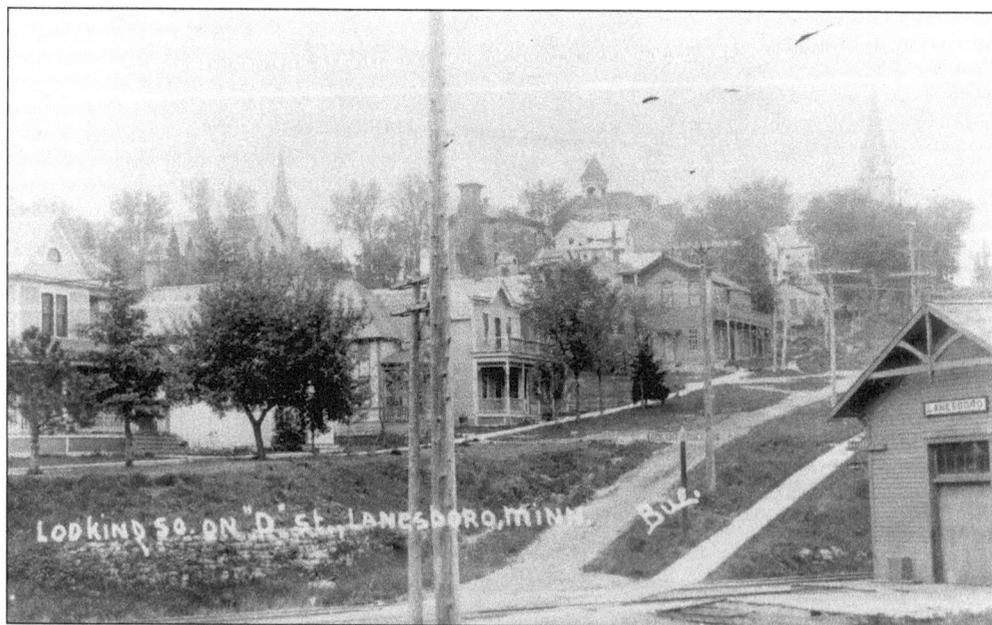

LOOKING SOUTH ON 'D' STREET. This Bue photo, taken about the time the young photographer arrived in Lanesboro, shows the Lanesboro train depot at right and 'D' Street rising up Church Hill. At the summit, the Catholic and Lutheran Churches book end the Old Stone School and High School Buildings. Most of the buildings shown at left are still standing.

SPECIAL DELIVERY. Clarence Williams hitches a ride from brother Claude Williams on the east side of Main Street in 1912. Playfully inscribed, "Williams' Heavy Dray Line," the photo gives a taste of Matt Bue's sense of humor as well as his desire to photograph not only the grand and official, but also the everyday events that reflected the spirit of the community.

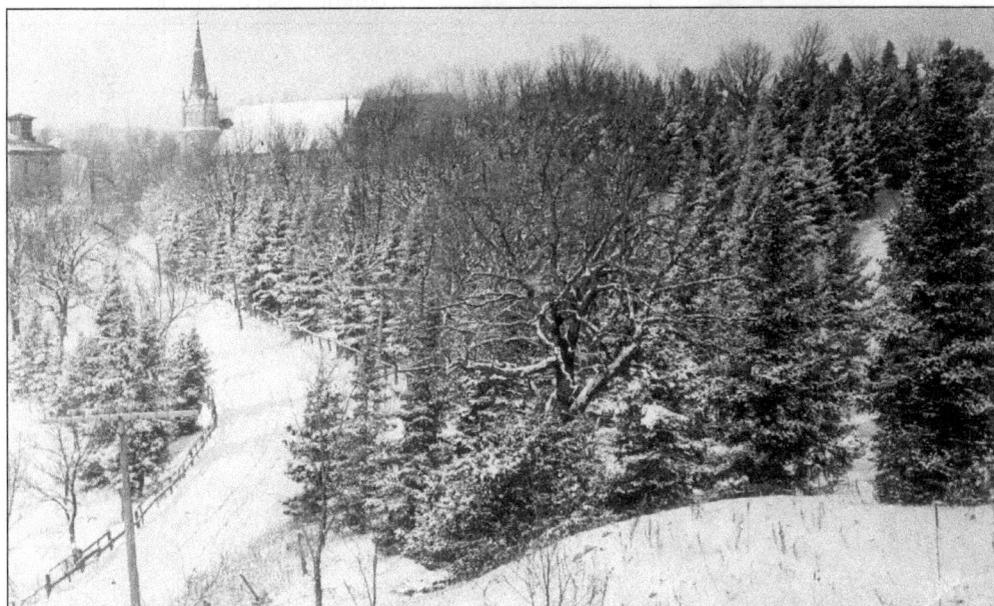

CADY HAYES PARK. Inscribed with the title, "Lover's Lane In Winter," this beautiful photo by Matt Bue captures not only the winding scenic lane from Church Hill to Brooklyn, but also the snow-covered pines of Cady Hayes Park. Retired Lanesboro farmer Cady Hayes had scores of young pine trees transplanted onto the site in the 1890s. The area was opened for the public to enjoy furnishing many fond memories.

BUE STUDIO & GIFT SHOP.
After Lanesboro's Corner Store building was moved one lot south to make way for the new Scanlan-Habberstad Bank in 1923, Matt Bue purchased the building and relocated his studios there. The photo's inscription reflects Matt's love of his adopted hometown, "located among the most picturesque hills and valleys of Minnesota. You have not seen Minnesota if you have not seen the Root River Valley."

SALES & DISPLAY ROOM. Pictured is the well-appointed sales and display room of the Bue Studio & Gift Shop in Lanesboro. A variety of Bue images adorn the walls, both portrait samples and wall pictures offered for their aesthetic value. The stair at rear leads to a full photographic studio on the building's second floor.

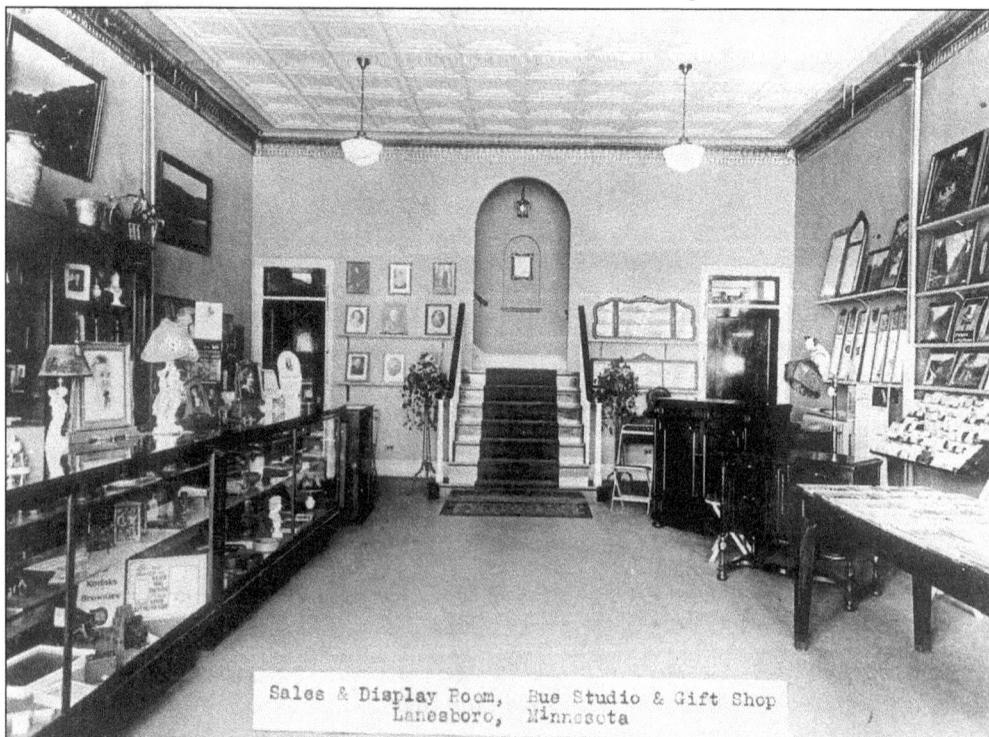

Sales & Display Room, Bue Studio & Gift Shop
Lanesboro, Minnesota

MATT BUE IN ACTION. This photo of Matt Bue actively plying his trade was taken around 1920 and may have been a clever self-portrait. Note the wood tripod and the nature of the equipment used to create the wonderful images for which Mr. Bue is so well known.

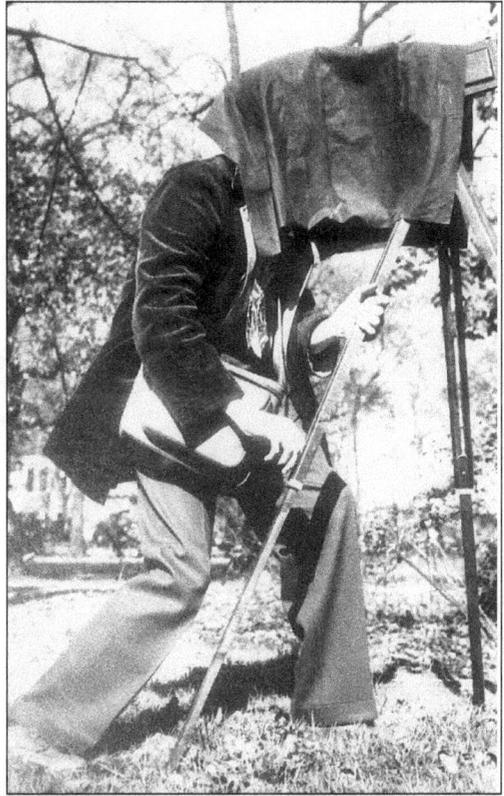

THE BUE HOME. Matt and Suzy Bue (standing) celebrate their silver wedding anniversary in their home in Brooklyn on April 28, 1940. The photo's inscription reads, "Silver wedding cake presented them by the studio 'gang'." Matt married Miss Susan Larson three years after his arrival in Lanesboro. The couple had no children but did raise Jo Anne Bue, youngest daughter of Matt's brother Hans, after the death of the girl's mother.

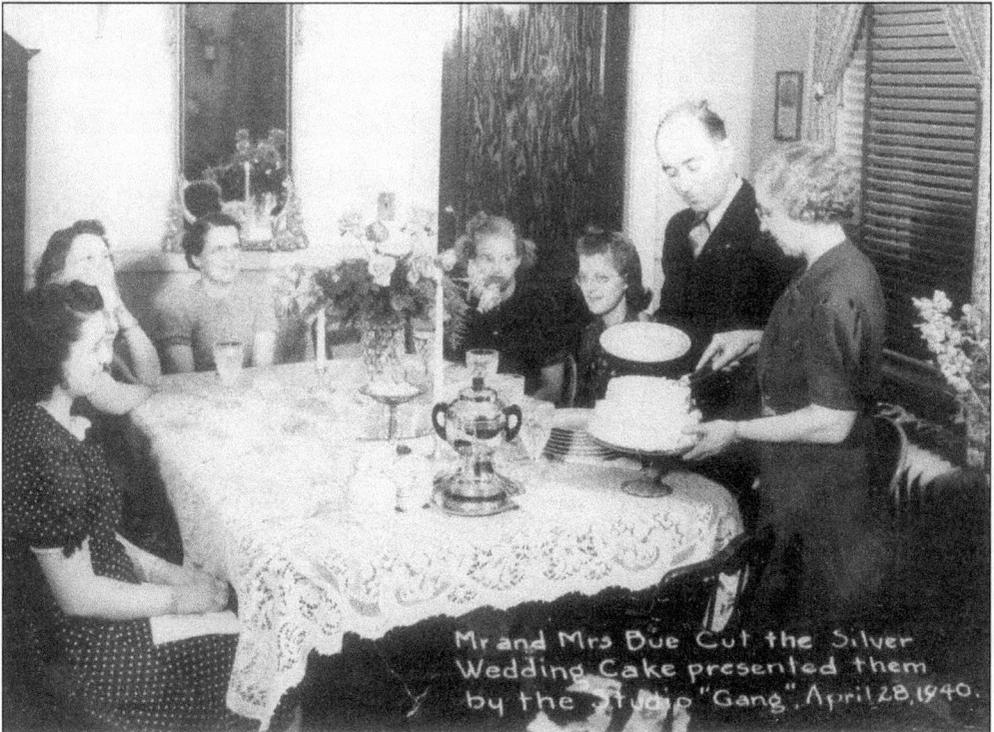

Mr and Mrs Bue Cut the Silver Wedding Cake presented them by the Studio "Gang". April 28, 1940.

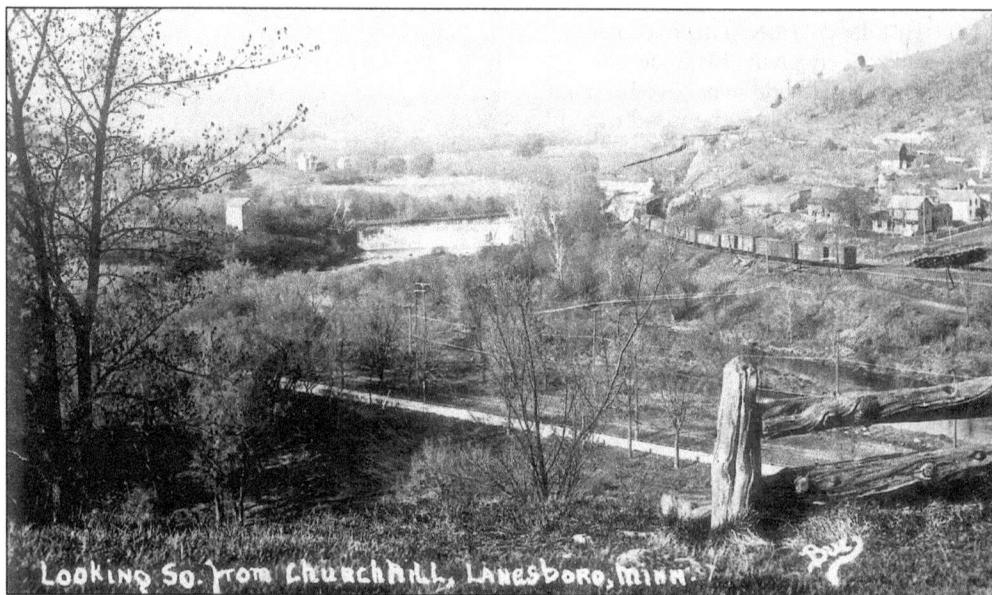

LOOKING SOUTH FROM CHURCH HILL. A long freight train snakes around the bend toward the cut in this languid photo by Bue taken around 1915. In the foreground is the old wooden bench on Church Hill that afforded a restful place for untold numbers of people stopping to refresh themselves with the beautiful view. A successor to this bench is still available to sight-seers today.

SYLVAN PARK IN SNOW. Taken in 1921, this Bue photo shows Sylvan Park and the Isaac Walton League Cabin wrapped in a wintry blanket of snow. Its scope defined by the surrounding hillsides and the former course of the Root River, Sylvan Park was donated to the city of Lanesboro by the Lanesboro Townsite Company and is acknowledged as one of the loveliness natural parks in the state.

108

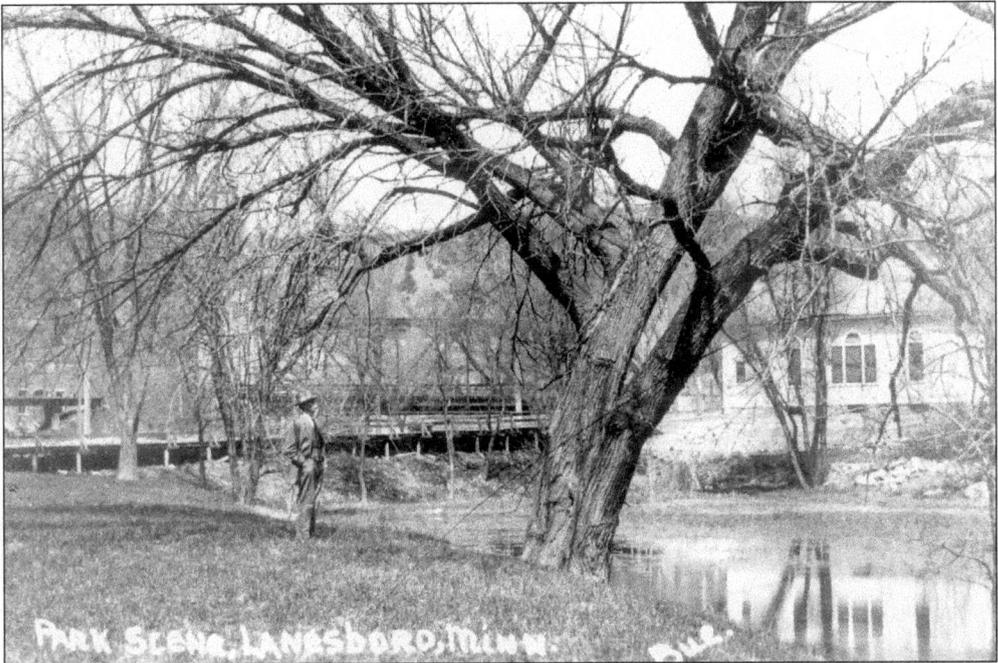

PARK SCENE. Tree branches form a latticework over the west end of Sylvan Park in this Matt Bue photo. The boardwalk along Parkway Avenue is visible and water fills the old river channel below the Lutheran Church Hall. Built on the site of the old limekiln that supplied mortar for many of Lanesboro's early stone buildings, this structure later became the Sons of Norway Hall.

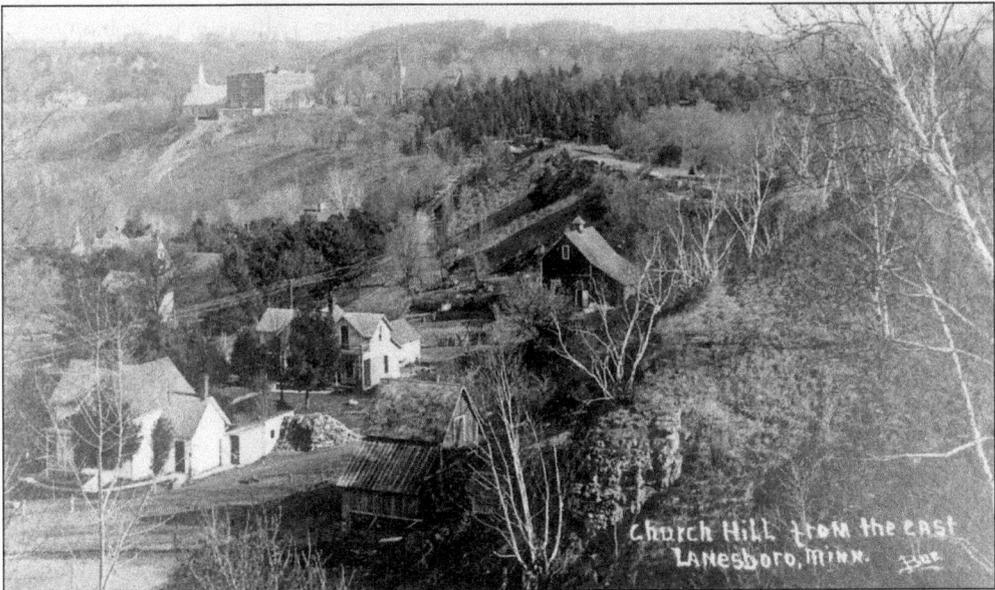

CHURCH HILL FROM THE EAST. For many years it was common for Lanesboro residents to see Matt Bue, laden with camera and tripod, hiking out into the hills surrounding the town to make pictures. This unusual view of Church Hill from the ridge to the southeast hints at a significant afternoon hike. Taken between 1917 and 1919, the photo shows the public school building before the 1919 fire.

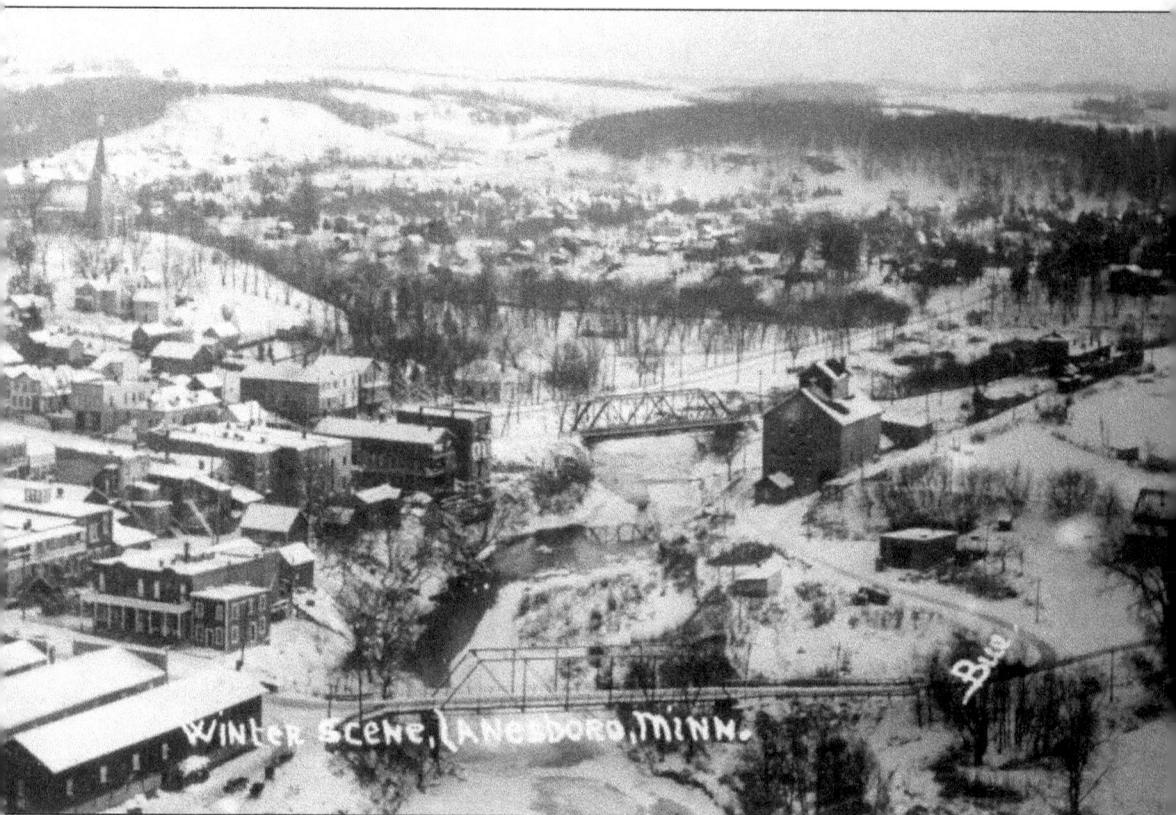

WINTER SCENE, LANESBORO, MINNESOTA. Matt Bue retired in 1946, selling the business to partners Robert Fifield and George Barry. Matt and Suzy spent the remainder of their lives in Lanesboro and are remembered as charming, neighborly people. Matt himself was known for his easy, sociable nature and ready, distinctive laugh. The prolific photographic record Matt Bue created is a gift by which Lanesboro's past can be remembered, while the artist behind the camera is remembered as well.

Nine

DEPRESSION ERA TO THE RETURN OF TOURISM

On October 29, 1929, just 63 days short of the new decade, the United States stock market crashed, ushering in the Great Depression. The people of Lanesboro found they were not immune. Businesses closed, belts tightened, and showing the kind of heartiness that had served their pioneer grandparents so well, the people persevered.

Just as the stock disaster of Black Friday came at the brink of the next decade, so too did the disaster of August 31, 1939, as Nazi Germany invaded Poland igniting the Second World War. As it had in World War I, Lanesboro again gave up its young men while the rest of the community pulled together to support the war effort.

Throughout the fifties, sixties, and seventies, Lanesboro's economy was based on the support of agriculture. Changes in transportation and hard times for the family farm weakened the town's business infrastructure. Passenger rail service ended in the 1960s and in 1979, the railroad was completely abandoned, setting the stage for the primary activity of the next decade.

In an ironic turnabout, the 1980s brought a return to tourism as the old rail line was re-purposed into the Root River State Trail and citizens interested in Lanesboro's future focused their energies on promoting the town. By the late 1980s, Lanesboro was well on its way to being one of the finest small art towns in the nation as well as a popular tourist destination just as the founders of the Lanesboro Townsite Company first envisioned in 1868.

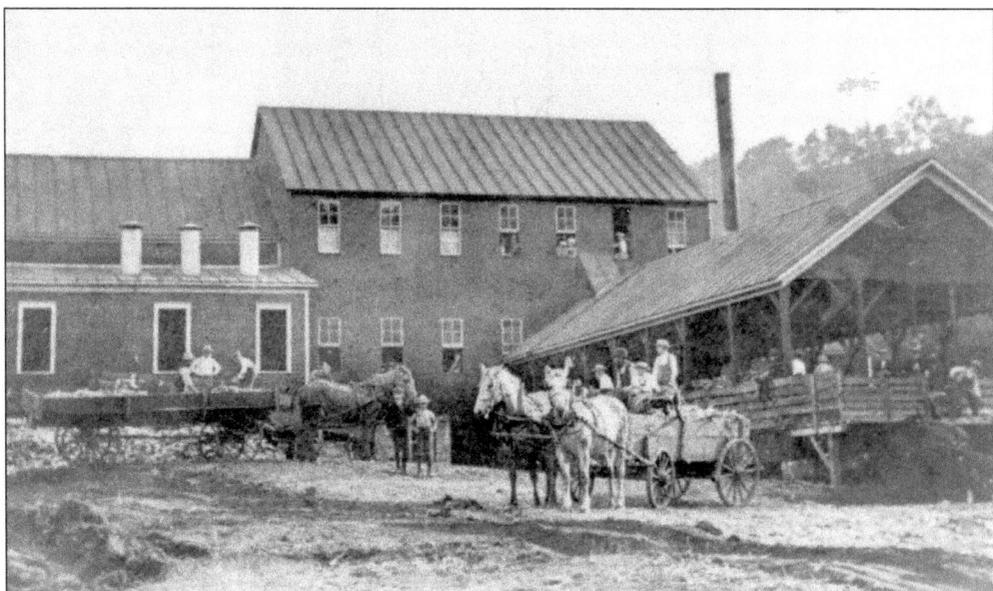

LANESBORO'S FIRST VICTIM. The Lanesboro Canning Company's factory, located near the Mill Pond, was one of the first Lanesboro businesses to succumb to the Great Depression. The factory produced Lanesboro Pride Corn for many years but closed its doors in the early 1930s. The buildings were eventually torn down to make way for the new west road and bridge into Lanesboro in the mid-1960s.

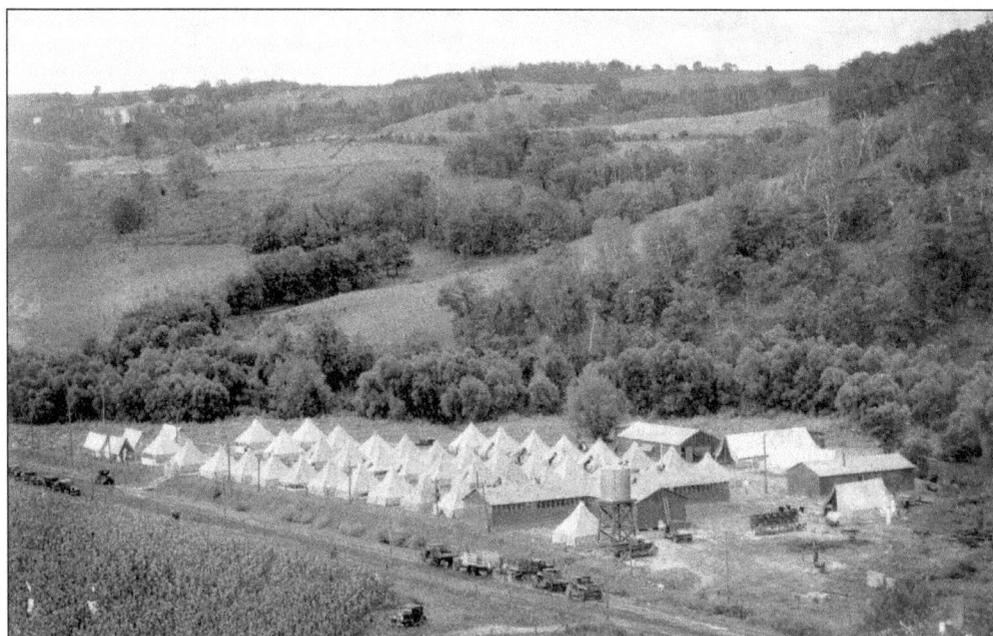

TENT CITY, 1933. The front lines of FDR's war against unemployment came to Lanesboro on April 27, 1933, with the official creation of CCC Company 751. The Civilian Conservation Corp. was the most popular of FDR's New Deal programs, putting 2.5 million young men to work from 1933 to 1942. This tent city was located a mile south of town and quickly evolved into a sprawling complex of wood barracks (seen on page 111).

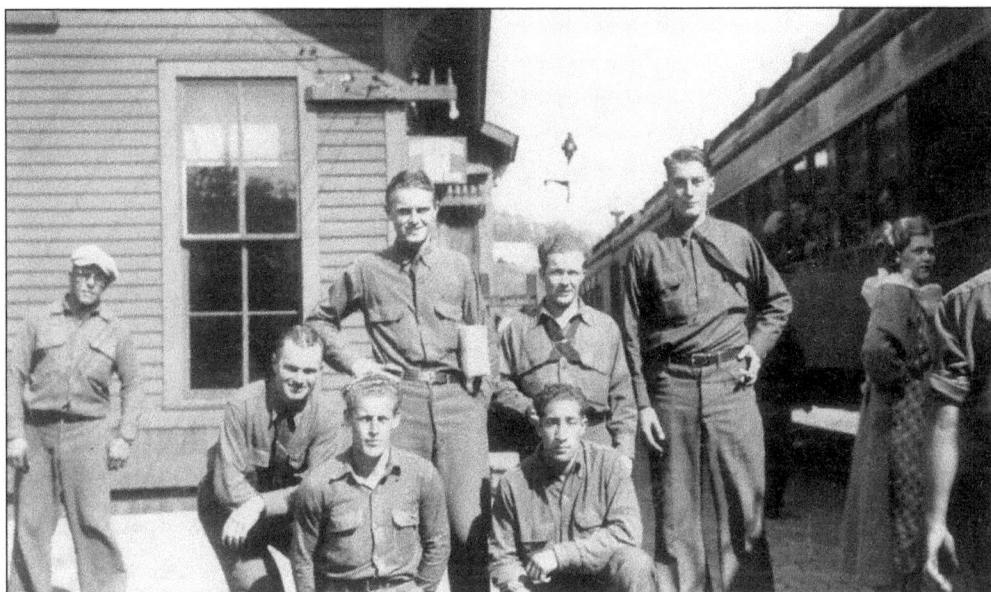

ARRIVING FOR WORK. Young CCC enrollees arrive at the Lanesboro depot, circa 1935. The men earned $30 per month and sent $25 home to their families to ease economic hardships. Lanesboro businesses benefited from the remaining $5 per man allotted for personal expenses. The men worked hard and ate well while improving public lands. Among their efforts was extensive work on small dams and waterways around Lanesboro.

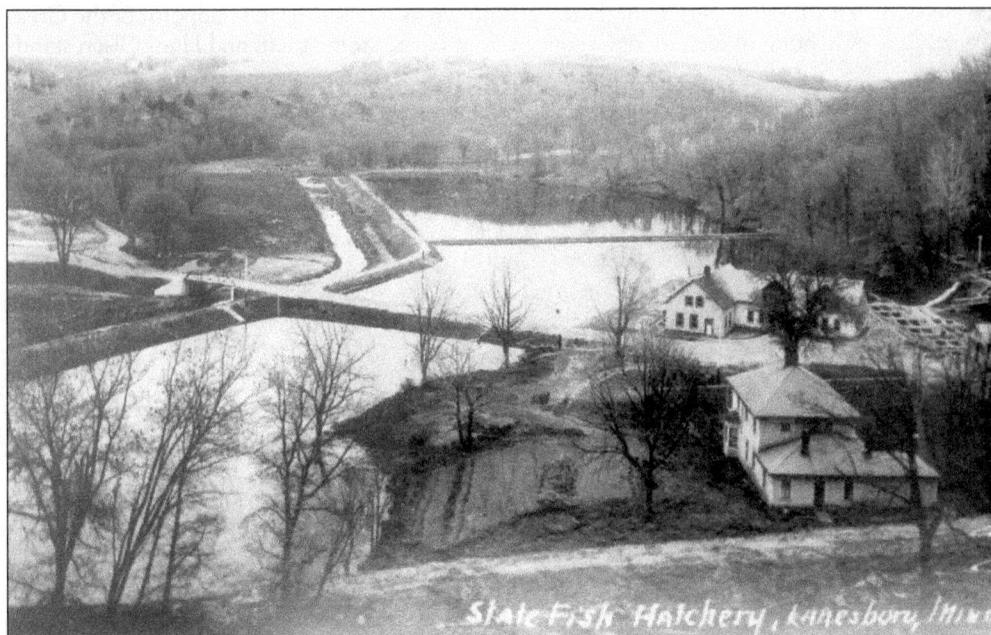

LANESBORO STATE FISH HATCHERY. Established in 1925 at the site of the old Duschee Mill south of Lanesboro, the location was chosen to take advantage of Big Spring, which has the largest spring flow in Minnesota. Ole Duschee built a mill there in 1876 for the same reason, and artifacts indicate native peoples frequented the site. Today the hatchery is one of the largest in the Midwest.

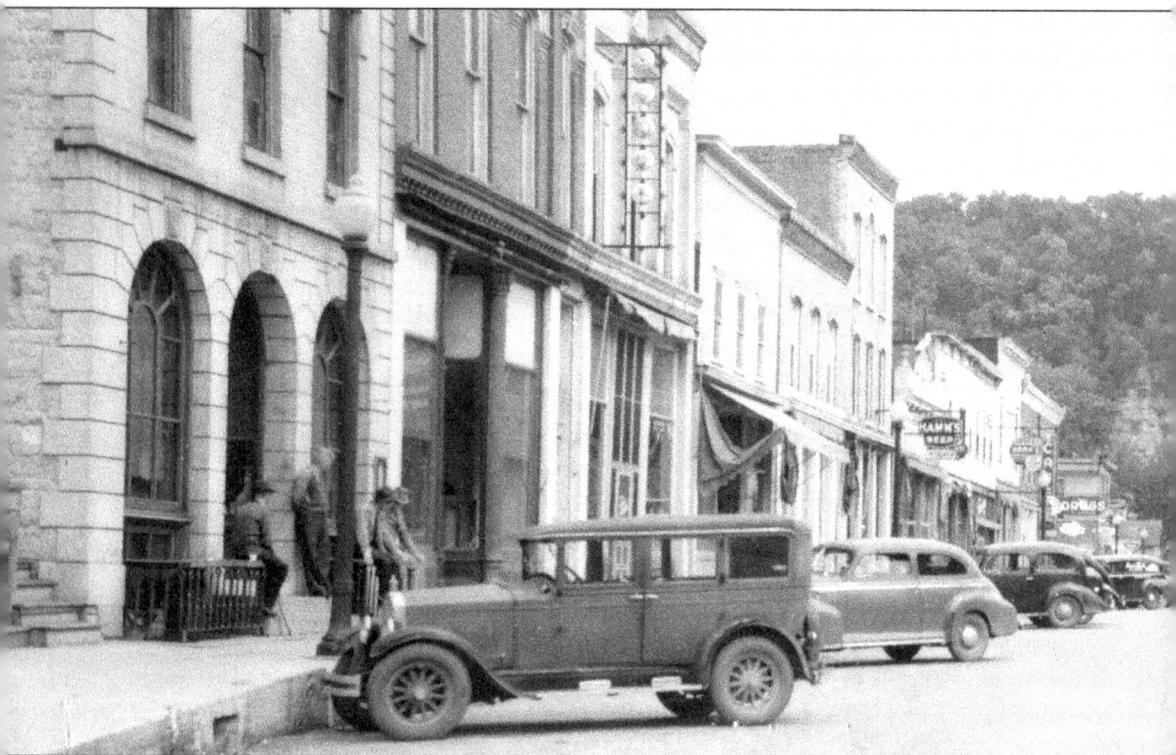

DEPRESSION ERA LANESBORO. Lanesboro's downtown as it was near the midpoint of the Great Depression. A handful of men lounge about in front of the store at left, and Hans Olson stands

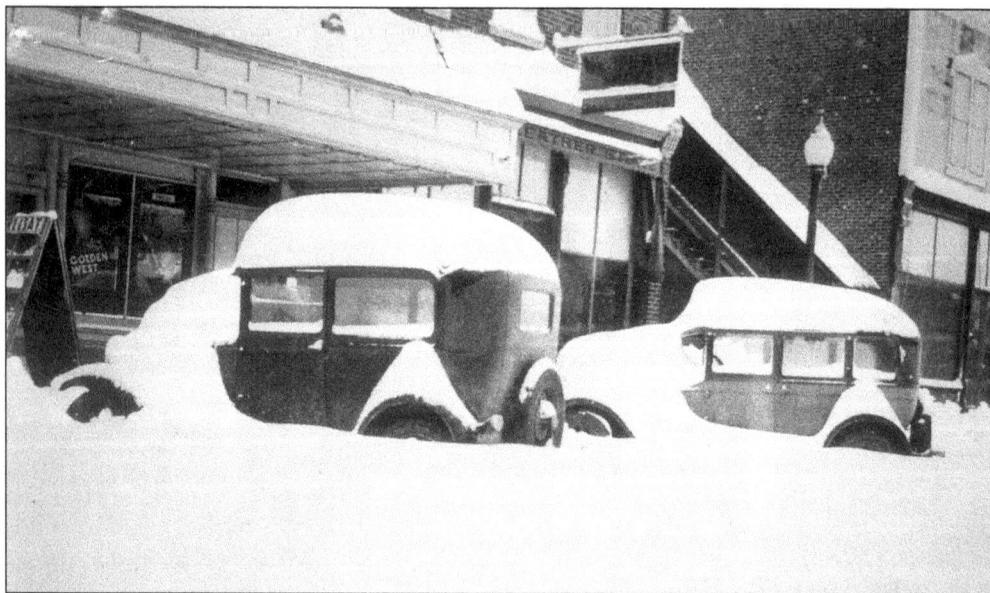

A MINNESOTA SPRING. Minnesotans are no strangers to snow, heat, and unpredictable weather changes. Nonetheless the blizzard of March 20, 1933, must have been trying for even the hardiest of Lanesboro's citizens as heavy snows defied the approach of spring. These snow-blanketed cars are outside the Elite Theatre on Main Street (now Parkway Avenue).

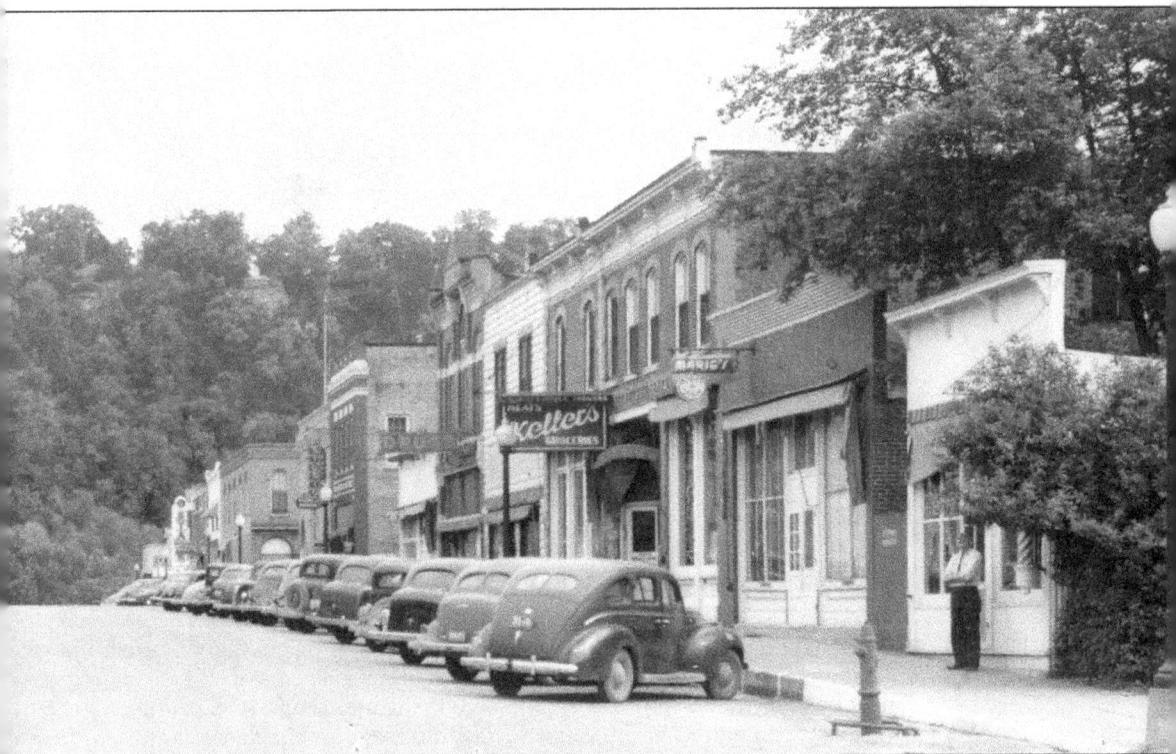

in front of his barbershop at right looking out on the quiet street.

THE CHANGING FACE OF BUSINESS. G.B. Ellestad, jeweler, retired after a decades-long career in Lanesboro business, and the building on Main Street that had housed his jewelry store was put to other uses. Here, Culbertson's, a radio and electronics store, occupies the space in 1938. From left to right are Harold Thoen, R.W. Culbertson, G.B. Ellestad, Emil Syvertson, Hans Paulson, Oscar T. Johnson, and Julian Gilbertson.

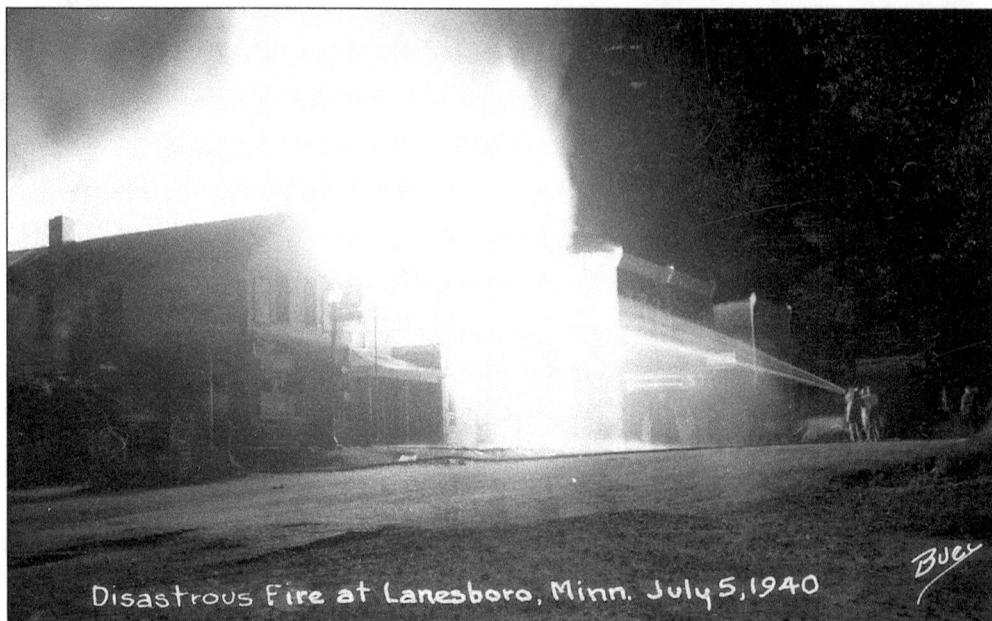

Disastrous Fire at Lanesboro, Minn. July 5,1940

DISASTROUS FIRE AT LANESBORO. The night of July 5, 1940, brought yet another disastrous fire to Lanesboro. This time it was the north end of Main Street that suffered with three buildings gutted by fire, including the White Front Café. Lanesboro firefighters can be seen pouring water on the blaze. The remodeled State Theatre is just visible to the right of the flames.

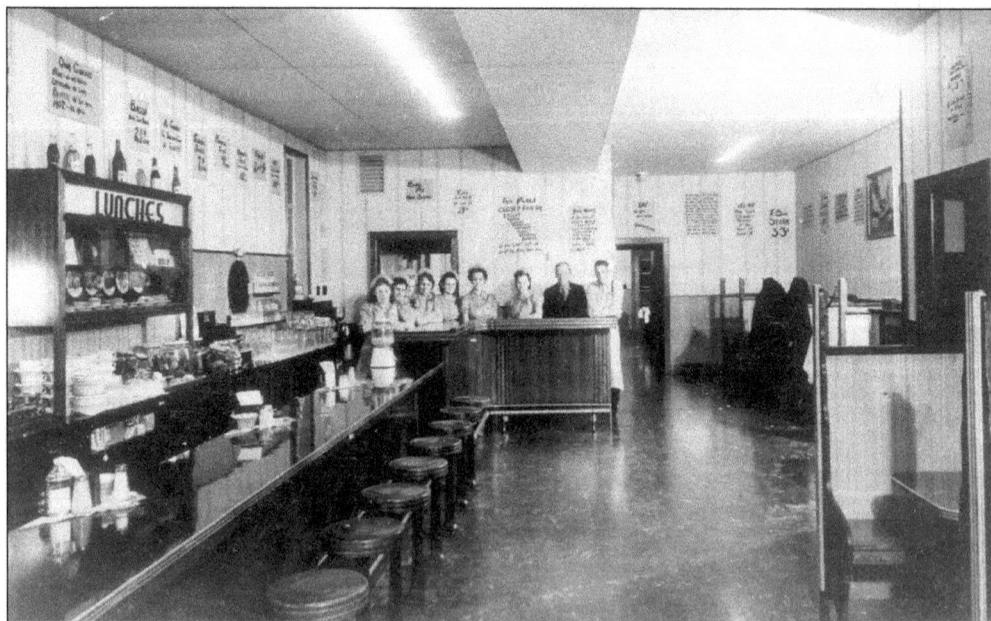

WELCOME TO THE WHITE FRONT. Completely rebuilt following the 1940 fire, the White Front Café is shown, c. 1945. The proprietors offered good food with a side dish of fun. One of the many signs shown reads, "This place closed everyday except Monday, Tuesday, Wednesday, Thursday, Friday, Saturday, Sunday." From left to right are unidentified, unidentified, Clara Evenson, Mrs. Elmer Walters, unidentified, Olya Benson, unidentified, Jach Hansen, and Elmer Walters.

COMMUNITY BUILDING. Built in 1928 at a cost of $30,000, this spacious community building served Lanesboro's residents until 1941. The present Lanesboro Community Hall was built on the same location in 1953 and was extensively remodeled in the 1990s with expanded public library, city offices, and meeting rooms.

ANOTHER TERRIBLE LOSS. Once again fire ripped through one of Lanesboro's public structures on May 15, 1941. Townspeople are seen surveying the smoking remains of the once proud Lanesboro Community Building following the fire. In the shadow of the Great Depression and with the Second World War already underway in Europe, it would be 12 years before a new building was constructed to replace this community loss.

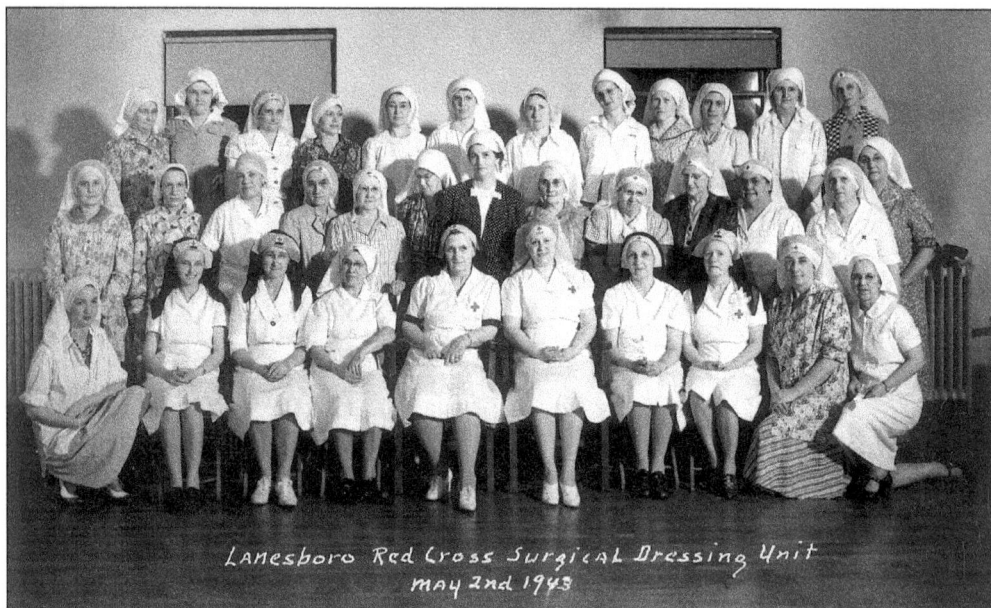

Lanesboro Red Cross Surgical Dressing Unit
May 2nd 1943

SUPPORTING THE WAR EFFORT. Following the bombing of Pearl Harbor on December 7, 1941, a number of Lanesboro's citizens joined those already active in the armed services. At home, wives, parents, siblings, and children waited—but not idly. Here the Lanesboro Red Cross Surgical Dressing Unit is pictured on May 2, 1943. These women made up dressings and packaged them for shipment to military hospitals overseas.

A MAN IN UNIFORM. Several young Lanesboro ladies are pictured having caught hold of Kenneth Swenson while on leave in Lanesboro in 1943. Lanesboro has contributed soldiers to every U.S. war effort since the Spanish-American War, including Korea, Vietnam, and the Persian Gulf. From left to right are unidentified, Alene Austin (Ward), Kenneth Swenson, Betty Ferguson, and unidentified.

FLOODWATERS OVER DIKE. Even with a dike in place along Parkway Avenue, the Root River, swollen by rain and melting snow, floods across the roadway and into Sylvan Park in this photo from March of 1950.

BRIDGE COLLAPSE. Groups of spectators ogle the collapsed Hwy 250 Bridge from either side of the Root River. The partially submerged semi-tractor trailer truck proved too much for the aging bridge, causing it to give way completely. The bridge was later replaced at the same location on the east end of Lanesboro's "flats." The driver of the ill-fated truck escaped unhurt.

FULL SERVICE ESTABLISHMENT.
Hank's on Lanesboro's Parkway Avenue advertises its varied services with a sign that reads, "Hank's Café, Bakery, Ice Cream Store [and] Rooms." A further enticement in the window above the door promises, "It's air cooled inside." Owner Hank Langlie, remembered as friendly and humorous, was part of a multigenerational tradition of Langlie merchants in Lanesboro.

HANSON'S IGA. Orvis and El Doris Hanson's IGA store draws a crowd as a new sign is hung outside the building following a fire on August 10, 1964, that extensively damaged but did not destroy the building. The Hanson's were in the grocery business in Lanesboro for nearly 40 years. They started at this location in 1960.

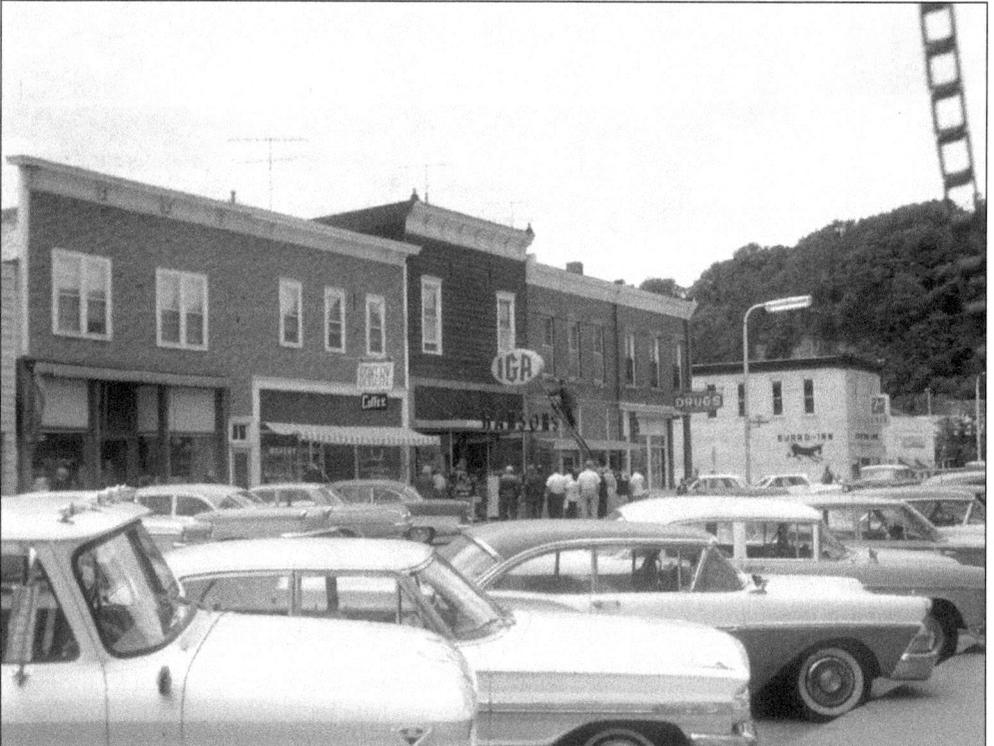

NEW ARRIVALS. No longer a boomtown, Lanesboro's beauty and friendly atmosphere still attracted newcomers in 1960 like Chuck St. Mane, who brought his family to Lanesboro to open a hardware store. Chuck and wife, Cathie, were quickly adopted by the good-hearted people of Lanesboro and in turn devoted themselves to numerous community activities. Pictured are Clint St. Mane (left) and Chuck St. Mane (right).

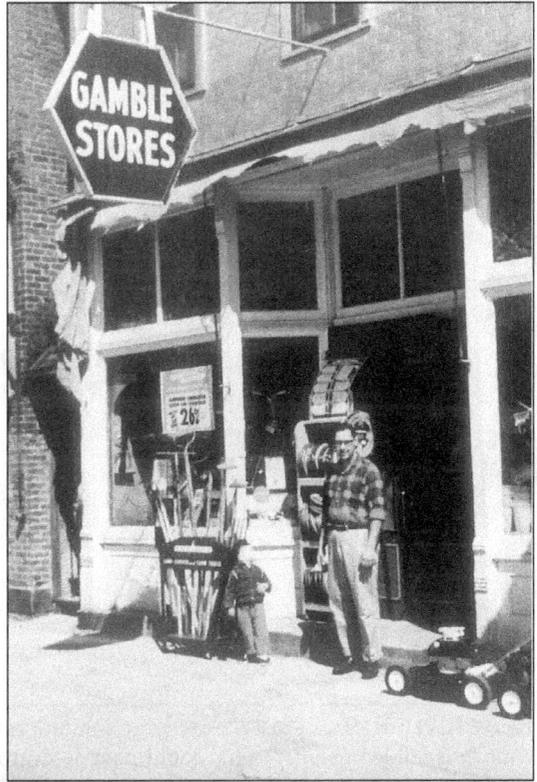

LANESBORO VOLUNTEER FIRE DEPARTMENT, 1969. Lanesboro celebrated its centennial in 1969 with citywide events including a call for all men to grow beards. From left to right are (front row) Lynn Iverson, LeRoy Erickson, Virgil Bothun, Harris Overland, Gordon Peterson, and Lee Boyum; (middle row) Ed Gatzlaff, John Solberg, Charles St. Mane, James S. Johnson, Clarence Johnson, Dave Campbell, Dave Drake, and Roger Benson; (back row) Curt Hanson, Arnold Holte, Don Wangen, Dave Nelson, and Earl Sveen.

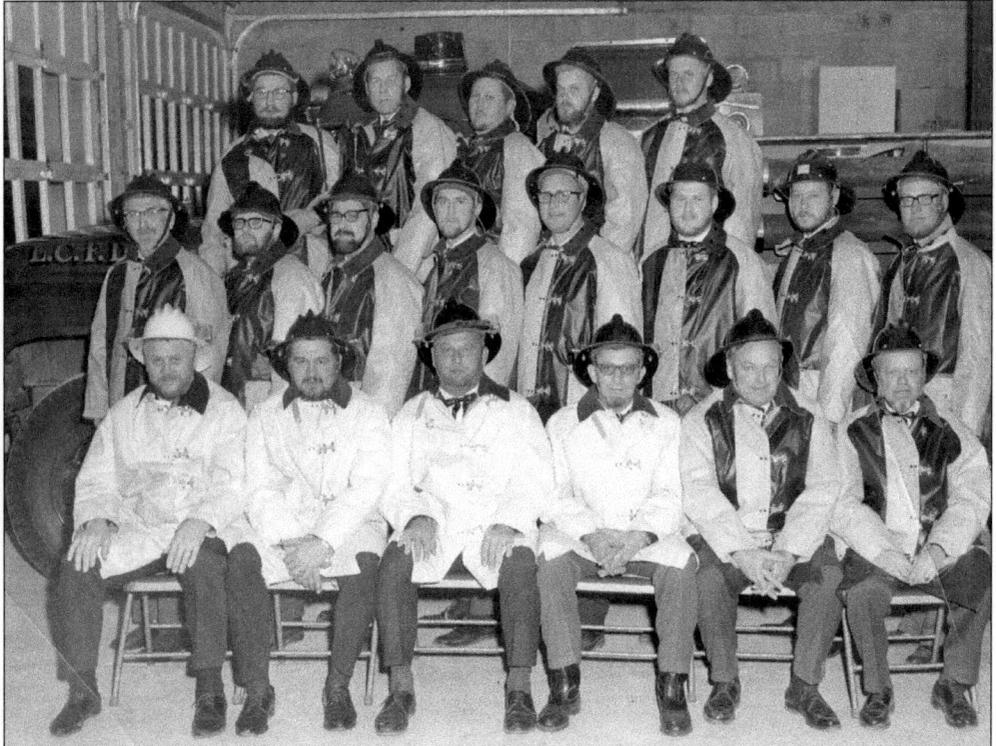

ROOT RIVER RENASCENCE. "An idyllic summer resort town rich with natural beauty, clean air and pleasurable pursuits." This could be a description of Lanesboro today or the Lanesboro of 1875. No longer the "Biggest Little City," Lanesboro is instead the "Best Small Arts Town," "Minnesota's Hidden Town," or the "Little Town in the Valley"—depending on whom you ask. Whatever the title, Lanesboro is as timelessly charming in the 21st century as it was in the 19th. Picturesque views draw people along the winding Root River State Trail that follows the old Southern Minnesota rail bed into and through town. Canoeing, hiking, and bicycling are prevalent and the arts have blossomed in this place of scenic beauty hidden away for decades and only recently rediscovered by an appreciative public.

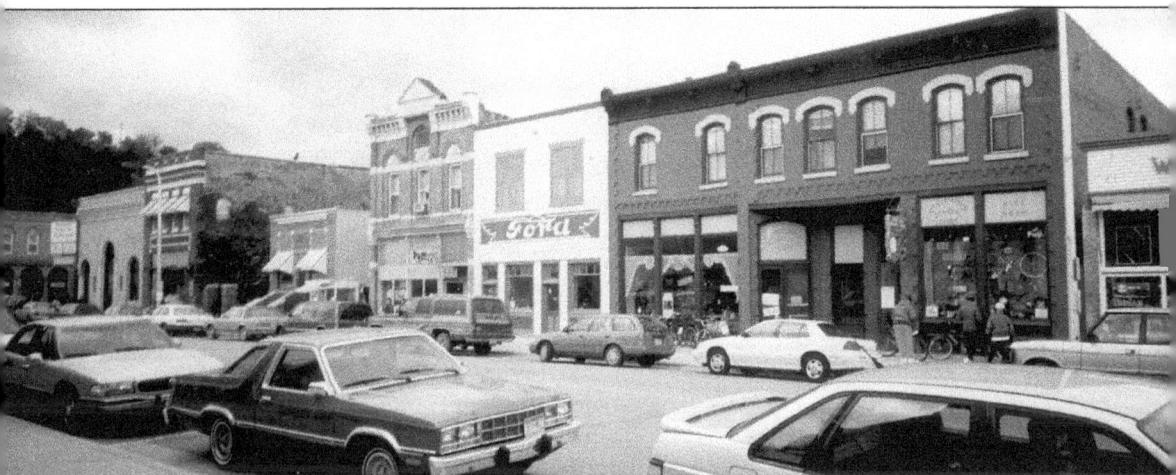

LANESBORO'S HISTORIC DOWNTOWN. Many of Lanesboro's downtown buildings are listed on the National Register of Historic Places. Preserved passively for decades, Lanesboro's historic buildings gained active protection in the 1980s, when local citizens formed a Historic Preservation Committee, working strenuously for historic district recognition and support. Today as many as 200,000 visitors enjoy Lanesboro's historic down town every year.

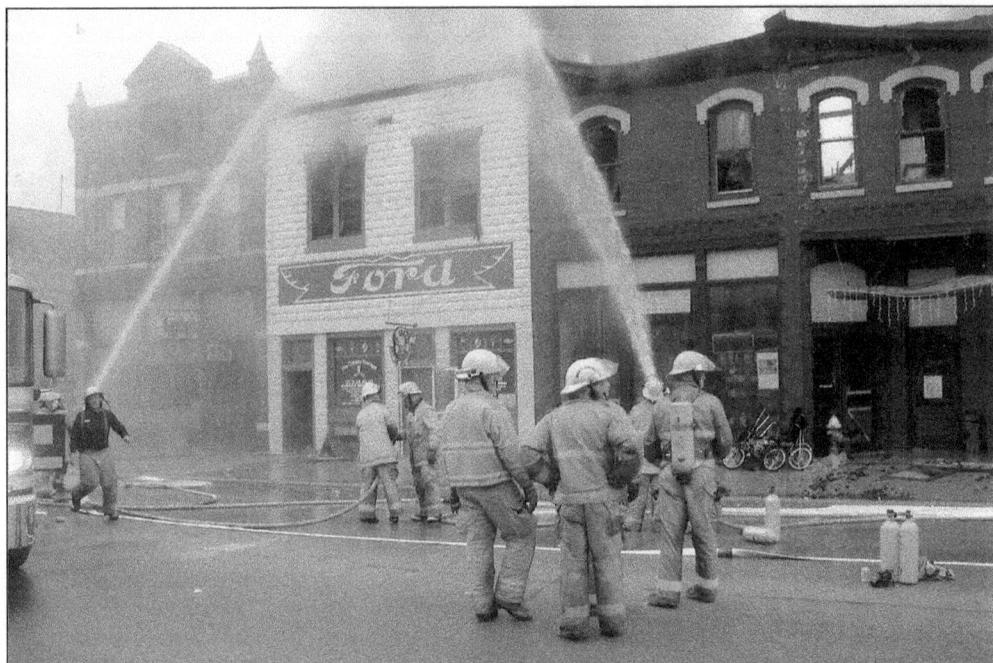

DOWNTOWN BURNING. Three historic buildings in the heart of Lanesboro's downtown were destroyed by arson on April 7, 2002, displacing three families and two businesses. Firefighters from Lanesboro and four other area departments fought the blaze. Owners Jeff, Mary, Chuck, and Ted St. Mane had renovated the buildings in the mid-1990s. Bizarrely, Lanesboro's police chief later confessed to setting the fire to impress a former girlfriend.

LANESBORO'S CREAMERY, 1944. The Lanesboro Co-op Creamery was established in the early 1920s and served the area's dairy farmers for more than 40 years. The sign in front of the building proudly announces, "The Land O' Lakes Creamery now making fresh creamery butter for the U.S. Navy!"

LANESBORO'S WINERY, 2002. The Scenic Valley Winery produces numerous varieties of local wine. An early addition to Lanesboro's economic rejuvenation of the 1980s, the winery has been important to the community for many years.

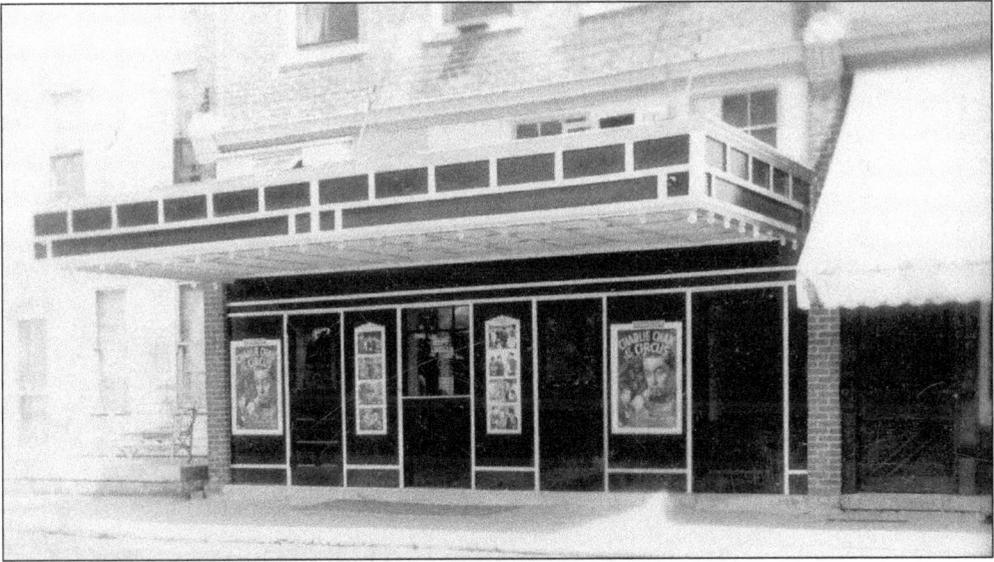

THE ELITE THEATRE, 1936. Manvel Olson opened the Elite Theatre in the early 1900s, showing silent films accompanied by piano music from the balcony. Leone Rogers and Cecil Ward were among the local accompanists who enriched the movie experience before the introduction of "talkies" in 1927. Later the theatre was remodeled and reopened as the State Theatre, which it remained until closing in the 1960s.

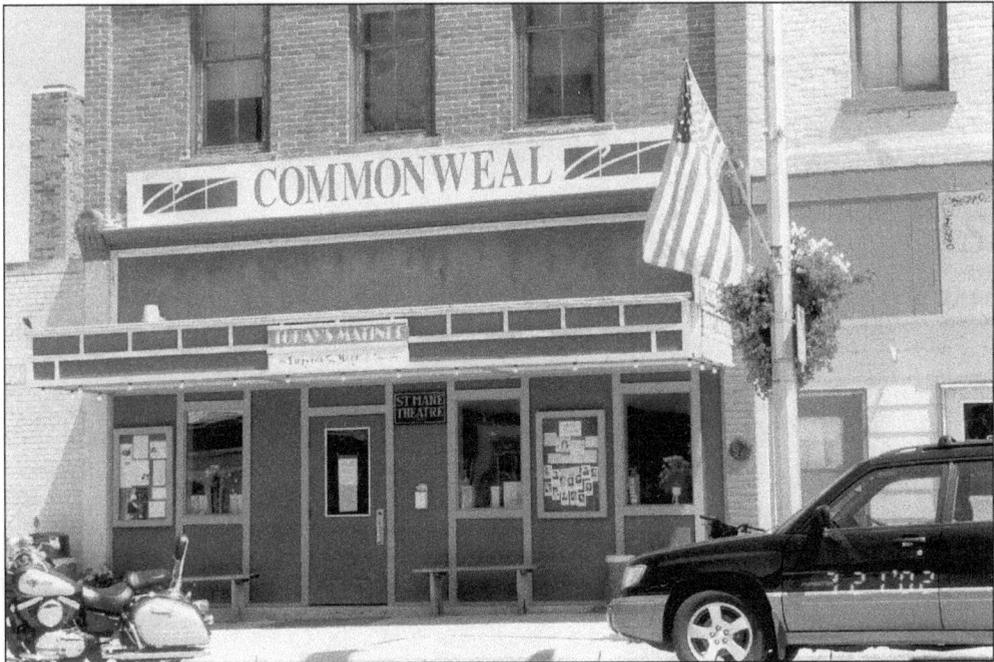

THE ST. MANE THEATRE, 2002. Opened by the Lanesboro Arts Council in 1984, the theatre was named for Post Master and community advocate Chuck St. Mane. In 1989 Eric Lorentz Bunge formed the Commonweal Theatre Company, which has made the theatre its home ever since. This company of theatre professionals has expanded the scope of theatre in Lanesboro through masterful performances and innovative arts programs greatly enriching the area's arts scene.

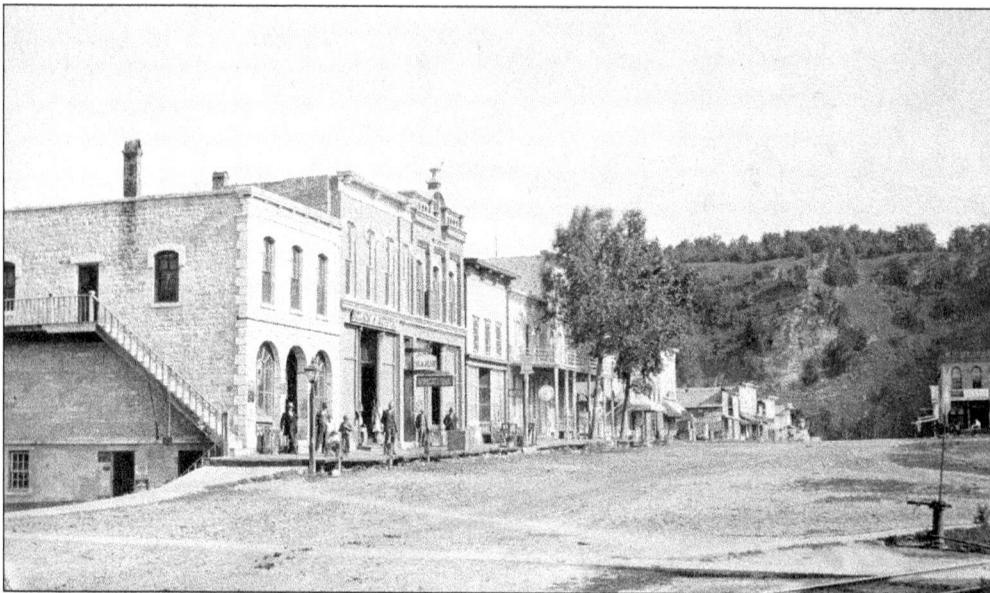

LANESBORO'S DOWNTOWN, 1890. The sidewalks are wood planking and two tall trees shade the middle buildings. A Mortar and Pestle adorns one building's crest and the streets are paved with dirt. Still, this view of 'E' Street, later called Main Street and now Parkway Avenue, is more recognizable than one might expect given the amazing scope of change from the 19th century to the 21st.

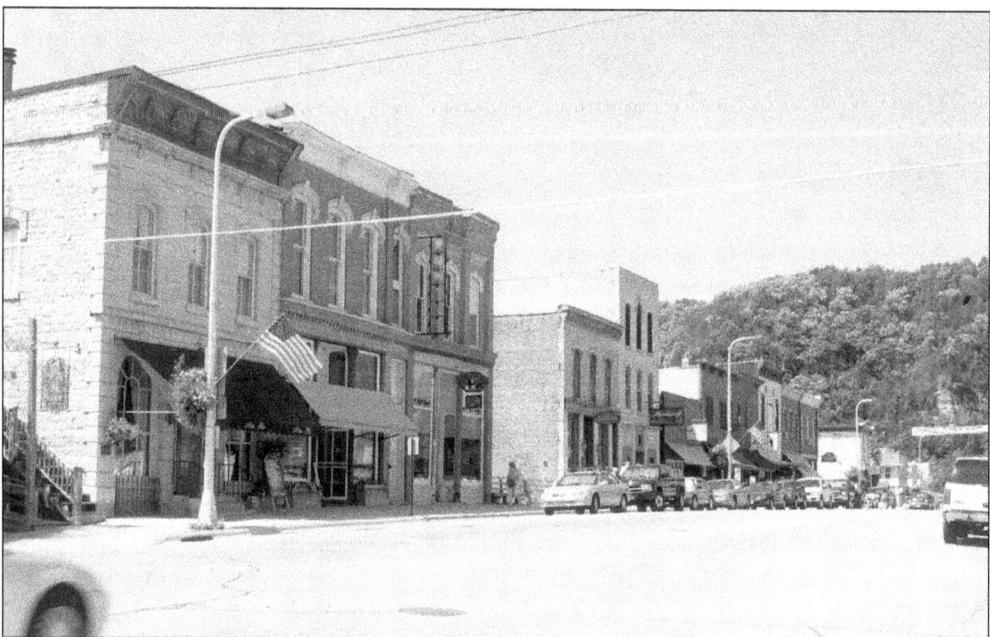

LANESBORO'S DOWNTOWN, 2002. Modern Lanesboro sports electric lights and does without trees downtown lest they should spoil the view of the street. There are cars rather than carriages, and one would expect that the people strolling around Lanesboro today have more time for leisure pursuits than the town's first residents. Whatever the differences, similarities abound with an ethic of friendliness, hard work, and community pride always evident.

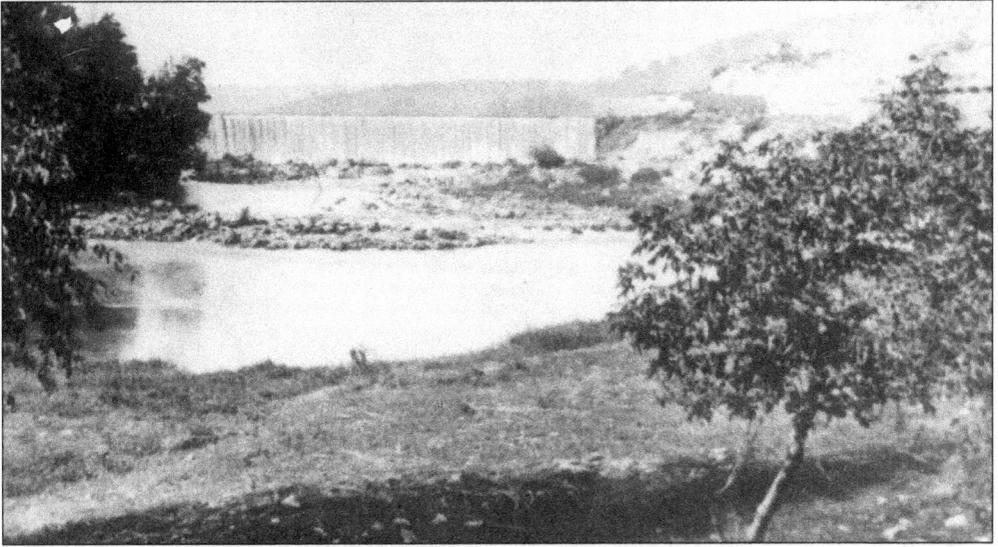

THE LANESBORO DAM, 1873. Pivotal to the growth of early Lanesboro and important throughout the community's life, the Lanesboro power dam generated motive force for numerous milling operations including a flax mill, one of the country's earliest roller mills, and the still-operating Lanesboro hydroelectric plant established well over 100 years ago. The dam is seen here shortly after its completion.

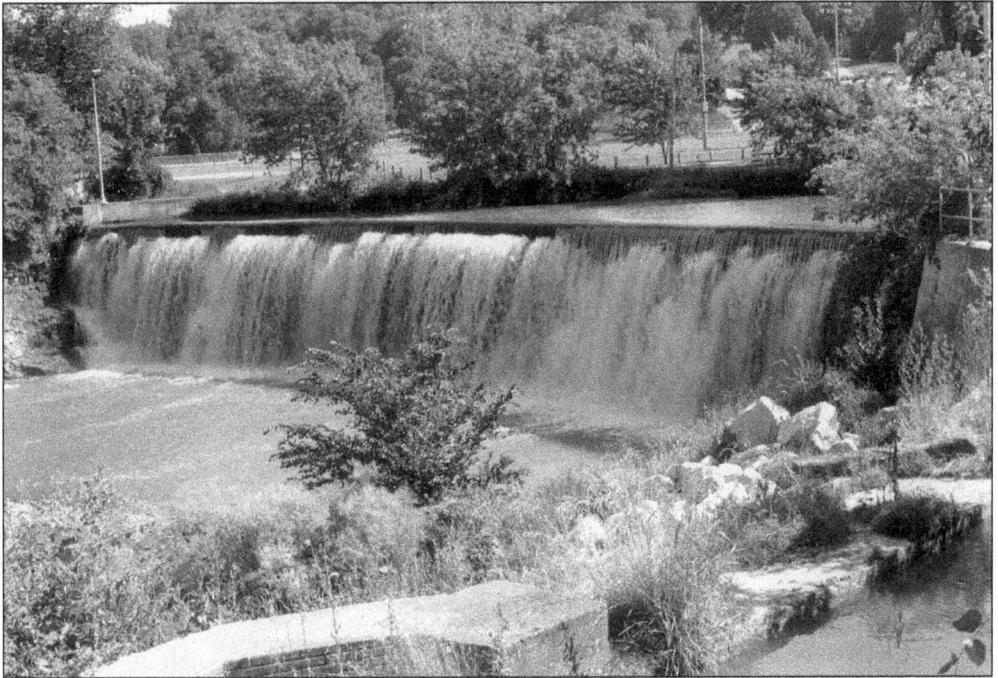

THE LANESBORO DAM, 2002. Time is the great leveler and age is often seen as decline but some things just get better with the passing of the years. Such is the case with the dam at Lanesboro. Hillsides once bare are ripe with hardwoods, and the white water of the fall shimmers in contrast to the weathered stone. How many have looked with pleasure on this sight and felt refreshed by this combination of man and nature's handiwork?

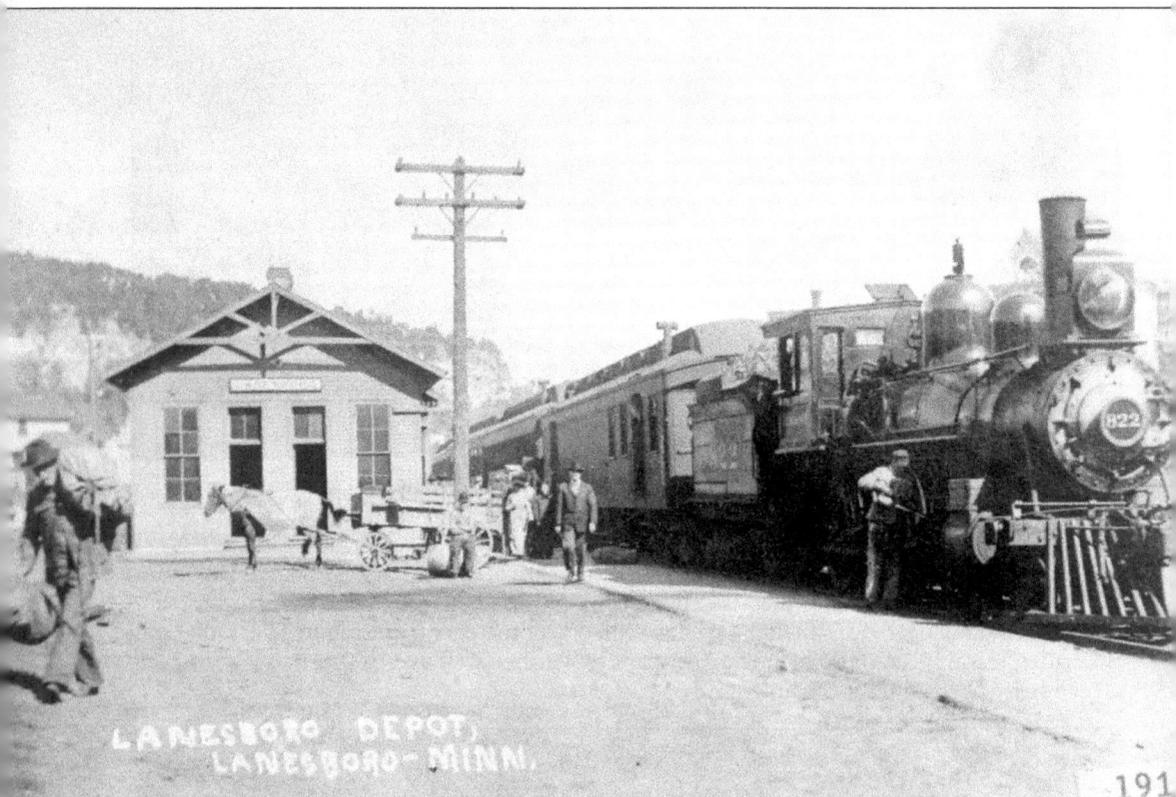

LANESBORO DEPOT,
LANESBORO – MINN.

191

HISTORIC DESTINATION. Just as the coming of the railroad sparked the activity that led to Lanesboro's creation, so too the departure of the railroad ironically set the stage for Lanesboro's current redevelopment. From spring through fall, the city swells with throngs of visitors, and even in winter, skiers and sightseers come to this beautiful little valley to enjoy nature's abundant charms. On sleepy mid-summer afternoons in the 1970s, Lanesboro's downtown might not harbor a single car as far as the eye could see. Today the challenge on that same street is locating a place to park. Whatever the rise or fall of economic fortunes, the families who have lived and worked in Lanesboro have never lost their enthusiasm for their unique little community. In 1939 the Lanesboro Trade Committee expressed a sentiment that is just as fitting today: "Lanesboro is a friendly cooperating community. Come here and enjoy this friendly spirit with us. Make Lanesboro your destination."